MW01286653

## ADVANCED PRAISE FOR *THE AUDACITY OF RELEVANCE*

"*The Audacity of Relevance* isn't just for arts leaders but for artists, philanthropists, and arts-loving audiences. It provides a modern look at our organizations and invites us to break the echo chambers we operate in. By forcing us to see the world differently, Alex Sarian asks us to rethink our purpose by leaning into our shared humanity." — **SARAH ARISON**, Trustee, MoMA

"Alex Sarian has written a practical and positive provocation that invites all of us to take a step back and have a people-centered approach to the future of the arts. By challenging us to balance our artistic and civic responsibilities to reassemble today's arts sector, this book is a must-read in these particular times of change." — **MARIE-JOSÉE DESROCHERS**, Présidente-directrice Générale, Place des Arts de Montréal

"It has become clear that a big RESET button needs to be pressed on the core value proposition of the arts. Alex Sarian's brilliant book offers the blueprint that is so desperately needed." — **OWAIS LIGHTWALA**, Assistant Professor, The Creative School at Toronto Metropolitan University

"Alex Sarian has curated a stellar line-up of thinkers to reflect on what went wrong and what needs to change. As arts communities around the world grapple with a poly crisis of issues that are fundamentally changing the way our sector operates, these conversations are essential to illuminating a way forward."— **CHRIS LORWAY**, President & CEO, The Banff Centre for Arts and Creativity

"Alex Sarian has given us a manifesto for the arts in times of crises. Chock full of compelling stories of organizations (including his own)—challenging us to ask 'What are we good for?' rather than 'What are we good at?'—Sarian forces us to focus on the experiences that bring people together." — **TIMOTHY J. MCCLIMON**, Executive Director, Signature Theatre Company

"Alex Sarian's *The Audacity of Relevance* is essential reading for revitalizing the arts sector. Through insightful conversations with leaders from across industries, Sarian shows us how the arts can become catalysts to drive social change and community engagement and redefine our future."— **LARRY OSSEI-MENSAH**, Curator & Co-founder, ARTNOIR

"*The Audacity of Relevance* makes a compelling case for arts organizations seeking sustainability and impact in the twenty-first century, emphasizing the need for adaptability and community engagement, for the relentless pursuit of relevance." — **MUYIWA OKI**, President, Royal Institute of British Architects

"Essential reading for arts workers everywhere. Alex Sarian challenges the assumptions that hold the arts sector back from thriving in the twenty-first century by asking us to honestly consider whether we are stuck in a self-centered model of operating. From encouraging partnerships with other industries to rethinking our core value proposition, Sarian charts a path forward so we can reimagine the arts not only as relevant to our communities but as essential to a healthy and democratic society." — **AUBREY REEVES,** President & CEO, Business / Arts

"Alex Sarian provides a refreshingly honest reflection on the current state of the arts and an optimistic take on how to ensure their future is more equitable and inclusive. A foundational read for anyone who believes that the arts have the potential to shape society for the better." — **VICTORIA ROGERS,** Trustee, Brooklyn Museum

"*The Audacity of Relevance* encourages us to reimagine the role of the arts in a world that is constantly changing. Alex Sarian's book beautifully reframes organizational challenges into opportunities to redefine our importance. As a change leader, Sarian's focus on audiences through the lens of humility and service is essential for our sector!" — **DEVYANI SALTZMAN,** Director for Arts & Participation, Barbican Centre

"Alex Sarian takes us through a series of provocations that highlight choices—not merely to survive but to thrive in service to our communities and indeed to be catalysts in society. A must-read!" — **CLAIRE SPENCER** AM

"Alex Sarian's book is a launching pad for those passionate that the arts are for everyone. It exposes the threat of the oligopoly that protects and controls many of our arts institutions today and forces us to question whether these trends might lead to an extinction-level crisis for the next generations' love of the arts." — **MANISH VORA,** Co-founder & Co-CEO, Museum of Ice Cream

"*The Audacity of Relevance* is a vital call to action, urging all of us to courageously redefine the value propositions of our institutions and reconnect with our core mission of community service. Alex Sarian highlights the complacency and fear that have hindered our industry while also charting a path forward that prioritizes both audiences and artists. This is essential reading for every arts leader striving for prosperity and growth." — **MARK WILLIAMS,** Beck Family Chief Executive Officer, Toronto Symphony Orchestra

# THE AUDACITY
# OF RELEVANCE

## CRITICAL
## CONVERSATIONS
## ON THE FUTURE OF
## ARTS AND CULTURE

# ALEX SARIAN

Copyright © Alex Sarian, 2024

Published by ECW Press
665 Gerrard Street East
Toronto, Ontario, Canada M4M 1Y2
416-694-3348 / info@ecwpress.com

All rights reserved. No part of this publication may be reproduced, stored in a retrieval system, or transmitted in any form by any process — electronic, mechanical, photocopying, recording, or otherwise — without the prior written permission of the copyright owners and ECW Press. The scanning, uploading, and distribution of this book via the internet or via any other means without the permission of the publisher is illegal and punishable by law. Please purchase only authorized electronic editions, and do not participate in or encourage electronic piracy of copyrighted materials. Your support of the author's rights is appreciated.

Editor for the Press: Jennifer Smith
Copy-editor: Jen Knoch
Cover design: Jessica Albert

LIBRARY AND ARCHIVES CANADA CATALOGUING
IN PUBLICATION

Title: The audacity of relevance : critical conversations on the future of arts and culture / Alex Sarian.

Names: Sarian, Alex, author.

Identifiers: Canadiana (print) 20240399269 | Canadiana (ebook) 20240399293

ISBN 978-1-77041-773-1 (softcover)
ISBN 978-1-77852-326-7 (ePub)
ISBN 978-1-77852-327-4 (PDF)

Subjects: LCSH: Arts—Management. | LCSH: Leadership.

Classification: LCC NX760 .S27 2024 | DDC 700.68—dc23

This book is funded in part by the Government of Canada. *Ce livre est financé en partie par le gouvernement du Canada.* We acknowledge the support of the Canada Council for the Arts. *Nous remercions le Conseil des arts du Canada de son soutien.* We would like to acknowledge the funding support of the Ontario Arts Council (OAC) and the Government of Ontario for their support. We also acknowledge the support of the Government of Ontario through the Ontario Book Publishing Tax Credit, and through Ontario Creates.

PRINTED AND BOUND IN CANADA

PRINTING: MARQUIS    5  4  3  2  1

Get the ebook free!*
*proof of purchase required

Purchase the print edition and receive the ebook free.
For details, go to ecwpress.com/ebook.

*Existence is no more than the*
*precarious attainment of relevance in an*
*intensely mobile flux of past, present, and future.*

—SUSAN SONTAG

# CONTENTS

Dear Reader                                                      ix
Introduction                                                      1

Chapter One        The Value Proposition                 19
Chapter Two        The Experience Economy             35
Chapter Three      Belonging                                    48
Chapter Four       Programming                              63
Chapter Five       Messaging                                  74
Chapter Six        Education                                    88
Chapter Seven      Fundraising                              106
Chapter Eight      Advocacy                                  125
Chapter Nine       People and Culture                     140
Chapter Ten        Leadership                                 156
Chapter Eleven     Design                                     168

Afterword                                                       181
Acknowledgments                                          193

Dear Reader,

You probably picked up this book because you are a lover of the arts.

You might be an artist whose craft feeds and nurtures your soul, as it does for countless others, in times of darkness and despair. You might be one of the thousands of people who work tirelessly in your community's creative sector to prop up the work of an organization whose impact can't be contained within the simplicity of a mission statement. You might be someone who supports the work of artists and organizations—an individual donor, a government official, a family foundation—feeling the pressure of a future that increasingly depends on you, but perhaps not knowing what role you can play in leading change. You might be an audience member who finds joy in the escape of a dark theater or curiosity in the confrontation of challenging work. Or you might be all of the above.

If you love the arts as much as I do, you've probably noticed that things have not been OK recently. You've probably noticed such troubling goings-on as allegations of abuse within executive ranks, bankruptcy filings, reduced or canceled seasons, mass resignations of board members, and organizations going out of business—just to name a few.

Movements such as #MeToo and Black Lives Matter, compounded by the impacts of the COVID-19 pandemic, haven't created new challenges in the arts world—they've revealed problems that have been unaddressed and unchecked for far too long. And instead of actually doing the work to develop meaningful and lasting changes for this sector we love so much, most non-profit arts organizations have simply become exceptionally well-versed in leading surface-level exercises in public relations.

But why, then, you may be wondering, should you read a book by a first-time author who runs an organization you've probably never heard of in a city you've probably never visited? It's a question I welcome because it sits at the heart of what I want to convey about the power of relevance.

When I was first contacted by a recruiter about the president and CEO role at Canada's third-largest performing arts center, I was caught off-guard by the fact that I had never heard of it. Arts Commons was one of the largest arts facilities in the country and home to renowned organizations that include the Calgary Philharmonic Orchestra, Theatre Calgary, Alberta Theatre Projects, One Yellow Rabbit, and Downstage. I quickly came to realize that its irrelevance to me was seemingly shared by many within Calgary who were all too confused when I would tell them I'd moved here to lead the local arts center downtown . . . "Arts who?"

If we consider relevance to be a quality or state of connectedness, then it was becoming clear to me that non-profit arts organizations across the world were struggling to maintain a level of significance or importance with their dwindling audiences. In my new role as leader of a multi-venue facility, I was determined not only to invite everyone in our city to feel a sense of empowerment in defining our future, but to have it be a model for how others could reconcile an organization's cultural mandate with its need to be in civic dialogue with others—particularly those who had historically felt unwelcomed within our venues—and

have this dialogue be at the root of a new kind of business model for the arts.

Imagine my humility and delight when my determination was met with open arms: citizens were attracted by the tremendous power of our organization's commitment to our city, and the energy we were bringing to the creation of a gathering place where our city's cultural and civic future was being redefined—not by me, a newcomer to Calgary, but by the conversations we were nurturing among artists, audiences, and communities.

Compounded by this institutional disconnectedness was the fact that Calgary had long been known for a compendium of things that, while powerful, is fairly slender: for having been the host city for the 1988 Winter Olympics, for the Calgary Stampede (the world's largest outdoor rodeo), and for its boom-and-bust oil and gas economy—all of which fueled a longstanding identity crisis.

Today, I am ecstatic that Calgary is known for much more as it tackles a successful diversification of its economy. For one, the city is experiencing the largest population growth of all major Canadian cities. In fact, in 2022, Calgary welcomed more Canadians and more immigrants per capita than any other city in Canada, with more Canadians moving to Alberta than any other province in the country. With a median age of thirty-eight, Calgary is one of Canada's youngest cities and proudly stands as the third-most diverse city in the country, with 40 percent of residents identifying as members of a visible minority community.

As a performing arts center that was reimagining its commitment to connecting with our citizens, and to entrusting our relevance to their faith in us, Arts Commons is changing, too. Not only have we weathered the COVID-19 pandemic with a newfound sense of service, but this seismic shift in who we are and how we work is paying off: by the time this book is published, we will be ready to break ground on the largest cultural infrastructure project in Canadian history. The Arts Commons

Transformation project will create the largest contiguous indoor/outdoor arts campus in the country. And as you will read in this book, our transformation isn't just physical—in fact, the bulk of our evolution is in our organizational DNA.

While this book is deeply inspired by the work taking place at Arts Commons and in Calgary, a reader needs neither knowledge of nor experience with either. Rather, what I hope you connect to is how this improbable sequence of events—the alignment of our institutional mission with the evolving identity of our city—illustrates why relevance is so vital in our business. After all, we don't run an arts organization in a vacuum. We need to ensure that the limitless creativity of the artists with whom we work is aligning with the minds and hearts (and schedules and wallets) of the audiences we seek to engage.

Throughout this book, most of which is in conversation with professionals and experts in a variety of sectors, I argue that, regardless of your role in this evolving arts world, if you are not prioritizing the concept of relevance, of connectedness, you are wasting your time. No arts organization deserves to exist unless it is constantly re-evaluating and questioning its relevance. After this read, you will also hopefully agree that, without relevance, there is no business model for the arts.

I feel privileged, and so grateful, to have been able to sit down with architects, executives, and Indigenous elders—whose experiences range from GivingTuesday to SXSW to the social media platform formerly known as Twitter—to discuss the topic of relevance. I hope you'll find the conversations and reflections in this book helpful, and that you'll come away profoundly inspired to be a catalyst for change in the most collaborative way possible.

Sincerely,

# INTRODUCTION

Across the world, the arts have become a luxury good that is overconsumed by too few people. Don't believe me? Just take a look at how overdependent non-profit arts organizations have become on audiences who are not returning post-pandemic, making a fragile sector tremble with uncertainty.

While this is not unique to any one organization or geographic location, this problematic dependency was a ticking time bomb that needed attention when I accepted the position of president and CEO of one of Canada's largest arts centers in January 2020. What was completely unforeseen, however, was a global health crisis and a social justice reckoning that added an incredibly unexpected urgency to addressing this matter.

In May 2020, I began my tenure at Arts Commons, a 560,000-square-foot complex in Calgary's downtown core. Founded in 1985, in advance of the 1988 Winter Olympics, Arts Commons is the third-largest arts facility in Canada, hosting over 2,000 events per year and featuring rehearsal studios, production workshops, education spaces, art galleries, restaurants, public community areas, and six performance venues—including the Jack Singer Concert Hall, praised by the *New York Times* as one of the best acoustical venues in North America.

Among the many reasons I was attracted to Calgary from New York City was the exciting and ambitious Arts Commons

Transformation capital project, which would create a downtown arts campus by modernizing our current complex and expanding the number of venues and public spaces, resulting in more square footage dedicated to arts and culture than the Louvre Museum in Paris. Due diligence around the more than half-billion-dollar budget, the single largest cultural infrastructure project in Canadian history, had been building since 2010, during which time the project enjoyed waves of enthusiasm and momentum from the business community, members of the public, and levels of government. But as Calgary's economic strength fluctuated between 2010 and 2020, so too did the viability of this project—introducing uncertainty to its chances for long-term success.

I never imagined the reality we would soon all be facing when I accepted the position. The scourge of COVID-19 was just emerging as a health threat of unclear global dimensions, but by the time my wife and I arrived in Calgary in May 2020 from New York City in a cross-country RV odyssey with our two dogs, the pandemic was in overdrive. Cultural institutions around the world, ours included, went dark as the pandemic disrupted so many aspects of life and claimed all too many lives. Politicians, health professionals, and a divided public debated which gathering places needed to stay open in some manner and which needed to be shuttered to control the disease's spread, and we all got comfortable with the idea that we'd have to live without cultural institutions and in-person experiences for a while.

The physical spaces that locked their doors included theaters, concert halls, museums, art galleries, libraries, cineplexes, and more. Like many cultural institutions, Arts Commons is a business that revolves around people and bringing together communities in ways that demonstrate our care, intentionality, and responsibility to them. It was precisely for those reasons that we joined others in temporarily closing our doors for our collective well-being.

It was also out of love for our community that Arts Commons invested in its own health during the crisis. One day, soon, we knew that artists and audiences would re-emerge with a hunger to gather, share, reflect, and look forward to a new future. And we knew that, when it arrived, we had to be prepared to join those considered "essential" for our community's well-being.

The prominent part COVID-19 plays in it notwithstanding, this book is about more than the pandemic as experienced by the arts sector from 2020 to 2023. Indeed, it offers itself as an important, collective reflection on the lessons learned during an extraordinary dimming of cultural opportunities—of which we have not seen the last. It also bears clarifying that this book is not about Arts Commons, nor is it about the nuances of running an arts organization in Calgary—or even Canada. In studying our current state of affairs in order to be better prepared for future crises, we undertook the conversations in this book to amplify the pressing call for arts organizations: it is time to rethink how we engage audiences and artists in the creation and consumption of experiences and the sharing of spaces for exchange, celebration, and, sometimes, provocation.

## Building back better

The pandemic shone a spotlight on critical issues that had been nagging cultural institutions for decades.

In his post-pandemic report on the arts, *Art and the World After This*, written for the Metcalf Foundation and the City of Toronto, artist and researcher David Maggs points out that the sector is dealing with the effects of not just one disruption, but four: COVID-19, rising social unrest, the digital revolution, and the sustainability crisis.

But Maggs, artistic director of Camber Arts, regards this rewritten scene as an unexpected opportunity. Losing the familiar, he argues, does not always lead to things getting worse.

"Pandemic problems aren't the problems we need to solve," he writes. "We need to solve issues of inclusivity, we need to solve issues of business models, and we need to solve our larger purpose in the public imagination."

Calgary Arts Development chief executive Patti Pon echoed his convictions with this analogy: "If your house burns down, when you build your house back, you don't build it exactly the way you had it before. You make improvements. You do what you've always wanted to do. That's what we have a chance to do here—build back better."

As an arts professional who, for almost twenty years, had worked with arts organizations in fifteen countries spanning five continents, I was acutely aware that our houses had been burning for as long as there have been modern cultural institutions. The pandemic just became an unplanned stress test for the role our institutions play within communities and for the way we serve those communities.

As restrictions on gatherings eased in 2022, it became clear that our institutions could not, and should not, simply return to pre-pandemic ways. Tools like Zoom, which we'd scrambled to employ to deliver virtual experiences (and enable remote work), would continue to be part of a new reality. But the pandemic had magnified and exacerbated too many social injustices for institutions to just pick up where they had left off. And in Calgary, the arts faced an additional obstacle: as COVID-19 derailed the global economy, the province's oil-dependent prosperity confronted a possible end. While the price of non-renewable energy would eventually rebound, the shock of the downturn helped to jumpstart a conversation about how to diversify and reinvent our economy.

With more and more people working remotely, the conversation around reimagining the future of Calgary's downtown core, one most cities around the globe were forced to face for their own sake, was happening parallel to the conversation the arts world needed to have about its own future. The pandemic became an enforced shutdown that gave the cultural community—regardless of where it was located—the opportunity to re-evaluate everything about how art is created and delivered, and who is doing the creating, delivering, and receiving. Fundamentally, about where and how and why culture and community intersect and interact.

These issues were not new to me. Among my roles at Lincoln Center for the Performing Arts in New York City, I had served as the fourth executive in its sixty-year history to oversee what I refer to as its social impact portfolio: global consulting, hyperlocal grant-making, community engagement, artistic programming for young audiences and families, and the organization's famed education department. I was familiar with the challenges that a major arts center faces in engaging new audiences and what strategies were considered most effective. But as much as COVID-19 was a disrupter, it was also an accelerator. It made the challenges, and need for solutions, more urgent because the very future of our businesses was now at stake.

## A period of cocooning

If there is one globally recognized experience of the pandemic, it is the overwhelming sense of social isolation. This also stimulated a trend in how cultural goods are distributed and consumed, called "cocooning." Within popular culture the cocoon is not something from which you emerge, but to which you retreat and from which you possibly *never* emerge.

Concerns about cocooning's impact on societal behaviors are not new. Only a few weeks after September 11, 2001, American satirist and author Joe Queenan wrote in the *New York Times* about a grave concern regarding the psychic health of the nation—"The American people have entered a period of intense national 'cocooning' that may last from three months to 10 years." America as a whole may not have withdrawn into what some worried people might label "armored cocooning," which was summarized by Queenan as "stocking up on antibiotics, air filters, viral filters—the full home nuclear-winter arsenal," but cocooning as a leisure option continued to grow in scope and popularity.

People, for myriad reasons, have become more accustomed to consuming cultural material privately, especially at home. Televisions have gotten bigger and more affordable, with higher resolutions and improved sound systems, and people went from renting movies from a local Blockbuster to watching them on streaming services that multiplied during the pandemic. Books, similarly, no longer require a visit to a store: you can order whatever you want from an online retailer or download an ebook from your bedroom. Recorded music doesn't require a trip to a record store to purchase a new release when you can listen to anything you want through a streaming service. Let me be clear: none of these innovations are bad. Streaming and other online services have provided more choices, more diversity, and the perception of a democratic selection process in what we consume, and they are here to stay. But lost in the process is a collective, shared, and social experience—knowledge seekers interacting with knowledge holders (and one another) as they make these choices, even if the work is ultimately consumed privately.

The cocooning phenomenon only accelerated during COVID-19 because, beyond the appeal of the price and convenience of consuming arts at home, most of us had little to no choice. We either acquired what we wanted or needed through online purchases or

not at all. In the pandemic environment, cocoon-friendly services that had been growing in popularity soared and multiplied. The restaurant industry coped as best it could through third-party home delivery services like Uber Eats, while many grocery stores and pharmacies introduced home delivery for the first time. Video streaming services added millions of new customers. Netflix alone, which began in 1997 as a mail-based DVD rental service, had 77.3 million subscribers in Canada and the United States by the third quarter of 2023. As the fitness industry staggered with mandatory pandemic closures and customer fears of being exposed to COVID-19, the at-home cycle-fitness company Peloton witnessed spectacular growth: subscriptions increased more than tenfold from 2019 to 2022, to almost three million customers.

Two years into the pandemic, consumers could shop, eat, work out, and entertain themselves without leaving their homes. Cultural institutions, striving to retain connections with the public, found their own home delivery solutions for performances, lectures, and the like, through tools like Zoom and YouTube. Some strategies were already well established before the pandemic's onset. New York City's Metropolitan Opera had a long history of delivering performances to radio listeners when it introduced The Met: Live in HD in 2006, through which performances are showcased in movie theaters around the world. Opera buffs kept out of theaters by gathering restrictions could instead access The Met: Live at Home, an on-demand streaming service. The Met's goal has never been to replace the live experience of other opera companies around the world, but to nurture and grow the overall opera audience. At Arts Commons, we had been hosting a lecture series in our venues featuring National Geographic Explorers for over ten years. We met the desire to stay home during COVID with a digital version of our National Geographic Live series. By geofencing online access to the province of Alberta, we were able to deliver free programming featuring National Geographic content

to an audience of almost 60,000 viewers, when our maximum potential pre-pandemic in-person audience was only 20,000 if we sold out every single show.

For some institutions, online coping strategies have proven to be seductive, as they seem at first glance more convenient than the live, in-person events they were supposed to temporarily replace. It might seem hard to argue with the increase in audience sizes such virtual events can deliver. In the case of National Geographic Live, we found that 91 percent of online viewers were engaging with the National Geographic brand through Arts Commons for the first time, and about 80 percent were new to Arts Commons. But the question for us became whether our new virtual audience would drive a demand for an in-person experience at Arts Commons.

As pandemic measures began to ease in 2022, and doors reopened, arts organizations around the world grappled with how to function in the "new normal" of a hypercocooned culture, just as society itself was grappling with how much it wanted to remain in—or emerge from—its cocoon. Many arts organizations found, with no surprise, that in-person audiences did not return to their pre-pandemic levels as fast as we'd hoped they would. Many of us in the cultural sector across North America fretted about attendance figures that were anywhere from 30 to 60 percent below their 2019 levels. Perhaps some of this lag was due to pandemic trauma; even some fully vaccinated people were reluctant to gather in large numbers and needed time to get over their hesitation to congregate.

On the other hand, it was clear that, in many other aspects of life, people had surged back into public spaces at the first opportunity. I was traveling a fair bit as pandemic measures eased, and it was impossible to ignore the fact that flights were packed; the Canadian government was overwhelmed by a surge in demand for

passports in the spring of 2022. Whether for business or pleasure, people were overcoming whatever residual fears they might harbor about infectious disease and cramming themselves into crowded airports and long metal tubes with wings. Many, no doubt, were still nervous about COVID-19, but the desire to travel was too overwhelming. Other aspects of pre-COVID life saw similar rebounds. Sports arenas sold out. Most telling, perhaps, was the abrupt dip in the fortunes and subscribers of Netflix, as many chose to return to in-person experiences rather than continue to isolate and consume culture virtually. So why weren't people rushing back to the live arts with as much determination?

The underwhelming return of audiences to cultural institutions was an unpleasant reminder for me of the shock the culture sector suffered during the economic recession of 2009. Back then, the attendance downturn was thought to be purely dollar-driven. When people are out of work or otherwise suffering financially, discretionary spending is the first thing to go. The problems the cultural sector faced because of that economic downturn were multifold. Having lost audiences and revenues during the downturn, institutions then had to recapture them as the economy rebounded. But not all institutions survived long enough to manage that recapture. And those that did had to contend with a recalibration of spending priorities as many households and individuals found their way out of the recession. Now that the hard times seemed to be ending, where did people want to spend again? Did they feel they really *needed* all the things they had previously paid for or subscribed to? What were their new priorities? In a post-pandemic world, I'm seeing the same warning signs. People lagging in their return to arts venues but not in resuming other aspects of their lives is an indication that, even pre-pandemic, we in the arts did not articulate a sufficiently robust and relevant value proposition.

## A shared experience

The pandemic has been a perfect storm of crises: the outright loss of audiences because of health measures was compounded by a recessionary economy as well as a spike in inflation that eroded the purchasing power of consumers and challenged the operating budgets of cultural institutions. But the value proposition of the arts has been simmering for years. External crises have provided warning signs about deadly internal crises—crises we've ignored for far too long.

In late 2022, Connecticut-based AMS Planning & Research presented a fascinating study on the impact of the COVID pandemic on audiences. From May 2020 to December 2022, they tracked audience perspectives at more than fifty participating venues across the United States, totaling almost 300,000 respondents. One of their most intriguing discoveries was what audiences identified as their "main barriers" to returning to in-person programs in the arts. The greatest barrier was not what many of us in the arts community might have thought—namely: cost. As a cited factor, cost had increased over the course of the pandemic, but it still ranked lowest among the three main barriers. Concerns about contracting or transmitting COVID-19, while still an issue, had declined significantly. The largest barrier, by far, was the fact that audiences had not yet found a program they wanted to attend. We could interpret that as saying: because of tight dollars and COVID-19 fears, audiences felt they needed a more compelling reason to leave the house and gather with others. But we would be foolish to overlook the essential message that audiences have become less and less persuaded that our in-person programming is a desirable option for their discretionary spending and leisure hours. Our sector was providing less compelling programming at a time when we should have been doubling down on the creation or presentation of compelling work. We should be able

to look back at this time and point to a renaissance—both in what is being created by artists and how that content is being shared (lest we ignore the increase in artists sharing their work through unconventional and uninstitutionalized avenues on social media that don't rely on our arts organizations). Sadly, that doesn't seem to be the case. Such a missed opportunity. Organizations have not been offering enough of what people are interested in experiencing—and we are suffering the results of that.

Performing arts organizations, whose programming can be nimbler and more responsive than that of museums, which, for the most part, are "weighed down" by robust and expensive collections, have a unique opportunity to address the problem of a low post-pandemic rebound in attendance. But there is another, underlying responsibility. I am adamant that the performing arts cannot function—cannot continue to create and innovate, cannot endure—without the performer and the audience sharing the *experience* of performance within a physical space. Even in the museum world, that collective experience is the raison d'être of the arts. The importance of a shared experience, fundamentally, is a social one, and one that we now know is connected to our collective mental health and well-being. Simply put, we need to save the arts to save our shared sense of humanity.

But we in the arts sector have become part of the problem. We have come to view our offerings as streaming services and retailers do: a product to be consumed, rather than a social event to be experienced. During the first two years of the pandemic, thanks to technology, the world's population may have consumed more arts and culture than they had across the history of humankind. The difference is, of course, that we did this consuming largely by ourselves, in the privacy of our own homes, driving around alone in our cars, or walking with a pair of earbuds. During the pandemic, I participated in a comic book convention panel with clinical social worker Stephen Walker, who made the point that

when we consume arts and culture by ourselves, we may actually be doing more harm than good, regardless of how much more we might be taking in. When we are alone, or exclusively with people who think like us, we are living in an echo chamber of our own biases. Whatever we choose to consume, we are picking something that reinforces a belief that we already have, and we are doing it to comfort those biases.

When we share space with others, whether we are with ten people or 10,000, our experience of consuming culture is entirely different. We may have chosen to attend an event that we expect will align with our values and beliefs, but we have all been in a venue when a song, punchline, painting, or line in a script lands differently with the stranger next to us. If a stranger laughs at a joke, and we don't (or vice versa), we experience what mental-health professionals call "emotional referencing," as we compare our emotional response to that of others. The moment someone has an emotional response that we don't, our brain synapses start firing in new ways. *Why did that person laugh, and I didn't? Why am I in tears, and they aren't?* We start growing in new ways. Emotional referencing allows us to confront our biases and is a key process by which empathy is taught and experienced. And without empathy—the capacity to imagine yourself in another person's circumstance—a healthy society cannot exist.

The value of sharing space with people who have different lived experiences than mine was reinforced when I took in a Broadway performance of Arthur Miller's classic play *Death of a Salesman* in fall 2022. The last version many people had seen was a made-for-TV production in 1985, in which Dustin Hoffman starred as Willy Loman and John Malkovich as his son Biff. The acclaimed 2022 staging, directed by Miranda Cromwell, featured Black actors in the starring roles, including Wendell Pierce as Willy and Sharon D. Clarke as Linda. It wasn't just that parts that had always been reserved for white actors were now being

performed by Black actors. The script, delivered by a mostly Black cast, resonated very differently with me, a white man, as I sat in a theater with a predominantly Black audience—an audience that had historically been excluded from the Broadway experience. For me, the emotional referencing from being in this audience with people with different lived experiences, responding to a play from which the director and cast teased nuances no one had found before, was significant.

## Asking the right questions

When I was teaching at New York University, I would often pose a provocative question to my students: *What is more important in the arts: the intention of the artist or the perception of the audience?* It was a question that would launch hour-long philosophical conversations. That tension, between intention and perception, is at the core of a healthy arts sector. If artists create solely for their own benefit and put things out into the world without anticipating (or caring about) what impact they will have on people, then I'd argue there is no desire to foster civic discourse through that work of art. At the same time, if an artist creates something specifically to appease or appeal to an audience, I'd say there's no desire to challenge biases. By holding intention and perception in a healthy tension, you create a dialogue.

Today, more than ever before, building community around that tension is such a necessary thing. In today's polarizing world, if I had to prioritize one polarity of that tension over the other, I would pick perception. Siding with the audience's response is a game-changer in the short history of arts and culture organizations, and, sadly, a revelatory concept. (Although I would argue that the ancient Greeks knew this, as theater and music and poetry weaved their way into politics.) In many of the classical art forms

(theater, opera, ballet, orchestral music, fine arts), the prevailing attitude in modern times has been *This is what the artists intended, and you either get it or you don't.* The world is changing, and we need to prioritize relevance to the audience—which is to say, the community—just as much as, if not more than, artistic ambitions.

As arts organizations, our duty is to build community in and around cultural experiences. There has never been, in our lifetime, a greater urgency to bring people together for that process of emotional referencing. One mistake we may easily make coming out of the pandemic is to present the performing arts purely as one option among an increasingly crowded field of entertainment offerings. It is true that, for many people, the multiplying options in streaming services have consumed ever-increasing amounts of discretionary dollars, and that bingeing endless hours of TV seems to dominate people's available leisure time. But if entertainment options are presented as a reductive "choose Netflix or a live show," that's a value proposition we in the live arts (who are probably watching Netflix, too) cannot win. If, instead, our value proposition is that we allow people to be around one another, that we build community in and around the arts, then we've defined success in a brand-new way and no streaming service can compete with that. While the accelerated trend toward isolating ourselves—working from home, consuming culture from the couch—might seem to be a threat to the health of any activity that does not align with this trend, offering a necessary alternative is an opportunity for the live arts sector. The more the world pushes to isolate us, the greater the opportunity for us to articulate a value proposition that brings people back together again.

When we approach the future of the arts from the perspective of communal and collective participation instead of transactional consumption, we find ourselves asking very different questions about how to foster engagement. And in these times, a willingness to ask questions rather than impose answers is vital. If we accept

the idea that, as arts organizations, we have a civic responsibility to fulfill, that means we also have a responsibility to lean in and create a space for and facilitate conversation. For the last fifty years, most arts organizations have shied away from fostering this conversation, for a variety of reasons. But asking questions, and engaging in and hosting conversations, is one way we are finding the future of the arts in the unlikeliest of places.

Speaking of unlikely places, even for most Canadians, Calgary seems an unlikely place for someone to relocate from a global cultural center like New York City, but I hope that my experiences at Arts Commons can provide inspiration for people across all kinds of cultural organizations, in all kinds of locations. Finding the future of the arts in the unlikeliest of places also means that those of us within leadership roles don't need to have the answers to everything. Instead, we need to make a commitment to curiosity and inquiry. As arts leaders and organizations who historically have been seen as arbiters of excellence or society's tastemakers, we need to look for the future of the arts not within our own walls but within the communities that surround us. The answers to certain questions might (and probably ought to) be different in Calgary than in Chicago or London. But it is essential that we recognize we don't *yet* have the answers and that we need to start asking important questions as opposed to feeling like we need to produce the answers ourselves or that we should be entitled to think that only *we* have the answers.

If our role is to ask the questions instead of having the answers, then the process of gathering answers from and with the community unleashes further uncertainties about the preparedness of our organizations. If we're going to liaise with communities that historically have never had a relationship with us, who are the people doing the liaising on our behalf? We need to have those communities represented *within* our organizations, *within* our staff and governance.

Don't get me wrong—plenty of people are in the business of community outreach, but when you draw back the curtain, you often find masked marketing efforts. Organizations actually are saying, *I'm going to engage with your community, but all I'm really doing is hoping you buy what I have to sell.* The true purpose of community engagement is a leap into the unknown. You're saying, *My mission is to be in service to you, but if I don't know who you are and what you love, then what business do I have trying to create it with you?*

What we're after is the ability to sustain our relevance in ever-changing times. If our job becomes one of constantly and meaningfully asking questions, and being open to any manifestation of answers, then we're constantly re-evaluating our relevance. If you prefer to approach this issue from a purely financial perspective, that re-evaluation ensures a consistent flow of audiences, and those audiences represent earned revenues for the organization. Increased patronage also leverages increased impact, which is the growing currency of contributed revenues and philanthropic activities. If you want to call an arts organization's cultural work a product (as much as I have argued that the arts ultimately deliver a social experience rather than a unit of culture to be consumed), re-evaluation through listening to the consumer is the way you know when and how that product needs to shift. When the community plays a role in determining what you are delivering, you have a much better chance of consumers wanting it. Not only is asking questions and listening to answers the right thing for cultural organizations to do from the perspective of their civic role, from a business perspective, it's the only way to remain of interest and in demand.

## The perceived barrier

At Lincoln Center, we hired consultants to take a hard look at the barriers for cultural participation within a city. They discovered

there are three main barriers: there's a geographic barrier to cultural participation, and the pandemic, by necessity, allowed us to overcome some of this through technology, by allowing virtual attendance. The second barrier is financial. This has always been so for the arts, and likely will always remain, which is why most organizations have leaned into addressing this barrier by offering discounts or free ticket programs. The third barrier is the one that unlocks all of them: the *perceived* barrier. It's the perception people have that the arts don't belong to them, whether that means the venue, the arts organization, or what is being shared. And if the arts don't belong to people, they don't feel a sense of belonging in them—regardless of how much a ticket might cost or how far they might have to travel for it.

In many ways, this book is about tackling that third barrier, the perceived barrier in arts and culture. And perception does not mean it's an illusion: if people perceive it to be real, and act accordingly, then it's real. Arts organizations have invested too much time and energy in breaking down the first two barriers and not nearly enough time asking why people should care about what they're offering.

Of course, there is an inherent tension between what the consumer is buying and what the organization is selling, just as there is that tension between what the artist wants to express and what the audience processes or interprets. While we want to avoid irrelevance by not having cultural productions imposed upon the community, we need to be careful about the pendulum swinging too far in the other direction by not having a programmatic strategy at all. There is still a vital need for artistic curation, albeit with a democratized approach. We want to avoid being arbiters of excellence who have such a tight grasp on curation that we no longer have our finger on the pulse of what people want or of how different communities define and celebrate cultural identities and process what the arts offer them. There needs to

be a happy medium where we keep our ears to the ground and learn from communities, and in response to what we're learning, deliver incredibly high-quality arts and cultural experiences that are also community-building experiences. Artistic excellence still needs to be part of the conversation—but not at the expense of our civic responsibility.

In asking these big questions about the challenges that have disrupted the arts sector, we needn't look too far to find others who have struggled with and succeeded in redefining their relevance. Not only do we find art in the most unexpected places—we might also find solutions to the issues the arts are confronting in the most unexpected places.

This book looks at the urgent challenges we face in the cultural sector, identifies the opportunities we must embrace, and finds inspiration and parallels from other sectors and leaders who have the experience and wisdom in responding to change where relevance is a priority. And while my day job focuses on performing arts organizations, it's clear that the arts and culture sector as a whole is staring down the same essential challenges. It's why I hope all arts professionals and arts lovers can find lessons and wisdom in the conversations at the heart of these chapters.

# CHAPTER ONE

# The Value Proposition

It was a bold and unprecedented undertaking, moving an entire fire truck into a staid and conventional book room. But bold and unprecedented were kind of the point for Calgary Public Library when it set out to upend patrons' experience of the place by plonking a decommissioned fire rig square in the middle of its largest location in 2016. The flames it would extinguish in its unexpected environment would be of irrelevance and indolence and all the obsolete inheritances of libraries past.

The truck, which would offer a unique playscape for the kids whose boisterous presence had too long been quashed in this serious setting, would be a centerpiece for an evolved philosophy that embraced the Library's role as a public hub, swapping out its worthy utility as a facilitator of transactional operations alone. With this unconventional development, the Library stepped into its natural place in a civic landscape—and then stepped away from the wheel to let citizens steer the organization.

The fire truck experiment, says Calgary Public Library CEO Sarah Meilleur, was a roaring success. Calgary Fire Department's Engine 23, in its converted iteration as an Early Learning Center, delivered the space back to its roots as a nucleus of community engagement and improvement devoted to serving the needs of an eclectic customer base.

It's a fire that might be similarly lit under arts organizations that are currently sputtering in the coals of obscurity and directionlessness. A blistering reacquaintance with their raison d'être is just the thing so many stodgy, precious cultural destinations need to reignite their spark.

The relevance of arts organizations, as measured by a range of metrics, including the triple pillars of attendance, sales, and philanthropy, has been on the decline for decades, and while some might find it convenient to blame COVID-19 for audiences' apparent lack of interest in returning, the fact is the notorious virus simply accelerated the inevitable. None of our current problems should come as a surprise to anyone who's been paying attention to historic trends in audience participation within non-profit arts organizations. People have long been tired of the dynamic that defines the patron-artist relationship.

After all, arts organizations' offerings have always been pretty prescribed. What I mean by that is: we tell you when our event starts, where it is, how much it costs, and so on. We are so in control of what we supply that the only role you have as a consumer is to say yes or no. And it is because of this narrowness of offering that we now have a problem. People are saying no because they can consume so many other things on their terms and their turf—why should they support what we're insisting they support, especially since what we're insisting on is not informed by any of our outreach to discover their interests? At any rate, we scramble in response to their indifference, sputtering about free tickets, deeper subscription discounts, and on-site ice cream. We're on the defensive, wildly spinning to make an undesirable product appealing, when it's really too little, too late, and when we have, in fact, been responsible for the demise of the demand all along.

## Determining value

An organization's value proposition, a short statement that tells people why they might engage with it and choose its goods and services over others' in a clear expression of its plan to address their wants and needs, is the core of its competitive advantage. It's easy to confuse your value proposition with other brand assets, including your mission statement. But while they can have points in common, they're distinct from each other. At Arts Commons, our value proposition reads: "Arts Commons is the steward of Western Canada's largest arts centre, and the artistic and civic cornerstone of Calgary's downtown core, comprised of six world-class resident companies. By championing inclusion and reconciliation, and increasing the accessibility and reach of the arts in Calgary, we are reimagining the performing arts and ensuring their rightful place at the centre of civic life." On the other hand, our mission reads: "To be an inspirational force where artists, community, and organizations celebrate cultural identities, experience the full breadth of human emotions, and ignite positive change." In addition to our value and mission statements, at Arts Commons we also chose to articulate belief and responsibility statements: "Our belief is that equitable access to the arts is a human right," and "Our responsibility is to redefine a bold and adventurous Calgary by championing and investing in creativity."

You can start an organization tomorrow with a particular mission statement and, in five years, say, "Mission accomplished." But your value proposition is always there, and identifying it, particularly if it nudges you into a reimagined realm, is a critical push toward relevance and community engagement for legacy institutions. Libraries—nimble and receptive enough to appreciate both the limitations of their original mandate as book lenders alone *and* actually listen to their clients—offer prime case studies of organizations whose evolutions center people, acknowledging

at last that everything has to be about obliging their demands and desires, however they might force change upon a standard, however they might call for wholesale and self-effacing reinvention.

There is a range of value proposition categories from inside which an organization's own value proposition might emerge. Five of the more central ones are productivity, profitability, image, experience, and convenience. Some memorable value propositions out there include "Uber—The smartest way to get around," "Apple iPhone—The experience IS the product," and "Slack—Be more productive at work with less effort."

Arts organizations' value propositions have historically been about the artist. If they had been about people, like the Library's is, we might've been able to evolve as nimbly as they have. Today, the value proposition for Calgary Public Library reads simply: "Everyone Belongs at the Library. Your Library is a place for people to access ideas, inspiration, and insight so that they can realize their potential. Everyone belongs at the Library, because the Library belongs to you." Their value proposition is fundamentally inclusive. Or at least it is today. For all I know, the Library's value proposition fifty years ago was all about the books. But something forced them to revisit that framework and update it. Arts organizations might behave correspondingly.

Providing 240,000 square feet of functional, flexible, and exquisitely designed space in the burgeoning cultural hotspot of the city's East Village, Calgary Public Library's new downtown location is home to a physical collection of more than 300,000 books, dozens of free community meeting areas, a performance hall, a café, outdoor plazas, a children's library, dedicated spaces for teens, recording studios, and much more. The flagship branch of the city's system, Calgary's stunning Central Library is a key destination for library-goers—*and*, more importantly, for those people who have lost their inclination to go at all. Its five-year, $245-million construction, which *Architectural Digest* named one

of the most anticipated projects of 2018 and the *New York Times* featured among its "Fifty-Two Places to Travel" in 2019, produced an elevated library experience and destination for Calgarians and tourists alike, attracting more than a million visitors in its first seven months alone.

More than its physical beauty, though, this library is a stand-out for its attention to a mandate whose shifting nature it has embraced with grace. If libraries had been as immovable as much of the arts community continues to be, insisting on a self-centered model of operation in which they alone call the shots, they'd be out of business. Instead, libraries have revisited their mission of people-centric service with a fresh commitment to foster-ing communities around the sharing of knowledge and ideas, more critical than ever in a post–COVID-19 scene. "We emerge from years of disruption and transition and see a community that needs us more than ever," Meilleur declares. "We are a city facing urgent issues that require many voices around the table. That table where everyone is welcome is your public library. . . . Our promise is that everyone belongs at the Library because the Library belongs to you."

Indeed, libraries are models of people-focused activity—truly democratic institutions aimed at helping us become who we want to be. Keenly aware of the tribute customers pay them with their patronage, and of other shifts in the cultural landscape that have threatened their existence before, libraries were able and willing to morph during this latest, extended period of deteriorating relevance. When presented with the option of sticking to their guns or embracing change, they embraced change.

And that embrace has seen the post-pandemic Calgary Public Library attract its highest active membership ever. Still, says Meilleur, the victory was not without its challenges. Legacy cus-tomers' conviction that libraries must be silent sanctuaries and their resistance to an evolution that tolerates rowdy children quickly

emerged as a significant one. But play is part of the Library experience, she asserts, and if the clatter that includes is the concession you make to usher children into a reading life, so be it, especially if you can *also* accommodate legacy patrons with dedicated tranquil areas that validate their locked-in conception of the place. After all, a public-facing institution acknowledges *all* the members in a community, no matter how disparate their views. That the Library hosted almost six hundred events in its first year is confirmation, she believes, that the community is on board. "We thought through the journey to really understand our community and who we were serving, wanting to make sure, as we picked the furniture and programs and so on, that there really was something for everyone, that there was a holistic perspective at play."

The Library's mission—to connect community—has stayed the same, she says. The only thing is, the definition of community has gotten bigger since its earliest days as a small reading library. Now it serves everyone, including a child learning to read, a newcomer wanting to connect in their home language, and a senior who just needs to get out of the house to combat loneliness. It's there to help all people realize their potential in the full diversity of what that might be.

The Library's redefinition of community should resonate with those involved in the arts. In our world, people express their satisfaction with their wallets and feet, and if they don't come to our show, it's because we don't know what they want. We are not tapped into our community. At Arts Commons, we recently realized we weren't welcoming enough racialized minorities into our audiences. There are many reasons why that might be, including the terrible assumption that most arts organizations make—that if you don't have enough marginalized individuals buying tickets, it's because your tickets are too expensive. And if you respond with price cuts, you're saying we're going to be this magnificent savior to your unfortunate financial impediment.

But the truth is this population probably isn't coming because the organization isn't offering anything they want to see.

The summer of 2022, the year in which arts organizations around the world struggled to find new ways of doing things, was the busiest in Arts Commons' forty-year history. When people ask why, I tell them about partnering with a concert promoter who worked exclusively with touring artists from southeast Asia, and staging a fifteen-concert series featuring some of the most amazing southeast Asian artists that I'd never heard of before. (Under normal circumstances, if a CEO hadn't heard of someone, they wouldn't likely be programmed.) How dangerous we are as gatekeepers. But not in the summer of 2022, when we provided venues for these very popular artists to come to Calgary, where there is a sizable southeast Asian population that may well have felt underserved. This small change in our behavior resulted in tens of thousands of local audience members visiting Arts Commons for the first time, many visiting downtown Calgary for the first time, because we were presenting artists on our stages that meant something to them. So here we were in this year of transition, when many arts organizations were protesting about the lack of audience bounceback, having a record summer because we literally got out of the way. Sadly, this was seen as innovative.

There's no question, though, that it was an audacious move for our organization. But there's a level of urgency now that we can't ignore. People aren't coming to the arts the way they used to—and when I hear arts executives say they can't afford to take a risk to turn things around, I tell them they can't afford not to. And then I tell them, *Believe me, we didn't take ours out of the kindness of our heart. It made us money. People bought tickets, they bought concessions, our bar sales were through the roof.* We provided them with experiences that they came in droves to see—and that resulted in earned revenue, it resulted in contributed revenue. These concerts were not only the right thing to do civically,

socially, and culturally, they were also the only way our business would remain sustainable.

## The power of collaboration

As our organizations evolve and embrace a greater need to provide more for community (and, in doing so, become more competitive), collaborating with others becomes an opportunity we cannot ignore. In imagining its new future, Calgary Public Library partnered with a non-profit mental health center that offers on-site single-session counselling—a critical, welcome service for this downtown outfit.

Also in 2022, as arts organizations struggled to find their path out of the COVID-19 pandemic, we at Arts Commons took another page from the Library's book with our own spectacular adventure in collaboration. In all, six world-class resident companies thrive under the stewardship of the Arts Commons umbrella, including the Calgary Philharmonic Orchestra and Theatre Calgary. Typically isolated in our operations, and governed independently, we sat down with the Calgary Philharmonic Orchestra and Theatre Calgary and devised a plan for a project whose combined effort would exceed anything we might do individually. Specifically, we joined forces for the world premiere of the Boston Pops' concert version of a beloved Broadway musical, *Ragtime: A Concert Performance*. Produced by Arts Commons, featuring the musicians of the Calgary Philharmonic Orchestra and under the direction of Theatre Calgary's artistic director, Stafford Arima, the show, which is now traveling the globe, will always include the credit "world premiere: Calgary, Alberta."

As impactful (and profitable) as it was, and as proud of it as I am, it wasn't rocket science, this collaboration. Sadly, the bar is pretty low when it comes to initiating collaborative projects

that exploit available resources. That this achievement of ours is so revolutionary and innovative says more about the status quo than anything else. It says that, for whatever reason, we're not partnering enough, and we're not asking ourselves what we might do as a team that we couldn't do on our own. *Ragtime* is a perfect example of three organizations building on their strengths to do something new that opened each up to untapped audiences, talent, and funders. So as we talk about change, and we talk about growth, it's key to remember that, yes, we can evolve by ourselves, but we can also do it in partnership with like-minded institutions that are similarly grappling with how to adjust to a new world.

Meilleur explains that the Library has honed in on the idea of experiences. Previously a purely transactional site, where you got your books and turned on your heel, now it's all about exceptional member experiences, and that renewed focus is reflected in its design, its approach to services, its staff training, and so on. "It's about what we want our patrons to feel at the Library," Meilleur says. "The feelings matter more than whether you got the right information or book. If you had a good experience, you feel so much better about your relationship with the Library." And if our goal becomes providing patrons with the most unforgettable experience possible, then why wouldn't we work with others who might complement our services to create something beautifully unexpected?

It's another lesson arts organizations might take on board. When you look at the mission statements of those that have been around for thirty, forty, fifty years, you might see that they've stayed pretty static over that time, stubbornly linked to the art form and the artist rather than the evolving cast of characters on the receiving end of the experience. You have dance companies that will celebrate a certain genre of dance, museums who only dive into certain periods, theater companies whose missions are devoted to a lone playwright or genre, and so on, the lot of them

resolute in their commitment to elevate the art forms that fueled their formation and not so much to the spectators for whom they're presented. What's happened over the past several decades is we've confused our celebration of a genre or art form with our need to generate dialogue with our audiences. Too many artistic companies are realizing, decades after their establishment, that they've in fact built a single-minded culture that doesn't leave room to change in concert with the world around it. I mean, sure, you're creating for the moment, but when the moment changes and you don't, you expose the inequality in that give and take—and also that you were actually creating for yourself all along.

Never transactional like libraries, arts organizations have always been in the business of designing experiences for gathered audiences. But the irony reveals itself when an arts organization's proffered experiences aren't the products of missions that were focused on dialogues with those audiences, and so feel disconnected or even tedious. If we are precious about the artist at the expense of the audience member, we create an unbalanced experience. Instead, we must focus on *the intersection of the artist and audience* and, rather than being precious about either one, be precious about *the experience*, which brings everyone together. Because if someone has a good experience, they will probably take a chance on us the next time we invite them into our house because they trust the organization.

Just as the Library's mission has little to do with the Library and more to do with the people who need it, so too should the arts respond to the audiences they serve—and develop their programs by keeping their ear to the ground. While the artistry is critical, the mission should expand beyond it to find that tension in the middle that says: *We are still unapologetically an arts organization, but what we engage in is conversation with others to identify what the world needs and what we are uniquely positioned to provide through the lens of a cultural experience. Here are the conversations people are*

*wanting to have, and here is how we can respond through arts and culture in a way that engages them with it and with each other.*

Easy, right? In theory, sure. In reality, however, it's taking a minute to sink in. Years ago, I met an artistic director of a theater company in Berlin who told me they were so well funded by the government that they could do an entire season of plays by Bertolt Brecht, not sell a single ticket, and still collect abundant federal support. And while different arts communities around the world rely on very different funding models, this is a perfect example of an arts organization that was so committed to their precious art that they'd lost sight of the part of their mission devoted to the people in the theater. You need to sidestep narrow, inward-facing missions and pick one that's impactful on others, and that evolves as they do.

But change is a bugger and enacting it can be prickly for arts organizations that haven't historically granted consumers of art the same regard as they have creators of art. It's not about asking the theater to kill Brecht or even care less about him—only to consider the people around him to the same degree. Artists, and arts organizations for that matter, can't exist in a vacuum.

## Serve the people

Other challenges are more concrete. If you're part of an organization—a museum or gallery, for example, or a library—that operates on the strength of its physical collections, you might have a harder time leading change. But rather than be weighed down by the artifacts to whose accumulation you've devoted decades, you might leverage them by introducing fresh conversations that pay attention to the world around them—by, for example, pairing works acquired or developed around the history of the colonial American South with works by African-American painters that shine a light on a different side of history.

The performing arts are not burdened by collections, but they still suffer from psychic holdouts that limit their potential. The Oregon Shakespeare Festival (OSF), a regional repertory theater in Ashland, Oregon, founded in 1935, is one of many theater companies around the world that are built to celebrate Shakespeare, and are therefore subject to the question of whether a modern organization can sustain itself on the works of one man, let alone a white man, let alone a white man who embraces a certain colonial past. Chicago Shakespeare Theater is another.

In 2019, the OSF hired their first African-American artistic director, brought on to reimagine the company such that it still sustains its Elizabethan legacy but does so in new and different ways. Much has been written about the turmoil that resulted in this white, middle-class community that was perhaps not ready for such novelty or shakeup. To me, that's an example of an organization (no fault to the artistic director) trying to lead change without bringing the community along for the ride. There was a desire to reform internally as an organization, but the community was not ready for it. Meanwhile Chicago Shakespeare Theater is readier for conversations about race and power dynamics because the community in which it's embedded is already having them. In Chicago, a city in which there is no clear majority of any race, the arts organization is trying to keep up with civil discourse, but in Ashland, Oregon, with 89 percent of its population being white, it's trying to be a catalyst for it.

In both examples, however, there's no question that the internal changes need to be deeply connected to the community to be successful. Whether it's the leaders or the organizations that are trying to catalyze conversations, they need to be supported and accompanied—by the board, by the community, by funding bodies—if they want to see them through.

What I find fascinating is there are certain companies that, when their audiences don't materialize, say, *We need to throw*

*more marketing dollars at that.* Yes, more money will help, but at what point do you acknowledge that you're simply not serving something that people want? The non-profit arts have been going through decades of declining relevance, the pots of money being lobbed at marketing and audience development initiatives notwithstanding. In the end, it has little to do with exposure. It's that we're doing it wrong or people don't care anymore. And that's a really hard pill to swallow.

If you think of libraries over time, their mission has long been based on the idea that they had something we wanted. We wanted books, and libraries had them, and they built their business around that fact. But today, for a variety of reasons (you can download ebooks from your smartphones, for one), physical books aren't enough anymore. And so the library's mission started to fizzle. The libraries could've said *We're going to close up shop because the demand for what we're supplying just isn't there anymore.* They didn't. Nor did they stubbornly double-down on their mission or wildly switch up their products. They simply zoomed out to harness a more inclusive value proposition. They said, *We're not just about books anymore, we're about sharing ideas. We have evolved.*

When you talk about evolving, you talk about pivoting, and pivoting often requires having one foot in your comfort zone, drawing the question: what are you pivoting *on*? Libraries have collections of books, yes, but they also have space. Calgary Public Library pitched itself as a destination and convenor of space wherein exchanges of ideas might take place. It's why the library invested in storage holdings for books not on regular rotation, to free up space. "These are libraries for people, and we wanted more room for people and less for collections. That made a real difference," says Meilleur.

Change should be about becoming more relevant to more people. The Library could've asked legacy patrons *what do you* not *want?* But that is a dangerous question because it invites value

judgments that sometimes come at the expense of others. Instead, it asked, *What do you* want? So the legacy customer might have said, *I want a quiet room*, and the single mother of three might have said, *I want a childhood center where the kids can come and learn on their terms, which might be noisy and messy*. And the Library has responded effectively to both.

Not unlike other performing arts centers, Arts Commons has the ability to host an incredible number of events each year (two thousand, in our case), so there's no reason we can't change too, and be more relevant to more people, no reason we can't keep the legacy audience members happy while still creating new entry points for folks who are not familiar with our facility.

In considering the issue of library awareness, and the barriers that discourage some from using libraries, Calgary Public Library's Meilleur asked, "Where can we be so the library becomes a habit?" and "How can we build that in advance of bricks and mortar libraries?" The institution began venturing into the community to serve would-be Library consumers on their turf, with book pop-ups and "story trucks" in neighborhoods whose populations research had revealed weren't already engaged with the Library. "You need to know your community and to work with others to serve more folks."

If we change who we are but nobody knows to come because they've lost the desire to engage in arts and culture, we're no further ahead. I see us as having two responsibilities: first, we need to evolve within our own house, and second, we need to play a role in increasing arts-going habits in the average citizen. One of the ways we did that during the pandemic was we looked at a heat map of where ticket buyers lived. When we spied a site without any heat, we'd say, *People aren't coming to us from here, so we need to go to them*. We developed an outdoor pop-up concert series in neighborhood parks, parking lots, any public space where people could gather safely after asking the question: *How do you celebrate*

*cultural identity—and do you have beloved artists that we can help highlight when we come into your community? This way, rather than us telling you what arts and culture should sound like, we're amplifying a definition you've already come to on your own.*

That might sound altruistic, but there's a strategy behind it. We are building trust with a community that didn't trust us before, and understanding their arts-going habits. And if we do our job right, that allows us to take the next step in building a stronger relationship: not only do we thank them for welcoming us into their homes and communities so graciously, we reciprocate their generosity by welcoming them into our home so that we might demonstrate what they've taught us, and furnish them with a sense of belonging along the way.

The value proposition kicks in right about here. Arts organizations that seek to be in service to their audiences must develop and amplify statements that reflect that recognition. Using memorable language that connects with community-driven goals and strong verbs that'll distinguish them from the pack, these value propositions should be emphatic, and ideally feature a call to action that speaks to those folks with whom they seek to connect.

In point of fact, Calgary Public Library put Engine 23 in the *old* Central Library, in 2016, before it reinvented itself with the spectacular *new* Central Library, setting the city up for a new era of Library operations. Indeed, it changed the conversation in the community about what the new Library would be before there even was a new Library, and the change it spurred set the new space up for the success it has enjoyed ever since.

Arts organizations might equally look to bridge their operations between old and new. And between their two responsibilities, artistic and civic, always with an ambition to hold them in balance—and sometimes in tension. The Library doesn't have those two solitudes to negotiate, and can lean into its civic role far more than arts organizations, which really must focus on

refining their missions and evolving their artistic responsibilities in a way that puts the people for whom they produce experiences front and center. But the distinction between us and those exemplary public institutions notwithstanding, there's no question that we—public-serving libraries and arts organizations both—have the same fires to put out.

# CHAPTER TWO

# The Experience Economy

Consider this: sports teams are grappling with the same altered reality as those of us in the non-profit arts scene. So are all the many players in the tourism space. Even within our world of arts and entertainment, large-scale arena concerts are selling out with ever-growing ticket prices. And yet here we are, many of us in the non-profit arts world, convinced we'll never fully recover from this interruption of business.

The first lesson in this chapter might very well be this: we're not that special. There's actually a vast and far-flung cohort of businesses and community-based organizations that rely on live group experiences for their livelihood every bit as much as we do. And if we're smart, we'll pay attention to one another over the next little while and learn a thing or two about pandemic-sprung tricks for navigating uncertainty in audience behaviors and consumer confidence across this revised landscape.

It's no wonder people in our business find comfort in the narrative that audiences simply aren't gathering anymore. It absolves them from having to take responsibility for the thin flesh-and-blood presence at their shows, relieves them from the notion that they play any part in this contracted scene. But it's not good for us, this perspective, as much of a relief as it may be to embrace it. For one thing, it's self-perpetuating. As people in the business of gathering, we have a responsibility to evolve along with our

audiences because, if we don't, we'll take our fears about diminished houses and make them so. There is an evolution to this process, but, more importantly, there is a consistency—*there will always be a need to gather*. And if arts organizations can meet that need with appropriate attention and care, they can enjoy incredible success from it. That's the second lesson.

So, how to meet the need? The two big things that come up for me are the *content* and the *business model*. First, the content. Are the shows we're planning relevant to the people we want coming to see them? Are we putting meaningful matter into the world that people will be inclined to sign on for? And, second, the business model. Is the business model behind our programming being reconsidered to accommodate this identified audience? Are we employing professional processes that make sense for our revised reality?

Enter the "experience economy." This enigmatic concept acknowledges experiences as their own category of commercial value, and the economy they inhabit is defined as one in which a combination of goods and services is sold on the strength of the effect they can have on people's lives. It was formalized in a 1998 article by B. Joseph Pine II and James H. Gilmore describing the next economy following the "agrarian economy," the "industrial economy," and the most recent "service economy." They argue that tuned-in businesses must orchestrate memorable events for their customers, and that memory itself becomes the product—the *experience*.

In fact, customer experience has been a preoccupation of business for many years and the experience economy has been floating around as an intriguing cultural offering since well before Pine and Gilmore gave it a name. Indeed, futurist Alvin Toffler's groundbreaking book *Future Shock*, published in 1970, landed upon the idea in his considerations of the rapid changes to American society and humans' capacity to adapt to them. He declared that

an economy was taking shape whose focus was the provision of psychic gratification and that the process of psychologization was prompting people to strive for a better quality of life. In response, he wrote, manufacturers would enhance their products with a "psychic load," and the world would shift to make room for industries whose sole output would be preprogrammed experiences that extended to customers the opportunity for adventure, danger, and other pleasures. The economic value of these purchases would make up the experience economy.

In the experience economy, experience is the repository of value—the property that commoditized products and services exploit to create competitive advantage. Experience, as far as lots of organizations are concerned, trumps product and price as a competitive advantage and brand differentiator. A recent survey conducted by Eventbrite found that 78 percent of millennials would choose to spend money on a desirable experience or event over buying something desirable, and 55 percent claimed to be spending more on events and live experiences than ever before. All of these data points make a strong case for the enduring value of—and appreciation for—an *experience*. And arts organizations know a thing or two about such things.

At least in principle they do.

## The art of gathering

The lesson for all of us participating in the experience economy is that we must acknowledge, first, that the content we're putting into the world—and I'm generalizing, because this is not always the case—is often not wanted or not perceived as being compelling enough, and, next, that we are looking to mitigate this shortfall with economic solutions. *It's just that the tickets are too expensive*, we tell ourselves reassuringly, and then we conclude that the

solution is simply a matter of providing free tickets to our shows or offering a discount on them for groups we've identified as needing it. *We have to lower the barrier to entry*, we say to ourselves and each other in voices pitched with the thrill of discovery—and then we hasten to do so.

But when we follow this impulse, we are not only presenting less appealing content to our audiences, we're doing it at a discount. By assuming that the problem of our dwindling fan base is people's inability to pay for our product as opposed to people's *disinterest* in paying for it *and* by lowering the ticket costs or making the content free, we're shooting ourselves in the foot (twice) because now we have no earned revenue from a ticketing perspective.

Better to holster the pistol and spend some time working to understand the scene. To wit, there are a few basic assumptions to which we all need to agree. The first is that people will never stop gathering. We've been gathering for millennia in different ways—filing into our rock seats at ancient amphitheaters, pressing up against each other in sweating concert arenas, convening on hillsides to tip our heads to the distant stages in the valleys below. If you think about it, the business of gathering hasn't changed markedly in thousands of years. Sure, the acoustics have gotten better and the seats have gotten comfier, but we're still bringing people together in front of a live performance or in aid of a common philosophical focus every bit the way the ancient Romans did. Only thing is, we've lost some of our touch with being responsive to the people with whom we ostensibly exist to engage.

The second assumption on which we need consensus is that people in fact *are* willing to pay for quality experiences that they find valuable. And the third is that our community needs to figure out a new business model that is more sustainable than the current one, which sees audiences either not coming to our presentations and gatherings or arts organizations giving tickets away for free

to no effect. It's a vicious and self-perpetuating cycle of our not furnishing people with what they want and then blaming everyone but ourselves for their lack of attendance and our diminishing ability to generate revenue.

At the core of these three assumptions is the home truth that people *will* gather around high-quality experiences and *will* pay to attend the events and programs that they want to attend. The art of gathering is alive and well for those that care to appreciate its nuances. I'm oversimplifying all of this, no question. Those organizations who've mastered the tension between their ability to curate something worth gathering for and the community's desire to consume it have figured out this tug of war.

"You have to give yourself a good, long runway," Todd Hansen says of arts organizations' return to gathering traditions. "And pay attention to the thing you're doing with a laser focus. And be OK with it occupying a lot of your time and your life." He should know. For ten years, Hansen led conference programming at SXSW, the film, interactive media, and music festival that sizzles to life in Austin, Texas, every March. More recently, he joined others to launch the Artist Rescue Trust, which was formed to provide relief funding to musicians and artists whose ability to perform, tour, and earn a living was negatively affected by COVID-19. And he is an executive producer at Web Summit, which *Politico* called "the world's premier tech conference" and the *New York Times* said is an annual assemblage of "a grand conclave of the tech industry's high priests."

As someone who has such concrete and valuable experience in how to design events that draw attendees in droves—SXSW started in the late eighties as a local music festival, but has grown into a premier international launching point for up-and-coming music acts, under-the-radar movies, and burgeoning tech start-ups—Hansen can weigh in on the art of gathering with impressive gravitas. The arts sector could learn much from someone like him

and his efforts to keep the business of gathering at the forefront of innovating.

When events started reappearing on the post-pandemic scene, says Hansen, there was an initial tidal wave of enthusiasm for their return. On its heels, a lot of the smaller and mid-sized events started to come back and the live-gathering nest began refeathering itself in earnest. "It was great," says Hansen. "It helped the ecosystem, and everyone felt they needed to be at everything again." Things have slowed some since, and people have become more selective about the mid-sized events. I will concede that the supposition that people aren't attending as many events after the pandemic as they were before it may have some truth to it; but I'd hazard that's so because of an increased sense of discrimination, which has produced a landscape that might be a little more competitive than it was before. But that's not a bad thing. There's a healthy outcome to competition that should result in our continual improvement of who we are and what we do. "Post-pandemic, my gauge would say more people got a lot more selective about what they wanted to do," Hansen confirms. Still, he says, people are hungry for personal connection and are seeking out events that will furnish them with just that.

He talks about an event he's worked with that began organically on LinkedIn and then on Slack and has evolved into an "awesome, enthusiastic curated community of marketing and PR folks" that's experimenting with moving into an in-person environment.

"The idea was the online community could not sustain itself as a Slack group unless you sandbagged it up and started creating some brick walls inside which they could meet to make it tactile." They began with small gatherings where organizers went into the community and asked, *What do you want to talk about?* People, having been hungry for the opportunity to hang in a room with others, were thrilled with the event, Hansen says, and had plenty

to talk about, as it turned out. Today they do a general monthly meeting that's "in service to the community."

Those of us in the arts, who constantly worry and puzzle over how we might innovate into the digital frontier, have a lot to learn from the enthusiasm tech leaders have in wanting to evolve their online communities into in-person experiences. Who knew our conventional gathering practices would be so attractive to virtual organizers? Perhaps we are taking something for granted—namely, our collective need to be among one another. The irony, of course, is that this cohort of digital gatherers is wanting to move into the in-person realm and wishing for our command of live audiences, just as we're rejecting it in favor of the seemingly more seductive virtual alternative.

And, again, all this feels counterintuitive to us in the arts trades, as we see ourselves as dinosaurs with our consistently concrete consumables. It's truly eye-opening to realize there are others in this world who regard what we have—in-person attendees at our brick-and-mortar events—as necessary to their success.

The lesson here is simple: we're not just taking the need for in-person experiences for granted—we're seeking a virtual alternative to escape the reality that we're maybe no longer good at bringing people together in person. Critical to our success needs to be the self-reflection and humility of reading the room.

## Reading the room

SXSW is a creativity-focused summit that, says Hansen, has long attracted attendees going through their cycles, attending the same events through the year, seeing the same people at those events, finding the right connection points, and getting on with it. But the pandemic threw a wrench in that and, while everyone tried to turn it around however they could, lots of organizers got

burned out from the effort. On top of that, the pause that resulted inspired attendees to re-evaluate whether they even wanted to keep up their traditions of going to their usual conferences and getaways and to think about the business and creativity value of their attendance at these events.

That's where arts organizers need to dial up their facility for appreciating what it takes to draw audiences to their events, and for organizing them such that they're attractive to old hands and newcomers alike. That's where the ability to read the room rises to the top of the multitude of tasks event conveners need at their disposal.

An organization as big and multilayered as SXSW reads the room to discover what people want to be engaged in for its film festival by inviting up-and-coming filmmakers to submit films for screening consideration by organizers who attend "all the festivals" and are in constant communication with agents. "You have a culture of always being open to all things," Hansen says. Whether it's the film festival, the music festival, or the conference, SXSW employs an interesting selection process. The SXSW "panel picker" is a user-generated platform. Artistic hopefuls can submit a proposal whose eligibility the SXSW team will consider according to the criteria they set out, and then they let the community vote on what they want to see. That's an interesting version of having a curatorial voice that also invites the community to weigh in on what you do.

"People probably don't understand the amount of work that goes into what areas we would want to call for, what criteria we would put around submissions, how much detail and thought we invest in all of this," Hansen says. "It has to be in the DNA of the place for it to work. And the DNA of all the processes that you're building year after year, when you're only doing one thing a year. Reading the room—each of those areas is a room unto itself. Then you bring everyone together into the great room of programming."

I find the idea of reading the room fascinating. It doesn't matter if you're an organization that's starting from scratch or SXSW with all its history and legacy. It's about how you celebrate ideas coming out of the communities you seek to serve. Your goal in the exercise is for you to spread community awareness and word of mouth.

More than that, arts organizations' curatorial responsibility is to respect both ends of the spectrum in play inside that room, taking care not to be a dictator of a programmer while minding that the pendulum doesn't go too far in the other direction, where they're not challenging or advancing, where there's still a role to play as a programmer or someone who's shaping the experience. Says Hansen: "You're not just opening a room and throwing people in there and saying, 'Have a good time, good luck.'"

In other words, there's still curation. When SXSW gets down to the last few days before its final announcement of programming, organizers lock themselves in a hotel conference room for two or three weeks; there, they turn over all the ideas, giving time particularly to the ones that have generated conversation among the team members.

Because of the increasing discernment of the audience, an organization needs to land on programming that cuts through the noise and reaches people in ways that'll appeal to them now and that'll encourage them to spend money with you later. The best approach, says Hansen, is to stir interest inside a genuine community along with word of mouth. "The people who believe in what you're doing can be a positive organic force for you."

Indeed. The last thing we want to do is build something that no one wants to come to. In regards to the Arts Commons Transformation project, I remember saying to my board when I moved to Canada, *Listen, anyone with the right pocketbook can build a building. The transformation needs to be internal.* Key to success on this front, says Hansen, is for the organization to

possess a willingness to admit when they're wrong about things and to catch itself early enough in the process that it can recover from being wrong. "I think it's a bit of admitting to yourself that you're wrong, but it's also about having the right people in the room with you. That's where empathy and transparency come in. If I'm wrong about being wrong, then let's go and be really right. I think that's the team thing.

"Leadership is the loneliest place to be," Hansen says. "So trying to be less of an island is probably the most important thing. Or at least that's worked for me. I can speak to sitting in rooms with staff and always wondering: *Was it the right thing we did?*"

From there, Hansen says, organizations must engage in genuine authentic communication with their stakeholders about why they decided to do what they're doing. And they should be timely about it, he says, not have it come out of the blue. And they must give their audience a way to follow the narrative of the journey as best they can. "Take them along with you, bring them into the story of why you're trying to do what you are doing."

## Free to swim

An organization's success with the experience economy, Hansen believes, is built year over year over year. "It's always tough to get people to come, but if you build a great experience and they have a great experience outside of the event itself, that'll make all the difference." He takes pride in distinguishing between the business of gathering and the business *to* gathering. The former, he clarifies, is simply the mechanics of organizing events to which people might be inclined to flock; the latter is the business reason that always lurks behind a gathering. There is a business model behind gathering, but the environment we create at these gatherings is also conducive to the taking place of other business.

In other words, it's not just the event, it's everything surrounding the event that serves as an attraction for potential attendees weighing the prospect of their attendance at a gathering. It's a social experience.

You bet, agrees Hansen, who says the critical social aspect of a gathering is undeniable to anyone paying attention in situ. "The minute you stop paying attention to the content, when you start walking around, watch where people's eyes go, especially if they're wearing a badge. Everyone's looking for a name. Everyone wants to identify others at a gathering that they can have social engagements with."

That reality is definitely familiar to the arts world. Sixty to seventy percent of the experience at an arts program is whether you had dinner before the show, whether you had a positive intermission experience, whether there is somewhere to gather after the show. And what does parking look like? What does mingling before the curtain goes up look like? In fact, a lot of the reason we have corporate sponsors is they want to use these events as hosting opportunities for their staff and their clients. So I wouldn't undermine that social side to this business whatsoever. I'd say our business with a customer begins from their first visit to our website.

That social impulse will never disappear. Why would it? Do as many breakouts as you want on Zoom, but one thing the pandemic showed us is that even the best digital versions of ourselves are not the same thing as being able to run into someone in a lineup, to feeling the vibe of an event pulsating on your skin, to finding yourself getting invited to a dinner, to having people sit down next to you and sparking up a conversation with them.

"People don't realize what they have until it's gone," says Hansen, referencing the panic that set in when we watched COVID-19 shut everything down around us—including those precious opportunities for social interaction. So accustomed to just tumbling off their

couches and attending things—this or that from the abundance of possibilities that might attract their attention in the arts, business, and so on—people now felt like the air had been let out of the room. In the sudden scarcity, these people's lifestyles and sense of community took a profound hit. "We figured out how to get around it," says Hansen, "but it wasn't the same. I think there was probably a bit of psychological damage from that."

In response, he said, organizers of gatherings needed to brainstorm how to get people back into the world, how to literally "propel them off their couches." I like the concept he's onto here. The idea of propulsion. The idea of taking brand loyalty to the next level and seeing to it that people are propelled into action, propelled into a deeper engagement with an event. It's not about donating to a cause or simply buying a product. It's about physically going somewhere.

As things returned to how they were and episodes of propulsion became the new normal, people registered surprise at how big a role their gatherings had played in their sense of contentment. When they were released once more to spend time in each other's company, to vacate their couches for the larger universe, they realized how much they had missed the practice. "The excitement of getting back into the real world was incredible," Hansen says. "And then having it be this wonderful exuberance of getting together, people hugging each other, people being true and honest about who they are, their business identities, it was tremendous. It was a victory lap for people getting through their own slogs. That kind of energy, when you're in a space and that's happening, makes you think we must be doing something right by gathering. Otherwise, why would we be getting together? It serves all sorts of higher psychological needs. Safety in numbers, knowing that you're OK, I'm OK, that we're OK together. And then there's all the other things going on in the subconscious—the smells, the sights, the colors, all of those things that you can't just replicate online.

"I felt like a lot of people had the feeling of treading water," Hansen says. "And then when they got to their events, they felt they could finally swim. They were free to swim to the edge instead of paddling out into the middle of the deep end."

And the swim can be lucrative if the pool offer is extended generously and properly. So many of us in the non-profit arts world live in the shallow end, dog-paddling with a scarcity mentality, obsessing so much over our lack of resources (namely time and money) that we become unable to focus on anything else. But I believe that by diving into the business of gathering and the business to gather, we can cast a wide net and reach as many people as possible, and that we can still scale up in the physical world.

These are the four things post-pandemic arts organizations need to bear in mind: the gathering business versus the business of gathering, the important transition of digital to in-person, the infinite rewards of reading the room, and the idea of propelling people into action and engagement.

The business case for staging gatherings needs to be top of mind, too. After all, there's no shame in admitting that a financial interest fuels some of your efforts. It is the experience *economy*, after all, and the business piece is built into the concept. There is money to be made in the physical world, and reaching the point where we're reaping it is simply a case of introducing constituents to the idea that we're going to try this gathering exercise again, in the ashes of a pandemic that scared the pants off some of them. In doing so, we need to reassure ourselves that, while it might take time before we see meaningful returns, people are indeed hungering for meaningful in-person experiences. Perhaps then we'll remind ourselves of the truth that will keep our sector alive— that gathering humans together to jointly participate in a shared public experience is enormously valuable and richly rewarding.

# CHAPTER THREE

# Belonging

B efore I dive into this chapter, I need to acknowledge the positions of privilege I inhabit as a white cis male in my early forties who finds himself in a position of leadership within a large and complex organization. I share this as a way to provide context for the lens through which I approach the necessity, urgency, and authenticity of working with equity-deserving communities— work in which all of us must engage, regardless of where we're situated. I also share this acknowledgment as a reminder to myself, and others who might share my position, that while we are bound to make mistakes, we have a responsibility to leverage whatever privileges we have (earned or unearned) toward implementing change that combats so many of the inequities within our cities. After all, the work of embracing civic dialogue cannot happen without first recognizing the social conditions affecting different communities and the roles we (as individuals and organizations) play in these power dynamics.

The other reason I want to start the chapter this way is that we all need to find our own entry point into this commitment to social justice through the work that we do within arts and culture organizations. This personal pathway toward change is something of an antidote to the corporate and impersonal approach many organizations have taken in their efforts to address such issues as diversity, equity, and inclusion in the workplace. In fact, these

have all become such sanitized buzzwords that many corporate environments have built new (and, ironically, problematic) systems and formalities to hide behind instead of facing the discomfort of actually addressing meaningful change; hence, my stripping of this chapter's title of said buzzwords and focusing instead on why this work should matter to us: if our work and organizations do not belong to the wider array of communities we seek to engage, then those communities will never feel a sense of belonging within our work.

One way of approaching this complex topic, a subject that calls out for the attention of all of us, is a remarkably accessible one. It springs from the worldview of the First Nations people of North America and sees differences as assets rather than problems.

Those who are not able-bodied, white, straight, affluent, cisgender Christian men often face significant disadvantages throughout their lives, and those of us privileged enough with the opportunity and responsibility to lead change in the arts must bear this reality high in our considerations of reinventing our sector. More than that, we must be mindful of how organizations confront the issue of belonging and take care not to diminish it to simply an exercise in box-checking.

The pandemic has also accelerated and uncovered a long overdue social upheaval that civically minded organizations have a responsibility to address. For over a decade, a vast number of companies across the world have started to commit themselves to changing and evolving everything from their hiring practices to programming decisions. But few are actually doing the intentional and authentic work to ensure the sustainability of this change.

There's no question that some companies, and even some cities, are on top of this, and have proven themselves ahead of the curve with appointing VPs of inclusion, chief diversity officers, and generally well-intentioned task forces and committees. But while this period seemed productive and impressive, I'm not sure

it was. In fact, much of what this forward thinking did was create situations where the burden of evolving an institutional culture was dropped squarely within a silo whose success rested on the shoulders of an individual or small team. These organizational announcements of well-meaning intentions notwithstanding, all these organizations were actually doing was pushing the subject into a corner for someone else to figure out. Not surprisingly, many of the task forces or leaders assigned to "fix the problem" ended up burning out—not because of their lack of agency or determination, but because the companies and organizations were never actually prepared to expose all aspects of their operations to the change needed.

More troublesome than that was the fact that it was usually members of marginalized communities who were tasked with addressing the inability of these organizations—typically led by privileged white men—to be more welcoming to all people. There's a quote I've heard, which I will butcher, that goes something like "inequality isn't a problem of the oppressed—it's a problem of the oppressor." When organizations rooted in colonial practices— that is to say, practices and systems of domination rooted in a mindset that sees people as tools used to extract value—make a gesture by putting people in charge of fixing a problem they didn't create without the proper supports, they are creating an even bigger problem.

There are important lessons in all of this for arts organizations in pursuit of reinvention—so far, I'm not seeing a lot of us learning them. Don't get me wrong, this work is incredibly difficult and challenging, and may very well be the most important thing we tackle about our collective transformation. But whether we are challenged by the notion of privilege, or by a generational divide that still believes people can just pull themselves up by their boot-straps, we must acknowledge our discomfort—not as an excuse not to tackle the work, but as the first step in working through it.

The other tack we've taken is we've said, *Right, we're going to put people of color on the stage, we're going to be outward facing and representative, and we're going to leave it at that.* While I think this kind of initiative is important, I don't believe promising that a certain quota of our performers will be people of color while the rest of the organization remains unchanged is the way toward success. We need to think about changing the root problem—the DNA of who we are. And if we do that, then, yes, our artists and our staff and our boards *will* be more diverse as the natural and organic outcome.

## Civic responsibility vs. artistic mandate

Because of my background in arts education and community engagement, I have some firsthand experience with a cultural organization's education and community engagement arm being tasked with an entire organization's diversity and inclusion. After all, these teams tend to have the most relationships with community stakeholders, and people think they're the best positioned to gain favor with them.

But that's an unfair pressure to put on any department when this commitment needs to be unpacked and embraced in *every corner* of the institution. The accountability for this organization-wide issue needs to be the business of the *entire* organization, grounded with the individual or department who oversees the rest of its big-picture considerations, affording it the same level of attention and accountability as everything else.

Indeed, we need to believe in our organizations' civic responsibility before we think about our artistic mandate. Certainly, we in arts organizations operate through the lens of the arts, but focusing on our civic mandate forces us to put our artistry in service to something else, something greater. When you are

in service to others and the world is falling apart, as it was in the pandemic stretch, then our job is pretty straightforward: to respond to the need that is presented to us. There are too many arts organizations that never embraced their civic mandate and, as a result, didn't know how to manage the pandemic because they were never answering the question, *What are we uniquely positioned to help with right now?*

When I moved to Calgary from New York City and started this role in May 2020, I was all fired up because of my desire to put Arts Commons in service to Calgary civically, not just artistically. And while the pandemic gave us many opportunities to lean into our civic responsibilities, there was another incident that took the world by storm soon after my arrival: the murder of George Floyd, in Minneapolis, on May 25. As the world finally and collectively responded to this long-awaited social and racial reckoning, my first instinct was to declare a position as an organization to demonstrate—with not just words but actions—our denunciation of such behavior and a fierce message that things must change. I knew that we, as an arts organization, needed to lean into our responsibilities in terms of what stories we told. We had the power, the privilege, and the platforms, and we needed to think about how to exercise them—and not just culturally but civically.

But an Arts Commons colleague pulled me off from my soapbox early in my Calgary days and said, *We love that you're doing this but you're responding to the need for greater social justice as if you were still in the U.S. As a newcomer to Calgary, you need to understand that systemic oppression in Canada has been placed predominantly on Indigenous First Nations; if you want to lean into this through the lens of your new role in Calgary, you cannot* not *address Canadians' relationships with First Nations communities.*

That was a watershed moment for me. I said, *How do I start educating myself?* I needed to be better not just for my sake, but

for the sake of Arts Commons. I did research and learned there were some very large, historically white-led organizations—namely the University of Calgary and the United Way of Calgary and Area—doing powerful work addressing reconciliation with Indigenous communities. And what they had in common was they were both working with Drs. Reg and Rose Crowshoe.

Reg and Rose are well-known Blackfoot ceremonialists who live on the Pi'ikanni Nation in southern Alberta. He's the executive director of the Oldman River Cultural Centre and, together, they've pioneered cross-cultural programs for many organizations and institutions across North America. Reg's Blackfoot name is Awakaaseena—Deer Chief, in his language, and his grandfather's name. In 2022, they were jointly appointed members of the Order of Canada in recognition of their commitment to preserving Blackfoot culture and furthering reconciliation in Canada.

So, with so many other critical and seemingly more important issues needing their attention, I had the audacity to ask them if they'd be willing to work with me on sharing not only the learned and lived experiences of their Indigenous communities, but guidance on how to run an organization that wanted to become more civically minded for everybody. To my great fortune, they said yes, and I spent the first six months of my tenure in Calgary, having conversations with Reg and Rose Crowshoe.

I quickly realized I was working with elders who might do more than teach and enlighten me personally—Reg and Rose understood very large, complex organizations that were looking to change. As a newcomer to Calgary who had a background of working with communities with very different power dynamics, I found it beyond humbling to be learning from Indigenous knowledge keepers who were gifting me with ways of thinking that were already making me a better person—and, hopefully and eventually, Arts Commons a better organization.

## Finding parallels

What I noticed and loved from the start about working with Reg and Rose is that they're always talking about parallels. Reg feels strongly that it's not about picking Indigenous ways of living over Western ways of living—or vice versa; it's about acknowledging that there are multiple ways of seeing things and multiple ways of being, and about finding the parallels between disparate worlds so you can start building bridges.

"I think trying to understand two worldviews—a Western worldview and an Indigenous worldview—is so complex, we will never get there," Reg says. "But one thing I was taught by the old people in the community was to understand systems. I understand the Cree system, the Sioux system, the Inuit system. And because I understand each of their systems, I respect each of their practices of organization."

Reg believes it's by identifying the systems in our different worlds that we can find similarities and build bridges between them. He talks about how his understanding of relationships began when he was taken to the residential school system, government-sponsored religious institutions established to assimilate Indigenous children into European-Canadian culture—a system that lasted well into the 1990s and is responsible for the cultural genocide of many First Nations communities. "When I was young, I knew who Creator was, and I lived my life with oral practices. But when I went to residential school, I learned to read and write and use Western tools. In forcing me to forget my Indigenous ways ("That's the work of the devil," they'd say) they tied one hand behind my back and taught me to use the other.

"I think about it now and say, *We should be coming back to a point where we're working with both hands.* So I would say bringing the understanding of oral systems will allow us to start working with both hands." While an approach to reconciliation might

be activated in different ways by different organizations, for Arts Commons, that means accommodating oral processes within the default Western system in which many of us live. "If you can work with both hands," Reg says, "you can become stronger in the larger community."

Reg's words resonate with my desire to revise some of the problematic status quo in the arts world and Western world's inability to have brave conversations about topics that are potentially conflicting. The analogy of finding parallels is a meaningful one. Because we live in a Western society, we will always have to have written documentation and to live by the written word. But there is room for another way—an oral way; at Arts Commons, where any contract we sign needs to be first made orally and in person, honoring our commitment to relationship-building, we're looking to prove it. We've hired an Indigenous consulting firm to help us build a framework for Arts Commons that holds us accountable to these parallels. In a world that is piling on jargon and politicizing terms like "diversity" and "equity" to the point that they feel frozen or numb, working with Reg and Rose is an exercise in going back to the basic building blocks of humanity and community-building. In fact, as Reg shares, Creator made all beings as equal—plants, people, and animals. In the Blackfoot language there is no literal translation for the word "racism" for the same reason there isn't one for the word "pet"—if all beings were created equal, how could one be more or less important than another?

Even as I write this chapter, I realize I don't have all the answers (and likely never will), but I think we've at least landed on a new question: how do we change the DNA of our organizations so drastically and so rigorously that more communities feel welcome—not because we are overly committed to outward manifestations of inclusion but because of the change that is taking place at a very deep and internal level?

## Stop being the problem

As I've said countless times, the arts world has become a luxury good that's overconsumed by too few people. Many of our organizations have become a playground for the 1 percent, a destination for the elite. And while we absolutely need to consider economic barriers, we also need to take on board a home truth that at the core of people's choice not to come is the fact that they don't feel like they belong; they don't feel comfortable. What we put onstage—and how we put it onstage—is not a reflection of how many others define or celebrate cultural identity.

Legend has it that, more than twenty years ago, Lincoln Center Theater, one of the several resident arts organizations housed on the Lincoln Center campus, was realizing that their audience was "too white and too old." They assumed the only reason they didn't have a younger, more diverse audience was that their tickets were too expensive. So they launched a ticket program by which they would sell heavily discounted tickets, in person at their box office, the morning of the show, convinced that, by selling tickets this way, all these people who represented the diversity of New York City would magically emerge and line up around the block. Ironically, what they found was that the only people taking advantage of these discounts were the retirees within a three-block radius of the company—folks who had been paying for full-priced tickets the day before. So, what they realized was that the financial barrier, albeit important, wasn't what was keeping people from their theaters and that adjusting it wasn't drawing them in either.

When Arts Commons started doing those pop-up concerts within communities in which we knew we didn't have many patrons, we humbly went into those neighborhoods and asked

people how they celebrated cultural identity and if they knew of local artists that reflected that. Our job, from there, was simply to provide the resources for them to celebrate within their own community and build trust as a result.

We need to move away from the narrative that our audience isn't Brown enough, Black enough, young enough. . . . Recognizing who we're not engaging with is important, but we also need to recognize that *we are the problem*. If people aren't buying a product, it's never the consumers' fault. It's about the level of accountability we have to put on ourselves. Reg and Rose aren't giving me marketing tactics or a programmatic strategy. They're talking about building parallels between worlds, about the stars and biological beings. That's the level of foundational change that needs to happen for us to open ourselves up to these conversations.

There's no question that it's going to take some time. When I started these conversations with Reg and Rose, I was thinking, *We need to have a reconciliation strategy in three months—let's go.* But Reg quickly put me in my place: *That's not how this works*, he told me. *It's going to take as long as it takes, and you're never going to be done.* Three years later we're still scratching the surface of relationships with Indigenous communities. But we've made progress. In consultation with the Crowshoes, we at Arts Commons have developed an ambitious reconciliation strategy with members of Indigenous communities that incorporates Indigenous ways of knowing and living into a historically Western-led institution.

Specifically, in ongoing consultations with Reg, Rose, and Indigenous consultants and community members, we've developed four pillars to our reconciliation strategy—pillars that are serving as a framework not just to strengthen our relationship with First Nations, but that outlines our commitment to welcoming all people.

## 1. Sanctified kindness

As anyone who's been lucky enough to attend Indigenous gatherings, meetings, or ceremonies will know, smudging is the burning of medicinal plants like sweetgrass, cedar, and sage at the beginning of an event to help start it off in a good way. While the practice is based on the traditional belief that the smoke produced during the smudge is purifying, Reg talks about how the lighting of the smudge is also an exercise in sanctifying kindness in the space. When I heard this and witnessed it for the first time, I thought, *Isn't that what we do every day in an arts organization? Shouldn't we bring people together around not just a shared love for arts and culture, but—more importantly—around a shared commitment to sanctified kindness? What would happen to people's experience in our organizations if we embraced this philosophy?*

## 2. Building relatives

"Our natural law says everybody's your relative," Reg says. He talks about a conversation with an elder who asked whether being a "steward of the land," as many of the common land acknowledgments reference, has any power. Reg told him, "I guess so—we're making decisions on behalf of animals." And this man responded, "That's wrong. The animals and the plants are our relatives—how can we be stewards of them?"

Reg talks about stardust, about how there's no power dynamic among living things in his worldview, whether you're a plant, an animal, or a person. "Creator created everything from holy dust." From there, we went on to the next part of the story, which talks about magic beings, or biospecies. He explains that all creation is made of biospecies: the vacuum in space, the stars, the ecosystem we live in, animals, plants—they're all biospecies, and their interactions create natural laws, which give Indigenous people

the guidelines they live by. That's where our learning comes in. I realized early on that even though our conversations were unapologetically about Indigenous ways of being and reconciliation, at the core they were about building relationships.

Embracing the concept of relatives in all organizations is important, Reg believes, because doing so increases our care for our goals. "But it all starts from that background of sanctified kindness. So that's a call to order for the organization. That's a practice to say sanctified kindness starts when we call to order our relatives sitting in a circle. They might not be our blood relatives, but they are our relatives in the organization. It is only through building relatives that we truly commit ourselves to understanding people with differing opinions. If you and I are in a space together and we have a commitment to sanctified kindness, it doesn't matter what our differences are."

In other words, being an ally or a partner is great, but it's not always enough. When you are relatives with someone, you carry them and their burden almost as though you're carrying yourself.

This concept of building relatives has been a revelation to me. When I'm sitting in a theater, I see people from all walks of life. They may have different political and social beliefs (heck, they may even root for different sports teams), but when we are in a space that honors sanctified kindness as a basic tenet, we have a rare opportunity to build relatives. And in an increasingly polarized world, a chance to develop this kind of connection with someone is what we should be known for.

## 3. Ethical space

This third pillar builds on the previous two. If we have a commitment to sanctified kindness, if we are able and willing to build relatives in that space, then together we are building an ethical space. "Once we sanctify kindness and smudge in it," Reg says, "then

we're in an ethical space." Ethical space is a space that is caring, that is protective, that is brave. It's a space in which we can have difficult conversations. It strikes me that the world has forgotten how to have difficult conversations, and I told Reg as much.

In the arts, we've been building ethical spaces for thousands of years. After all, it's here in our environments that we can talk about challenging things without fear of retribution. To me, the epitome of good art is art that takes place in an ethical space and is both brave and safe at the same time.

In a Western default system, a so-called "ethical space" is one that is protected by policies, terms of reference, and procedures. That's what makes rehearsal rooms, classrooms, and boardrooms ethical spaces—places where people can safely hold discussions. And where the Western world's default is written policies and procedures, Indigenous peoples have living policies. If those can be understood as parallels, then we can say we've built a safe, ethical space from two systems and, inside it, bringing in principles from two different worldviews, we can start having important discussions.

Ultimately, the creation of ethical space is what will allow us to succeed in bringing people together to learn from one another.

So these three principles became the parallels for me—the bridges that connect what is clearly pivotal and important to Indigenous communities, but also principles that should be pivotal and important to the arts community.

## 4. Social business

There is a fourth principle that continues to stand out for me in my conversations with Reg, and it isn't one that speaks to the "why" of our work, but rather the "how." If most of us live in a Western default system—a system that uses the written word as a way of passing on information and doing business—then the opposite

of that is a way of doing business that relies on oral traditions. In fact, it doesn't take long to realize that, in many First Nations societies, knowledge is passed on from generation to generation via song and storytelling. Song. Storytelling.

What I find fascinating in talking to Reg is the realization that, if the "work product" of an arts organization is a "social product"— meaning that we are putting music in the air, we are putting words on a stage, we are placing paintings on a wall, we are telling stories in person—the rest of our business should similarly embrace social business concepts.

Arts organizations, after all, are no strangers to "social products" that rely on oral traditions (performances, plays, concerts, etc.). So why is our business not run in a similar fashion? An oral system does everything another system can do; we need these two systems to meet each other in ethical spaces that can provide a venue for safe, brave discussions that are respectful of different systems' ways. Reg explains, "If you're talking about shared values when calling an event to order, one side can say, 'Our call to order is sweetgrass' and the other side can say, 'Our call to order is hitting a gavel on the table.' Those discussions can now happen in parallel—not gavel *versus* sweetgrass, but gavel *and* sweetgrass. Then we can provide protection from the written and oral side—*both*. They become our shared best practices. And those best practices can be used to take on challenges that both sides need to work at."

The lessons from Reg, Rose, and the Indigenous ways are clear. While these pillars are rooted in teachings from Blackfoot elders, their ability to bring people together transcends demographics, making them applicable and relevant to all of us—regardless of where we live or work, and of the kind of organization we run. And let me be clear: the actual strategy we've developed includes concrete tactics that influence our programming, human resources, and governance practices (to name a few). Measurable outcomes

must and will be achieved. But not because we have to check boxes or appear a certain way to the outside—rather because it's the right thing to do, and it will make our organization evolve and thrive in times of change.

Early on in my tenure at Arts Commons I got course-corrected toward Indigenous reconciliation—and in doing so learned that to embrace the need for reconciliation is an exercise in acknowledging that we have an urgent need to restore positive relationships with communities whose values and ways of living have been falsely perceived as being incompatible with my own. Now I understand that, if Arts Commons does this right, if we adopt the spirit of building parallels between worlds, of acknowledging the lack of hierarchy in all things, from the stars to biological beings, and if we realize that this work is never over, we won't just be a place of belonging for Indigenous people, but a place of belonging for everybody.

# CHAPTER FOUR

# Programming

In 2022, in the culmination of a global search, Stanford University appointed Deborah Cullinan to the role of vice president for the arts after a successful tenure as chief executive officer of San Francisco's Yerba Buena Center for the Arts (YBCA). In this new role, she continues on her journey of revolutionizing the role that artists play in reshaping the social and political landscapes that so desperately need our attention in the twenty-first century. As a professional who considers artistry a pivotal catalyst for mobilizing and strengthening communities, she is the best person to ask the question that so few organizations are brave enough to consider: *If the arts are truly transformational to the DNA of communities and societies, then why are so many arts organizations struggling to survive?* The answer, my friends, lies in how organizations have taken up the mantle of programming.

The former executive director of San Francisco's Intersection for the Arts, co-founder of CultureBank, and co-chair of the San Francisco Arts Alliance, Cullinan is a disruptor of arts programming, fueled by the belief that most programmers have forgotten about the need to engage in conversation with a variety of audiences, and instead have found a self-serving sense of comfort in a transactional relationship with a small group of admirers who place their work on pedestals. "I've always been driven by a desire to move beyond the binary and to think about arts experiences as

community experiences," she says, adding that, "if we can generate community, can move from transactional to relational, then we can have that much more transformational impact."

She takes delight in imagining the most ideal place she might transport her arts organization to, and then in experimenting her way toward it, learning as she goes. At YBCA, she charged her team with "looking all the way at the other side."

"What could it be?" she asked them. "I think we're not patient enough and not good enough at looking at longer-term indicators." Metrics like the impact of the arts on a community's health and well-being aside, she was committed to creating a community center that also happened to be a place of extraordinary arts experiences, where community engagement wasn't an unanticipated outcome, but was central to the organization's success.

At YBCA, Cullinan and her team operated inside of three pillars: create, champion, and invest. The *create* piece is about moving away from top-down curatorial structures and building fellowships and residencies and other ways for artists to spend long periods of time in communities together. *Champion* is about advocating for the arts and telling the story of the impact artists have in people's lives and communities. And *invest* is acknowledging that our financial systems in the arts are broken, reduced to arts organizations and philanthropic entities transacting with artists one gig at a time, none of it stabilizing, none of it ensuring a healthy, creative ecosystem, the whole scene further injured by the pandemic.

It's abundantly clear, she feels, that there are new ways for people to access their own creativity, which are flexible, which meet them where they are, which are not transactional.

"Artists do the essential work of helping us make meaning of these times," Cullinan said, at her Stanford appointment. "Their capacity to visualize and realize a better, more equitable future is boundless."

Boundless, too, is Cullinan's faith in artists' autonomy and community connection. She's been known for engaging artist-led giving circles, putting money in the hands of artists who decide for themselves what to do with it. That is why she also oversaw a guaranteed income pilot, to demonstrate what happens when you provide just a base level of stability in the life of an artist. The investment, she explains, is returned tenfold in her community. "Every artist I talked to said, 'This is the first time I haven't had to worry about health insurance, or getting to and from work.'" They told her they felt safe now and were able to pay their collaborators. "Many artists would say, 'I did the project I'd always dreamed of doing.' And then you break that down and say, 'If we are not enabling artists to do the *dream project*, the moon shot, what are we losing as a society?'"

In San Francisco, she launched a hunt for stakeholders— government contracts, philanthropic partnerships, individual donors—who wanted the unique thing that this artist-centered approach would provide. She didn't find her partners right away, but when she did, the gamble paid off. "You really do need to invest in risk, and you really do need to give it time. And I think [you must] understand why an organization made the choices it made before you look to dismantle or shift direction." What I love the most about this is the clearly articulated need to move away from a scenario in which the artist is asked to take risks for the safety of the organization and to flip the narrative so that an organization can take risks to provide safety and security for the artist.

Looking back over programming history, Cullinan is philo- sophical. It's necessary, she says, to keep things in perspective when regarding choices from the past, rather than apply easy censure. "Decisions are made in context," she reminds. "Inevitably, the decisions we're making today might be revealed to be horrible. What we want to do is understand enough about the past and

then be in the present, but always, always, have an ability to see what the future will be."

## The harbinger of excellence

Arts programming is the multistage process of organizing, decision-making and allocating financial resources toward the curation and presentation of an art piece. It has a long legacy of short-sightedness and speculation, thanks to its quiet tradition of presuming a self-appointed arbiter role that declares what everyone else wants to see. Our ability to curate and be tastemakers, and define quality and excellence, has revealed itself to be a problematic practice. Because when you say "excellence" in programming, the first thing that comes to mind is: excellent according to *whom*?

None of this is to say that programming hasn't always been the manifestation of our commitment to celebrating cultural identity, because it has. But the concept of cultural identity can be complex and multifaceted, and can include an endless combination of shared characteristics by different groups of people. It is incredibly problematic when only a single person, department, or team decides what definition of cultural identity an organization gets to celebrate—or perhaps *overcelebrate*. In these cases, we are usually characterizing cultural identity according to a very small representation of a larger community.

This reckoning has come about now for a couple of reasons. On the one hand, there are various external social pressures whose recognition is long overdue—like the one acknowledging the communities some organizations have excluded from their cultural practices. Then there's the internal pressure of organizations having to be more dependent on ticket sales. Certainly, news articles about North American arts organizations being on the brink of collapse because audiences are not coming back as fast

as we need them to are in abundant supply. Taken in tandem, the disconnect is palpable. Here we are excluding potential audience members willy nilly while simultaneously realizing that our business model depends on increasing and diversifying our audience base through a reimagined commitment to programming. Every organization will say, yes, we need to diversify our audience base, to reach new audiences, to develop new audiences, but very few will have the maturity and humility to reflect on what they need to do programmatically to reach those new audiences.

Here comes humility again: while we arbiters still have a role to play, it may not be the role we've historically felt comfortable playing. Indeed, it feels downright threatening to have to relinquish our conviction that our views are ever-relevant, that we are the masters of programming. But there's still a rigor to this reinvented take on programming; there's still discipline required and work to be done. It's still challenging work—it's simply not the same work we've been focusing on for decades.

Most fear-inducing for programmers being forced to relinquish control, I would imagine, would be staring down these questions: *What's my job?* and *How am I expressing my or my organization's commitment to intentionality if it's not by telling the artist what to do?*

In fact, the arts programmer's new, evolved job is to not be so concerned about *what* the artist is doing, but *how* they're doing it. And it's to shift from a focus on themselves as the programmers or artistic directors to the work of the artist and how creative and safe that individual feels within the place that the organization has created for them. As for the second fear about not feeling like this new job description is intentional, I could see an artistic director saying, *Does my opinion not count? Does the mission statement of the arts organization not count?*

Of course they do. Indeed, I think the job of the programmer is to hold together the organization's mission statement. There's the intentionality. Like we explored in Chapter One with Calgary

Public Library, we need to know as an arts organization what we stand for. And the more intentional the organization is, the easier it is to facilitate conversations around that mission. So the new job is essentially to say, *This is what we stand for as an organization, or this is what I stand for as a programmer.* What comes next might be anything, from a commitment to social justice to producing new works with emerging artists. In any case, your mission, as a manifestation of your values, gives you certain guardrails. And your job as enlightened programmer is to walk inside them and ask yourself: *How do I welcome artists that align with our mission and values, who might create something that is stunning, powerful, challenging, and that I, as a programmer, never saw coming?* That's very difficult. In many ways, this revised role of the programmer is far more complicated, challenging, and nuanced than the dictatorial one we've understood for decades.

But the rewards are so much greater.

## Humility's role in programming

Charged with identifying what's more important, the intent of the artist or the perception of the audience, Cullinan picks facilitating dialogue between the sides, which she's convinced is the institution's responsibility. It's a unique answer that introduces the programmer's responsibility to this triad. She says it's not just about a dichotomy; it's about asking another question altogether: *what is the role of the arts organization?* To her mind, it's not a two-person game; it's a three-person game: the artist, the audience, and, as the conduit for engagement, the organization.

The answer to her question is the new job of the programmer. If we know that the historical role of the programmer was to live in this ivory tower where it was "my way or the highway," holding tight to a vision, convinced they knew what people wanted, and

if we're moving away from that into a world where the lines are blurred, where we're *not* the experts on how different communities celebrate cultural identity and we *are* the forces behind bringing artists and audiences together, then we know what programming might look like. By asking ourselves what our responsibility is to artists and audiences, all with different missions, values, vision statements, and stories, we're putting the organization in service to that dialogue. And we're shining a spotlight once again on humility.

Humility is important now, and in different dimensions: as it relates to our relationship with the artists, who are ultimately creating, and as it relates to our understanding of what we think audiences may or may not want. There was a time, not too long ago, when Lincoln Center would go into the South Bronx in an effort to "take arts to the South Bronx." To me, that is the opposite of humility because I don't know of any community that celebrates a clearer definition of cultural identity than the South Bronx. For an organization to burst into any community and say, "We're going to bring arts and culture to you," is completely insensitive, incredibly irrelevant, and disrespectful. This is not to say that an organization like Lincoln Center doesn't have a role to play in the South Bronx, but it's not one of telling people what they want. It's one of learning, listening, and then facilitating new collaborations that celebrate a community's own definition of cultural identity.

A good programmer knows how to bring people together and also knows when to step back. The widespread, dated approach to programming notwithstanding, there's no shortage of humble programmers afoot. Don't believe me? Talk to artists that have been performing for decades about who their favorite programmers are, and you're likely to get an answer featuring someone who's supported the process, partnered with and supported the artist, given some structure for them to create within, and known when to get out of the way.

As programmers and organizations, we still owe a duty to our audiences, Cullinan says. But the duty—once deemed to be an arbiter of excellence—should always have been to be a facilitator of conversation. Arts organizations have a responsibility to create the conditions within which artists can boldly reflect on the times in which we live and can create in ways that speak to them.

"We try to play around with what's going to draw people in very broadly," she says. She feels that large, ambitious, inclusive projects have proven a good way for the organization to meet new folks and get them interested. During her time at YBCA, the center would regularly invite people together for day-long explorations around the most pressing questions and interests of the day. "We open the whole place up to those artists at the end and say, 'Show us what you've done. Put it on our stages. Let's demystify these places, let's create community, and let's let you change us.'"

It's this kind of boldness, she says, that's key to the next incarnation of programming. And, she believes, it's the arts organization's job to create the conditions inside which someone can exercise such boldness. "Everybody has to be bold," she says, "and you're creating the opportunity for the artist to feel safe to create, and for people to have challenging conversations about it all. You must create an environment that can live at the intersection of being safe while allowing artists to take certain risks.

"I can only imagine what our world would be like if everybody felt safe," Cullinan says. "So much of what we're dealing with around the world is because no one feels safe. It's a crazy time, a meta-crisis, not like other times. And I think artists are such an underutilized resource to help us see past ourselves."

Some people, she acknowledges, considered some of the things YBCA did "too risky organizationally." But there was a reason for the risk, she says. "In moments of deep fissure, the most important thing we could do was build trust and step aside. The work

is not meant to make you feel safe. The art experience is meant to make us all feel seen and to free us to contend with who we are."

Too many arts organizations, meanwhile, are anything but free, locked into inherited operational silos. In organizational theory, departments can easily create artificial, lateral barriers that inhibit an organization's effectiveness. In the arts world, programming departments exist in similar structural conventions, entrenched in antiquated models of funding, producing, presenting, and curation. Artists don't create in silos and audiences don't consume in silos. So why do we program this way?

## Start a dialogue

At YBCA, Cullinan developed a variety of ways through which community members kept the programming team tapped into what's important to them. Community engagement, she believes, is not just a way of selling people a product that a team of administrators created, but of actually letting community into its creation. Out of the silos then, programming becomes a democratic, collaborative process—a dialogue—and the programmer's role morphs into facilitator and nurturer and host to that dialogue and even the instigator of that dialogue, for being the one that asks the sparking question, this act itself a far cry from the alternative, the one where we're convinced we have the answer.

If convening becomes part of the job description of programmers, then one might look at the generosity with which we host, knowing that patrons who feel a greater sense of welcome and belonging are more likely to freely participate in the act of building community. When asked for an example of this, Cullinan points to a seemingly insignificant but powerful gesture the Frost Amphitheater at Stanford University facilitated recently, when it hosted rock indie pop artist Cavetown for a summer concert.

It was a hot evening in Palo Alto, and the head of operations decided that he wanted every one of the musician's young fans in attendance to have a water bottle. So he got a bunch made up and distributed them throughout the fervent crowd. "It created a sense of community and a sense of being taken care of," says Cullinan, who calls such tiny efforts acts of "radical hospitality." Seemingly tiny but powerful gestures.

"How you build a team and align everyone around the thing we decided on together is really important. That challenge has been a part of my whole career—it comes up in every institution. If you're creating the conditions for your staff to feel a part of something, to feel seen, to feel safe, to feel like they can do an excellent job, it will [be returned to you].

"You're also creating the conditions in which those silos can be broken down in an organic and collaborative way."

And if you're engaging the community, she believes, you need also to be gauging the community. Where too many arts organizations measure the success of their programming by how much earned revenue it brings in, Cullinan suggests that the more complex and nuanced ones measure it by the level of a community's health and well-being, including focusing on such indicators as youth development, education, and neighborhood vitality. "If we look at the factors we know drive health and well-being, like social cohesion and belonging, sense of place and identity, feeling safe, those are all vital conditions. So is art, and if we measure those things over time, then the data will show up. If we are cultivating inclusion and belonging and are driving a sense of safety and well-being with [our programming], we are going to be able to develop those models that return financially." And for those who say these measurements are too difficult to achieve, let me draw our attention to some of the following national statistics within the U.S.: at-risk students involved in the arts are 23 percent more likely to attend college than peers with low arts involvement (*The*

*Arts and Achievement in At-Risk Youth*, 2012); 67 percent of music therapy participants with dementia felt less anxious and reduced their use of medication (*Creative Health: The Arts for Health and Wellbeing*, 2017); concentrated cultural districts are associated with reduced poverty without neighborhood displacement, improved child welfare, and lower morbidity (*CultureBlocks Philadelphia*, 2013); and 45 percent of medical institutions nationwide offer some sort of arts program, with 80 percent stating that they do so to benefit patient recovery (*Arts in Healthcare*, 2009).

She acknowledges that there's an evolution afoot and a call for a baton-passing of trends. And she speaks to the necessity and urgency of that baton being passed as our requirement and effort to reach new audiences emerge as critical. Today we're realizing that what was relevant to one audience may not be relevant to another. And it's a hell of a thing, quite frankly, to have to juggle two realities: the status quo of maintaining this arbiter-of-excellence role while taking on board that *our* definition of excellence is not reaching the audiences we want, and need, to reach.

At a time when there are so many definitions of culture readily available for consumption with the click of a button, the convention of programming directors and arts managers being the last and only call on what kind of arts the rest of us can access is preposterous. It's an infinitely better idea, and a more sustainable and engaging practice, to invite the people for whom the arts are intended to play a role in their curation.

# CHAPTER FIVE

# Messaging

C urious about which aspects of arts organizations are best designed to actively engage with the public? Look no further than the twin forces of programming and marketing. These foundational departments, paired with the all-important organizational value proposition, make up the three points of an organization's most essential audience-facing triangle. Given its prominence in communicating our company's ethos and activities, it's shocking what a mess arts leaders so often make of marketing.

Programming is the material offering of arts organizations, and its engagement with the consumer is kind of a given. But your messaging, which communicates what your organization stands for—your values, mission, vision—and which informs your marketing strategy, which is ultimately what leads to engagements and transactions, is every bit as crucial for connecting with an audience. If we're truly changing the DNA of our cultural institutions, we have to go beyond working and programming in new ways—we also have to talk about ourselves differently.

And no more so than at a time of renewal. After all, if an organization decides to steer its ship in a different direction from the one in which it's been heading, but doesn't bring anyone along on that sea change, then the effort is effectively worthless.

If you are an entity in flux, which most of us should be, transforming from one thing into another, making this effort is even

more important. Because, unlike with fresh gambits, where there are no preconceived notions to either wrestle with or benefit from, an existing brand gives you some equity to play with. You have recognition—along with accumulated legacy, relationships, and a track record, good or bad—and so don't need to build an awareness from scratch, to introduce a new presence in a field that's maybe already saturated. That's not to say it's not possible; people do it all the time. But I'd rather use the place we're privileged to occupy as leverage for change.

## More than words

When I joined Arts Commons, people were all too happy to share with me their disappointment at the rebranding that took place in 2014, when Epcor Centre for the Performing Arts became Arts Commons. I was begged by many to rename the center. But I had no interest in slapping on a "new coat of paint." Instead, I was far more intrigued by defining our identity in more meaningful ways. So I started to talk about messaging in terms of concentric circles. At the epicenter is the very real and self-serving need to sell tickets to generate earned revenues—but this is just the first of three concentric circles, that of performance marketing. This part of what a marketing or communications team needs to do for an arts organization is important, no question. But it's only circle number one.

Sadly, many organizations stop there.

We host two thousand events a year at Arts Commons—ranging from contemporary music to musical theater to keynote talks; if we halted our messaging efforts at the performance marketing stage, all our team would be doing is talking to the world about two thousand siloed events, pushing them out, and trying to get people to slam down their credit cards to buy one-off tickets for them.

But in addition to selling admission to all those performances and events, we need to cast our net wide enough to encompass the second concentric circle—what I call institutional messaging. At this level, we connect the various performances to the organization's value proposition, then—importantly—we explain how those two thousand events are connected to each other and to who we are as an organization. The extra layers are key. If I tried to describe Arts Commons through the lens of performance marketing alone, I'd be describing two thousand marketing campaigns, bombarding our audience with two thousand emails, never mentioning our overarching commitment, never layering on articulation of what we're all about, never mentioning that we're one of the largest and most diverse hubs for cultural activity in Canada. With this second layer, I've moved away from talking about an individual show to sharing a narrative that connects it to our all-encompassing commitment to, and impact on, people and the community.

And before I get accused of diminishing a commitment to earned revenue, let me be clear: my belief is, if you get institutional messaging right, it'll actually reinforce your ticket sales. Because when you're selling the ecosystem as opposed to just a performance that blooms inside it, you're building loyalty—not to a single show or a single artist, but to an organization, and even, beyond that, to the art it champions.

Which brings us to the third and final concentric circle of arts marketing: what I call advocacy messaging.

Here's what advocacy's about: you remember that scene in *Miracle on 34th Street* when a Macy's sales clerk is helping a frazzled customer find the right toy for her child and, after thumbing through a catalogue, speaks up to send her to—gasp!—the competition. "We don't carry that brand," he concedes. "But I think Gimbels does." The monetary loss Macy's suffers with this play is miniscule compared to the deep well of goodwill it cultivates in its beneficiary.

That's the essence of this final circle, which is aimed at developing arts-going habits: we are greater when we work together and when we work with the public we serve top of mind.

As the messaging circles pool out, they go from being self-serving to being seemingly more selfless. We are pushing arts and culture for everyone with this third circle, regardless of our part in the exercise. A rising tide lifts all boats, after all, and if we embrace the concept of advocacy, our ticket sales will surely increase.

Not convinced? Look at Patagonia, a brand that has long blurred the lines between marketing and advocacy. Their talk about climate change and sustainability evokes subjects that are much bigger than their product. By tapping into that conversation, they are expressing and manifesting their brand and value proposition, and reaching an audience of like-minded people. And the next time those people have a need to buy, say, a roomy duffel or an endurance vest, chances are they'll go to Patagonia, the store whose values reflect their own.

Ben & Jerry's is another example. There's no reason for an ice cream company to have an opinion on politics, and yet they have because it's a manifestation of what they stand for. With it, they score a new visibility for their brand.

Before we start drawing comparisons between the non-profit and for-profit worlds, it's worth noting that both Patagonia and Ben & Jerry's are examples of certified B Corps, meaning that they have opted into a voluntary certification program for for-profit corporations that is predicated on a rigorous assessment of the company's social and environmental performance. I find it fascinating, and slightly ironic, that non-profit arts organizations, whose sole legal requirement is to provide a public benefit, are getting outshone by for-profit companies wanting to embrace their corporate social responsibility.

The other thing you do when you tap into advocacy, which is essentially tapping into what is the hot topic of the moment,

is you increase the odds of your brand being elevated organically and you put yourself in a position to benefit from attention that doesn't cost you a dime. It's selfless in that you're getting people to talk about things that are bigger than themselves, but it's also self-serving for the boost you enjoy because of it.

An example of this dichotomy emerged in the Trump versus Clinton era years ago, when Trump was disparaging Mexico, pitching building a wall and general divisiveness to his followers. Not surprisingly in this climate, love for Mexico's national airline, Aeromexico, started to dive in the United States. In response, the airline's advertising agency, Ogilvy, launched its audacious "DNA Discounts" campaign, which rewarded travelers with Mexican lineage with price breaks on flights. The campaign went viral on the strength of a single tweet, and the brand reached and sustained peak levels of attention for over a year as a result.

As a society, we're constantly being asked to identify with one belief system or another. You're conservative, you're liberal; you root for this hockey team or that one. As social beings, we're quite keen to group ourselves according to shared traits, behaviors, and beliefs. It's because of this inclination that a brand—whether it's ice cream, clothing, or arts and culture—that sits passively back waiting for people to come to it will soon realize that's not going to happen. There's simply too much saturation in the market right now for resting on your laurels to cut it. You need to engage with your customer by articulating your value proposition so that your declaration of it may line you up with their values and what they believe in—and, ultimately, where they choose to spend their money and time.

Mind you, there are companies that have amazing marketing campaigns but don't do the work internally. These are the organizations that might be accused of "putting lipstick on a pig" (a phrase I despise and for years have tried to replace with "putting

icing on a cake that's not yet baked"). It's very deceptive, and it can be jarring.

But the opposite—when you have an organization that *is* doing the work, and it's meaningful, and the value proposition is there but that doesn't know how to talk about it effectively—is also a problem.

Here's how it should work: your value proposition should inform and influence your programming; your talk about that programming should reinforce your value proposition. If that's not happening where you are, if you aren't leaning into marketing as a way to engage with your audiences and the communities that surround you, if you're saying the right things on the inside but never inviting community into the conversation, you're risking operating a marketing department that exists only to service your programming—its job sidestepping the higher call to elevate the arts and reduced to merely selling tickets or a product.

## Ch-ch-ch-changes

The message for arts leaders is clear: *You should not lead with messaging.* Arts organizations need to talk about themselves in a new way but can only do that if they have, in fact, changed. So, *first*, you have to change who you are and, *next*, you have to let people know you're changing and invite them to engage with your transformed self.

In other words, this idea that *if you build it people will come* is simply not true. You could be an amazing arts organization with your heart and value proposition in the right place, and be buoyed by a really solid slate of programming to boot, but if you don't have a marketing and messaging means to cut through the noise and get people—fielding, by the way, so many options for

how to spend their time and disposable income—to come to *your* things, you could go out of business.

Generally speaking, says Tanya De Poli, founder of the nimble, disruptive, agile, and global creative agency Founders, people are not that receptive to change. How problematic that is, she says, is "tricky" and largely a function of how much brand construction an entity already has. "When Apple very slightly changes its logo, people are all over it. They're just going to hate on it." In early 2023, the city of New York learned that when it worked with De Poli and her Founders team to release what many viewers considered to be an updated version of its long-time unofficial emblem, Bronx-born graphic designer Milton Glaser's iconic "I Love NY" logo, as part of a post-pandemic campaign to inspire tourism, municipal optimism, and civic action. The campaign wordmark reads "We Love NYC," in a blocky sans-serif typeface that updates the typewriter font used in the 1977 design, gets collective with its personal pronoun, and singles out the city from the state. People hated it, De Poli says, and reacted like their beloved original had been slapped in the face.

This campaign, which wasn't meant to compete with Glaser's icon but to build on it, was a success nonetheless. The "We Love NYC" message, which was centered on community, inclusion, accessibility, and collective well-being, allowed for whatever negative attention that campaign was getting to expose the beautiful values on which it was built. Because that's the truth—people may hate change, but they'll always talk about it. And every second you have someone talking about you that you haven't paid for is free advertising.

Besides, De Poli says, consumers' distaste of change should not always deter us from change in the least. "Even though people hate change, they also adapt to it. Especially when you think about how many times people have been so reluctant to change brand logos. People adapt to them. Any time people are talking about

your brand is constructive toward your brand." Social media, she says, has given a new generation a whole new voice with which to criticize organizations' attempts at reinvention. "It's hard and it's scary to propose and promote change" because of these developments, she says. "But I'm still all for it—100 percent."

Still, intones De Poli, it's important to bear in mind that there are consequences to getting talked about. "In going viral, you need to relinquish control a little bit. You need to let the public take over—which is why you need to stand for something. Otherwise, you have no control over the version of you that's being scaled up by the public."

## Get social (media)

Speaking of the vital subject that is social media, the marketing sector regards it highly for generating eyeballs and impact. In its *Ultimate List of Marketing Statistics for 2022*, software developer HubSpot declares Facebook "the primary content distribution channel for marketers today" and says "marketers believe Facebook is the most popular social media platform across all age groups."

The report cites videos as the primary form of media organizations use within content strategy, and calls video marketing "a highly effective strategy when trying to appeal to and convert your target audience. With impressive video capabilities on smartphones today, it's also an affordable and easy tactic to implement, no matter your business type or resources. These statistics offer insight into how other companies are using the medium to reach, educate, and nurture their audience." Beyond that, 46 percent of marketers who leverage short-form videos consider them effective, 64 percent say a Facebook video has resulted in new clients in the last twelve months, 83 percent say video has helped them generate leads, 84 percent say they've been convinced to buy a product or

service on the strength of a video, and 93 percent of brands say they've got a new customer because of a video on social media.

What does that all mean? Simple: arts organizations that haven't embraced these trends might want to get acquainted with their video tools.

As for the "We Love NYC" campaign, De Poli isn't fussed by the negative backlash. In fact, she says, it's kind of the point. "When you have a sector like the arts that really needs to re-invent itself, it is worth doing something totally noticeable—just a huge, huge change, so that people talk about it. Some people are scared to go very disruptive. Some brands are like, *We're not going to go there.* But the more disruptive you go, the better the chances people will remember you."

In other words, she says, consumers' distaste for change not-withstanding, brands should always embrace the opportunity to reinvent themselves—so long as the effort doesn't detract from their equity, as it did for Twitter when it switched to X. Here is a brand that visited change on itself that was not the result of engagement but was centered on ego, and it wreaked havoc within the culture, the product, the consumers, and the business. That was the epitome of change, De Poli says—loud and big. And senseless. "The firing of the hundreds of people who had built Twitter created a negative aspect toward what [Elon Musk] was doing to the brand. There was a lot of love for Twitter as a brand, and it was very well positioned. Why destroy it? There was no real reason behind it. Twitter was not dying. Twitter was growing. Twitter was still an important brand. Twitter [morphing into] X was setting a nuclear bomb on a brand that still had years of potential, just a way of getting people to say, 'I don't want to be on this platform at all.'" And this mistake is costing them dearly: in 2023 alone, the social media company formerly known as Twitter lost as much as $75 million in advertising revenue as

brands such as Coca-Cola, Jeep, and Unilever paused or pulled their marketing campaigns.

To generate the opposite reaction—the good one—and encourage the public to commit to your brand, De Poli says the organization must ensure that the brand means something to its intended audience. "If my brand is about selling tickets to Broadway, I need to make sure that a person's mind immediately receives that." Part of that trick, she says, falls to other people promoting the message. Enter the influencer, a force that's bigger than ever on the all-powerful social media landscape. "You need to create that FOMO and that sense that that person you admire is doing something and [so you should, too]," she says. "We're living in the world of influencers." Whatever our opinions of influencers might be, positioning a fear of missing out strategy at the heart of our messaging campaigns makes one thing clear: consumers are socially motivated.

*The Ultimate List of Marketing Statistics for 2022* HubSpot report goes on to say that "social listening is the number one tactic used by marketers" and 66 percent of them say social listening has increased in value for their organization over the past twelve months. In point of fact, De Poli says, some 99 percent of what her agency does is driven by social listening—the monitoring of online conversations to identify and assess what is being said about any one company, individual, product, or brand on the internet. Within her team, there is a dedicated cohort of *listeners* charged with tuning into what people are talking about in the moment. The Women's World Cup finals. Beyoncé's concert in Miami. A new president in Argentina. "You have to see what the chatter is. Sometimes it's predictable; most of the time, it's not. In any event, you have to shift as needed. *You have to be listening.*"

The practice, as easy as it sounds, isn't easy at all. Just one of ten campaigns gets noticed, De Poli says, "and it's really hard to

hit that chord." Besides, she clarifies, listening is just one thing; understanding how to talk so people will hear you is another. "Once you have the story, the focus shifts to: how do you tell it? How do you cut through the noise?"

You do it, she answers herself, with exceptional storytelling—ideally that hits a mark with its audience. Many stories do not. How ironic that a sector that's based on storytelling sometimes can't figure out how to tell a story in a way that appeals to a targeted audience.

Enter Burger King and its highly unorthodox "moldy Whopper campaign."

Back in 2020, Burger King launched a global advertising campaign designed to communicate the company's commitment to dropping all artificial preservatives from its products, which featured a graphic video trained on a Whopper in all its time-lapsed glory, decomposing and turning furry over a period of thirty-four unpreserved days.

The creative sector thought the rotting Whopper campaign was God's gift to advertising, and it won all these awards and attracted all this praise for its original impudence. But, points out De Poli, it backfired with consumers because—surprise, surprise—no one liked the idea of looking at a decaying hamburger, let alone buying and eating one.

Like so many other brands, Burger King failed in this instance to communicate exactly what they stand for, to elevate storytelling above the call to anticipate how people will engage with their overture. The ad agencies, David, INGO, and Publicis, won all kinds of attention and kudos, but the viewing public, says De Poli, was flummoxed by this unappetizing lunch. "The campaign was brilliant," she says. "But getting the messaging correct and making a campaign that is (a) understandable and (b) memorable, is really hard to achieve. Listening is half the battle and knowing how to respond is the other half."

"I'd like to think this campaign was a lesson in *who was this for?*" De Poli admonishes. "Is it just about giving the ad agency an award, or is it to connect a company and a product with an audience and consumers? Even though it won these awards, my position is that it failed. Here's an example of [a campaign that] was well intentioned, that checked all these boxes—but at no point did they stop to consider: *Wait, what will the audience think watching a hamburger rot?*"

The key, De Poli believes, especially if an organization doesn't have a big budget, is to make sure it's dropping in to something that is relevant at a point in time that people are already thinking and talking about—and joining the conversation. Pulling this off, she says, calls for a certain amount of humility. "Having that awareness has very little do with your brand and everything to do with how you have your finger on the pulse of what people are talking about."

Like Philadelphia Cream Cheese, a much-loved American brand that had its ear to the ground when Apple released a bagel emoji. With a single tweet, Philadelphia Cream Cheese gave birth to an organic movement, an online petition urging Apple to modify its unadorned bagel emoji with the essential addition of cream cheese. Apple listened, and the public took notice. "Look at that," says De Poli. "Zero media spend. That's the impact it can have. That's why it's important that you pay attention to all these pulses—little moments of culture that last a day."

## Connection is key

De Poli is also a great fan of brands that use logos to attract the kind of attention that comes from building strong personal relationships with people. She calls a logo "the physical manifestation of a relationship," and says organizations need to make sure that

people can build deep visceral connections to their brand via their logo—so much so that when we see a celebrity or influencer engage with the brand it will stir a primal desire in us to engage and jump into action. She believes that if arts organizations, whose primary currency is hosting social experiences, could develop and activate brands with the same successful logo-based strategies, we could easily create that same fear of missing out. "That's the world we're living in—the world of influencers."

In the end, the "We Love NYC" platform created a communications storm in its corner of the world, attracting, says De Poli, probably 90 percent negative feedback in the first week. "I think the one key is that a message needs to hit any sort of chord, any sort of emotion, whether it makes a person laugh, cry, get angry, and so on. 'We Love NYC' made people angry, and that's OK. We want messages to connect with people. A lot of people just think 'emotion' is about making people cry. An ad can make me laugh, can make me cry, can make me furious, and I'll remember it for years to come. It simply needs to connect. Connection is the key. Storytelling is key to that connection. How you tell that story is how you're going to manage that connection. That's essential to any message-building."

Certainly, this strategy is a better employment of our time than curling up in a corner and playing the victim. But the post-pandemic arts world remains fond of talking about audiences not coming back fast enough, a woe-is-me campaign that buys us an alibi for having to try harder. But in July 2023, Calgary had just had its second-biggest Stampede in one hundred years, and Taylor Swift was selling out her concerts in minutes, even though they were a year away. People *are* coming back from the pandemic to spend their money on experiences—that's the hard truth. And if they're not choosing the offerings our arts organizations are extending to them, well, that's on us. That's a harder truth.

Running an arts organization has probably never been more challenging than it is today. What most arts leaders don't recognize, though, says De Poli, is that by loudly peddling a message that highlights our inadequacy to meet the moment, we are increasingly being perceived as a sector that doesn't understand what it stands for. Ironically, this cry for help has created a self-fulfilling and self-perpetuating prophecy that is spiralling toward discouraging people from attending our events. If we don't have a value proposition that is in tune with what's happening in the world, then whatever we do—our programs, our products—is going to be irrelevant, and our lament about people not returning after the shutdowns is simply going to be the last nail in the coffin.

It's not novel, by the way, this deflected defense about our state of affairs. Arts organizations were in the habit of blaming external forces for poor performance before anyone had even heard of COVID-19. It's a pattern of behavior we clearly can't break, and it's produced a tension between arts organizations saying *we need to be bailed out* and concrete proof that audiences are spending more money than they ever have. They're simply voting with their feet and wallets, perhaps disgruntled at last with a half-century-plus practice of arts organizations presuming to tell them what they should be consuming.

Whatever the reason, if arts organizations are laboring it's because they need to change themselves profoundly—and then talk about it abundantly. "If it's worth sharing," says De Poli, "you definitely need to share it. It's how you communicate that's key to your eventual recovery or success."

# CHAPTER SIX

# Education

Twenty years ago, when I was starting my career in arts education, I spent a heady afternoon daydreaming with Tomás Mayer-Wolf, a childhood friend of mine, in Argentina. He is one of the best artists, producers, and educators I've ever known, and we were deliberating the lofty idea of the two of us creating a performing arts center in Buenos Aires from scratch. We sketched out all these organizational charts for our imagined institution and, unsurprisingly, at the very top we had an artistic producer as the center's leader. Under that role we had directors of marketing, fundraising, and so on, until we landed on education. And I remember saying to my friend, just to mess with him, "What would happen to the DNA of the organization if we put the director of education in charge of everything? What would happen if the first commitment of the person overseeing the organization was to education, young people, families, while we still took care to endorse a strong commitment to the arts? What if the artistic commitment was in service of an educational mission?"

It was a provocative inquiry that led to hours of philosophical conversation for me and my old friend that afternoon all those years ago. And we landed, at last, on the conviction that this imagined institution would be the most accessible arts organization out there, and that we would have created a place that was in dialogue and in tune with its audiences. We concurred that whatever was

being put onstage would be the highest of quality, no question, but, more importantly, that the success of the artistry would be measured by how readily accessible it would be for audiences who didn't have a history of patronizing arts organizations and by how well it engaged these audiences.

We have yet to realize this imagined venture. Maybe we still will one of these days. But in the meantime, we need to see what we might do to improve upon what we already have.

The second biggest problem in the arts is that we focus more on artistic programming than we do on building community; and the biggest problem in the arts is that we separate these ideas at all. A programming team exists to program high-quality shows; an education department exists to build community through the arts. A thriving arts organization plays host to both of these commitments, which live side by side, one producing and pre-senting the highest-quality arts with a certain audience in mind, the other intentionally building community with that audience. For us to see these two commitments coming together fully, we must first define, distinguish, and respect the boundaries of each area—the education team should never tell the programmers what to program, and the programming team should never tell the education team how to work with young people. However, when these two parallel channels of operation are in harmony, neither one subordinate to the other, that's when they can begin to inspire and inform each other.

But before anyone's worrying about the trick to achieving this careful balance between arts and education, an arts organization needs to first ensure it even has a commitment to access in the first place. Too many don't, or have an undervalued sense of it, so they forfeit the meaningful improvements that a commitment to arts education might extend to young people, their teachers, and their families. In our collective defence, the advantages of arts education haven't always been understood, let alone leveraged

or incorporated into our larger mission and vision statements. One might argue that the defense of arts education is just as challenged as the defense for arts itself. A parent asking why their child should engage in arts education is posing no harder a question to answer than why a government should invest in the arts at all. Part of the challenge in advocating for arts and arts education arises from the historically low level of empirical evidence demonstrating its value. It's easy for school systems to test for literacy and numeracy because they are "required" or "core subject" areas and because of standardized tests that have been created to measure the progress of students. How can the arts in schools compete when they are rarely considered "essential subjects" and when their impact on a young person's life can't merely be measured via a standardized test? In a recent *New York Times* article, researchers found that students who had increased access to arts education saw improvements in emotional and cognitive empathy, school engagement, and higher education aspirations, while also having a lower incidence of disciplinary action. With more and more research on this topic, it's becoming increasingly confounding when schools and parents aren't quick to engage young people in theater, music, dance, drawing, and so many other creative outlets.

If education systems can't make sense of the arts, then it's no wonder the arts can't make sense of education: the perception of education departments within cultural institutions has long been as ancillary to their core mission, existing in many sad instances merely as an extension of their marketing efforts (a "butts-in-seats" strategy for new audiences), rather than a way to engage communities or, more importantly, to serve as an organizational mechanism for listening to, and learning from, them. For far too long, education departments and programs have lived on the periphery of arts organizations' core business model—as if they're

not at the beating heart of an institution's intersection with the wider community it serves.

Lincoln Center for the Performing Arts, considered by many to be the birthplace of teaching artistry, tells a fascinating—albeit forgotten—story of how and why arts education practices were so important in making a cultural institution accessible: in the early 1970s, Lincoln Center placed a great deal of importance on welcoming school groups to the many performances by the companies that called its campus home. Teachers quickly realized that, while impactful for students to visit this new iconic destination, performances by the New York City Ballet, Metropolitan Opera, New York Philharmonic, and others were often not fully understood (and, as a result, not fully enjoyed) by the young attendees. Lincoln Center leadership approached artists-in-training at the Juilliard School (also on the Lincoln Center campus) and offered to train and pay them in exchange for their going into schools to offer pre- and post-show workshops. The anticipated result was that young people were arriving to these performances with enough context and enough understanding to know what was happening. The unanticipated result of bringing artists into schools? Students realizing that learning can be different and fun. Whether it's giving kids access to falling in love with the arts or giving kids access to falling in love with education, it's clear that the combination of arts and education is powerful and has been historically underappreciated by policymakers and educational leaders alike.

But with an improved appreciation for arts education, we now understand (or should understand) that an organization's work with young people and their caregivers shouldn't simply be a one-way function of marketing cultural activities to a consumer set with their hands on their wallets, but a two-way exercise in civic dialogue with audiences that have been historically disengaged from the creative process. Through a commitment to education,

organizations can keep their fingers on the pulse of what communities are interested in and asking for, rather than behaving self-servingly by forcing audiences to accept and engage with content that is potentially not meaningful to them.

## If it's safe for kids, it's safe for all

Times Square is an internationally recognized landmark that has helped define New York City as the cultural capital of the world since spring 1904, when New York City mayor George B. McClellan signed a resolution that renamed Long Acre, the intersection of Broadway and Seventh Avenue, Times Square. The district has enjoyed a long association with the arts ever since, established by the relocation of many of New York City's theaters there from former entertainment districts farther downtown. By World War I, most of them had made the move to Times Square.

But its mid-century glory days notwithstanding, for a dark stretch just before the turn of the twenty-first century, Times Square fell into disrepair. Its reputation had slipped in stature, and the district was no longer associated with stellar cultural offerings but with things decidedly more sinister. In fact, Times Square had become a place to be avoided. In the 1970s, New York City suffered serious problems with delinquent street gangs who indiscriminately used violence to terrorize inner-city communities, including those of Times Square, and by the latter part of that decade, the Times Square area was recording the most felonies in the city. In 1981, *Rolling Stone* declared Times Square's definitive border avenue, West 42nd Street, the "sleaziest block in America," and one infamously colorful account of the neighborhood during this period declared the Great White Way "a byword for ostentatious flesh-peddling in an open-air meat rack."

In 1990, rising up from the anxious and thinning crowds, came a call for help revitalizing the area and returning it to its prior station. The assignment? To increase tourism—from New Yorkers, yes, but also from everyone else—to this one-time charmed patch of urban magic and to win back its original standing as a hub of artistic creation and community engagement. Enter The New 42nd Street, an independent non-profit called in, in a first-of-its-kind city-state initiative, to reimagine and renew 42nd Street. The organization was mostly focused on its eight historic theaters, built in the early 1900s as Broadway houses that evolved into purveyors of burlesque, then vaudeville, and then—in serious states of disrepair—porn movie theaters.

Later rebranded as New42, the organization was thoughtful in its reparations, weighing the various merits of such moves as closing the intersection to vehicular traffic, turning the area into a straight-up amusement park, entirely scrapping the old and starting again.

At last, the arbiters of the restoration project landed on a solution that acknowledged 42nd Street as an important NYC artery and historic site of theatrical performance whose legacy needed to be preserved. They chose to maintain and restore about half of the theaters there, and to shift the bulk of their focus to family-centric programming. The message New42 sought to project with its new realization of this historic site was one of diversion and security for families. After all, if parents and teachers felt comfortable bringing children there, went the memo, then it was surely safe for everyone.

New Victory Theater, New York City's first theater for children and families, is the jewel in this crown that is New42, a centerpiece of performance offerings for school-age children predicated on a philosophy that if Times Square was going to belong to young people, then there needed to be a theater that was accessible and affordable to young people, and reflective of their lives. Here, a

parent or teacher might score a two-dollar ticket to a destination designed for their child or student, where kids might not only run into friends or classmates in the lobby, but also see teenagers and young adults who looked like them working.

After the New Victory, one among New42's many real estate holdings, other theaters came on board in an outward and intentional commitment to young people, including the New Amsterdam Theatre, a ten-story beauty on the south side of 42nd Street, directly across the street from New Victory. In a nod to the newly family-centric bias of the area, the Disney Theatrical Group, the live production arm of the Walt Disney Company, assumed the theater's operation. Meanwhile, adjacent kid-friendly restaurants and retailers made themselves comfortable around the theaters, all of which agreed to abide by the mandate to build their entrances on 42nd Street (as opposed to the previously safer alternatives on 41st or 43rd Streets) and to select programming fare aimed at kids and families.

And with that, Times Square was reinvented as a scene that capitalized on a home truth about young people and the arts that my Argentine friend and I stumbled upon all those years ago: they need each other.

With many competing priorities vying for the future of such an internationally renowned and iconic destination as Times Square, it's refreshing to see a laser focus commitment on young people. "I'm very conscious of mission drift," says Russell Granet, president and CEO of New42, as he talks about the endless opportunities that come with charting a new course for Times Square's collection of historic theaters and the rest of the significant real estate in the area. "Anything we do is in support of the arts and access to the arts."

It's the access piece that's born in a crucible of arts education, and it's arguably New42's biggest mission of all. As opposed to those arts administrators who trot out a line about the importance

of education when it's convenient, Granet and his team regard the subject with consistent and enduring attention. Indeed, at New Victory Theater, education occupies as much of his days' efforts and hours as artistic programming does. It takes but a glance at his organizational chart, on which education shares top billing with artistic planning, to confirm his devotion to it. It's an approach other city-building leaders might similarly adopt and from which they might similarly be rewarded.

And those rewards are substantial, if occasionally existential. For one, by keeping arts education front and center, an arts organization regularly addresses hard questions about making art for the community and keeping growth and learning central to their operation. "One of the things education departments do for non-profits is they push the limits," Granet says. With arts organizations increasingly struggling with irrelevance, having an in-house team who can help us stay connected to community and hold us accountable to it is essential. "They are the ones saying, 'Why are we doing it this way? And is it for us or the community?' Education keeps us honest."

It also keeps us clever and sharp and fair and kind. Years of research show that learning about theater and music and visual arts and dance is closely linked to almost everything that we say we want for our children and demand from our schools: academic achievement, social and emotional development, civic engagement, greater social acceptance, reductions in other-regarding behavior, and equal opportunity for all members of society. A report published by UNESCO in 2023 declares that "arts education—including both learning of the arts and learning through the arts—improves the quality of educational systems and positively impacts student engagement, motivation, attendance, and perseverance."

"At the very least, participatory involvement with the many forms of art can enable us to see more in our experience," wrote

Maxine Greene, an American educational philosopher (and philosopher-in-residence at Lincoln Center for thirty years, prior to her death in 2014). "To hear more on normally unheard frequencies, to become conscious of what daily routines have obscured, what habit and convention have supressed."

More than that, the arts can be employed as a learning tool, every bit the equal of such conventionally pedagogic subjects as reading, geography, and math, for the impact they wield on human development. New findings in brain research and neurocognitive outcomes demonstrate that embedding the arts in educational offerings opens young people up to novel ways of approaching problems (like music's gift to understanding fractions, for one, or learning about a social issue by writing and performing a play about it, for another). It's findings like these that prompted Congress, in December 2015, to pass the Every Student Succeeds Act reauthorization with a provision that includes the arts in the definition of a "well-rounded education."

## Think like an artist

Organizations eager to lean into this kind of work would do well to remember that the number of students receiving arts education has shrunk significantly over the last few decades in a trend that experts pin primarily on the expansion of standardized-test-based accountability, a movement that's seen school boards respond by shifting their resources to a focus on tested subjects. As a result, students, especially those in historically undersupported communities, have been deprived of access and exposure to an essential aspect of humanity—and all the human gifts it entails.

People who've had access to arts education, says Granet, know the trick to navigating "successful failure" and are in possession of the critical skill of being able to "read a room." In a world

that is increasingly unempathetic, teaching young people (and, by extension, future adults) how to understand or be sensitive to the mood or feelings of people with whom you're engaging may very well be the greatest and most marketable skill we can instill in students. It's no different than learning how to dance with a partner, how to act in a scene, or how to play music with an ensemble. There's something about spending time in a conservatory setting, he says, that informs a person's appreciation for successful negotiation and persuasion. "I have watched people talking in a business setting and have said to myself, *Just stop, because you're simply not going to get what you want. You haven't read the room.* I think [mastering] that kind of thing is about theater training." Clearly, not everyone has had access to arts education.

Arts learning can improve a person's motivation, concentration, confidence, and predisposition for teamwork—all useful proficiencies for being a successful human and all traits that are in high demand by Fortune 500 companies looking to the future of employment.

It also extends a certain amount of reassurance to folks consumed by the conventional measure of grades on report cards, as involvement in the arts is also associated with gains in math, reading, cognitive ability, critical thinking, and verbal skills.

"I really have no interest in creating artists," Granet asserts. "If these kids want to go on to become actors and dancers and painters and musicians, that's great—but the programs I care deeply about aren't about that. For the critical mass, it's about giving young people the skills to just imagine a different life, a different way of thinking, a level of empathy for others. It is what makes a civilization civil. The education department is there in an arts institution to provide access to and be a translator for what these young people are seeing. And the work itself should live on its own. It's not about creating artists; it's about creating people *who think like artists.*"

For arts organizations to ensure the success of these programs, it is essential to engage a roster of professionals called "teaching artists," which live at the intersection of artistic and educational practices. Arts education expert Eric Booth offers my favorite definition of teaching artistry, which, he says, is constantly evolving: "a teaching artist is a practicing artist who develops complementary skills, curiosities, and habits of mind of an educator, who can effectively engage a wide range of participants in learning experiences in, through, and about the arts." Most arts executives don't have any expertise in education, something I would love to see change with an increase in C-level arts leaders having backgrounds in teaching artistry. Until then, and in the absence of this kind of experience within an institution's leadership, it's even more imperative that an arts organization partner with teachers and school boards—demonstrating an ownership of what it doesn't know and a commitment to improving upon it.

New Victory Theater offers professional development for teachers to make sure they have the skills to incorporate arts education effectively into their curriculum—and makes pre- and post-theater activities available, where families attend workshops, for example, and have conversations about the art they've experienced, including exploring prompts for parents to gauge their kids' experience with the programming and asking the kids about what kind of show they'd return to see on their own. "We're really trying to open a young person's mind up to having an opinion," Granet says.

Granet, who counts himself among the fortunate whose families took their most junior members to arts presentations from a young age, says he will not rest until he feels that "everyone who wants to go to the theater has access to the theater." It's why New42 operates a program in partnership with the New York City Housing Authority (NYCHA) that offers all of the New Victory's theatrical programming to families free of charge. Indeed, whatever the barriers to a young person's access to the arts—price

of ticket, access to transportation, a hot meal, etc.—Granet is dedicated to overcoming it. "We'll figure it out," he says, with all the conviction of someone who's deeply absorbed such lessons.

## Habit is what keeps us going

Once established, an individual's arts-going habit is powerful stuff. A two-phase study on the impact on children's attendance that was conducted in late summer 2018, starting with focus groups and ending with an online quantitative study, discovered a strong link between early exposure and subsequent patronage. Across multiple forms of entertainment, the study found that childhood exposure to arts presentations often leads to continued attendance as an adult. This effect is most pronounced for museumgoers, with four in five people who attended a museum in the twelve months prior to surveying reporting that they used to go to museums when they were children. Trends in live theater mirror this one, with two in three theatergoers reporting that they attended during their childhood as well. The most frequent current-day theater show attendees were also the most frequent show attendees as children. More than half of those who see six or more shows in a typical year attended regularly or "quite a lot" as kids.

Research, says Granet, reveals that three is the magic number in this pursuit. If you can get young people, between five and ten years old, into the theater three times, they'll be smitten. At a certain point, he says, you need to take the training wheels off and, if you've done your job, the people will return on their own—that is, if they'll feel like they belong there. "There's a big difference between feeling like you're welcome somewhere and feeling like you belong there," he points out.

For families living in NYCHA housing, New42 will pay for transportation, will get the audience members the tickets, will

show them a good time, but the truth of whether people feel like they belong will be proven by whether they come back to Times Square on their own. "It's very important for a young person to see themselves," says Granet, who feels himself that he's a product of that distinction. "My first two most impactful shows were *Oliver!* and *Annie.* I saw people my age onstage, and that hooked me for life."

Arts organizations that are focused on embracing their civic responsibility and play an important role in city-building should make education a cornerstone of their mission for two reasons—one from the perspective of the institution, one from the perspective of the student. For the former, education is how you create meaningful relationships with, and build intentional connections to, people who might not otherwise feel comfortable coming to your venues and engaging with your organization. If we truly believe, from the perspective of the organization, in equitable access to the arts, then we need a commitment that extends beyond the stage to embody our commitment to people. That's what education should do for a cultural institution.

And from the perspective of the young person, the move to feature education in an organization's mandate is truly transformative for the way it guides youth development and makes for more engaged and creative citizens.

According to a study by Stanford University and the Carnegie Foundation for the Advancement of Teaching, young people who participate in the arts, compared to their peers who do not: are four times more likely to be recognized for academic achievement, are three times more likely to be elected to class office, are four times more likely to participate in a math and science fair, are three times more likely to win an award for school attendance, will participate in youth groups nearly four times as frequently, will read for pleasure nearly twice as often, and will perform community service more than four times as often.

When you strip away the conversation around the mechanics of the supply and demand of arts education and other more executive matters, you uncover this amazing intersection where organizations are providing arts education programming for their own benefit, and their consumers are being touched by the experience in hundreds of different ways.

Given all that, I wonder why arts education is still such an afterthought.

## Where do you stand?

If I had to overgeneralize, arts organizations' regard of arts education currently falls into a few different categories. For one, they might view it as purely a revenue maker—like charging excessively for a summer camp, an approach that, while it could prove transformative and turn a young person onto arts and culture for the rest of their life, is nonetheless discredited in my mind for its profit-seeking motive and exclusionary tactics. When I realize an organization's primary reason for these programs is to generate earned revenue, I feel like I know all I need to know about them. The fact that you've created a pay-to-play structure for young people means it's not accessible or equitable—full stop. If that's your goal, fine. Own it. But know that you've not adopted this addition to your mission because you care about access, as you probably should. It's simply a cash cow.

Another perspective is embraced by people who flat out don't believe in arts education, who think that it's beneath the mission of an arts organization, a trivialization of artistic excellence, who would sooner see their organization shut its doors than work with young people. Don't get me wrong—no one's actually going to come out and crow from the rafters that they don't believe in it. We're not talking about tobacco or firearms here—this is the arts.

But their lack of faith in the subject is indisputably evident and it's insidious and even dangerous. I once had a boss who told me, "I don't like kids." While he thought that was a harmless position to adopt, it actually manifested institutionally.

Finally, and most frequently, there is the organization or leader that values arts education, but, when push comes to shove and they're hovering over a tough P&L statement or budgeting sheet, it'll be the first thing to go. This is a red flag to both the institution's understanding of arts education's value and its grasp of how to support it internally. These are the people who might see the virtue of these programs and even profess to believe in them, but who say, *I can't afford to run them because I know I'll lose money with them.* That's where there's a lack of understanding of how an institutional commitment to education—which is to say a commitment to access—works and how it taps into different kinds of financial support for an organization. If you connect these education programs to your organization's intention to become more accessible to the community as a potential solution to its declining relevance, and if you can truly embed this commitment into your mission and DNA, the irony will rear up before you because you will actually bump your contributed revenues with this position. Overlooking the impact of this kind of work on your philanthropic success is the kiss of death for any arts organization. It's to these folks that I always say, of folding an arts education initiative into their operation, "You can't afford *not to do this.*"

At Arts Commons, we are embracing a new commitment to arts education, and we cannot keep up with the demand: in 2022, we launched the most comprehensive longitudinal study of arts education Calgary had ever seen. In addition to learning from our growing work with young people and students, we surveyed parents, teachers, and artists to better understand how to overcome the gaps in providing arts education services. In response to our survey, we piloted Arts ReimaginED in May 2023, a new

week-long initiative that aligned with UNESCO's International Arts Education week. During this week, dozens of teaching artists provided close to 150 free arts education experiences across Calgary's four quadrants, ranging from puppetry workshops to Indigenous drumming to stage combat, totalling nearly 180 hours of hands-on learning to over 2,500 students and 400 families. The number of students on the waiting list who didn't get to participate was 25,000—ten times as many as those who did.

You might be asking yourself how we afforded to launch such an ambitious pilot program while still providing these opportunities 100 percent free of cost. Our commitment to providing arts education programs for free has fueled one of the biggest jumps in philanthropic activity Arts Commons has ever seen—and one that hasn't cannibalized on our other programmatic commitments.

But I digress. The vast majority of arts leaders are on the fence, needing to be convinced of the value of arts education programs. They might look to the New42 example as an illustration of what happens, not just to an institution, but to an entire city landmark when it's led by someone with a background in education and a commitment to access; when the arts are married to education from the get-go; when its participants' relationship to failure, resilience, and problem-solving derives from a transformational experience with a work of art. And New42 is not just *any* organization—this is an organization that has set the tone for one of the most recognizable destinations in the world. Times Square went from being undesirable and unsafe to being a truly welcoming space. This is what happens when you embrace a commitment to young people fully, rather than half-heartedly or for the wrong reasons. Or not at all.

As if his commitment wasn't already palpable, Russell Granet often interrogates school principals about what qualities they wish their graduating students to possess. They tell him they want their grads to be proud, to have opinions about the world, to give back,

to feel empowered to effect change. Then Granet asks them to show him where in their curriculum they currently cultivate these qualities. The principals, awash in a sea of mathematics and social studies, struggle to respond. "There's a huge disconnect between who we say we want graduating and what we're putting into place to make that happen," he says. "Don't get me wrong—95 percent of the people I talk to love the arts and think they're important. But [they] don't know how to make them work. They think they're superfluous, extra, for rich people, not necessarily for their kid." One of the dangers in depriving an entire generation of arts education experiences is that when they become school leaders (or leaders in any field), they don't know to fight for them. And we're seeing the results of this today.

Regardless of the reason people may not feel a sense of belonging to the arts, we must passionately, strategically, and intentionally push back against these assumptions of exclusivity. The arts are for everyone, and we're all luckier for it. We'd be luckier still if we could make plain the link between arts as an experience and arts education as a conduit. With leadership, innovation, meaningful partnerships, and a dogged insistence that the arts be central to the education young people receive, we can institute this new worldview in our arts organizations for the betterment of us all.

Arts organizations' job is not to construe their educational offerings as substitutes for those offered through schools, clarifies Granet, but to enhance them. "I have very clear views on what school districts and arts organizations should do," he says. "I don't think arts organizations should be replacing the dance, theater, music, and visual arts instruction that schools offer. That's not our job. If your schools are doing what they should be doing, teaching young people on the four major art forms, that's good. The arts institutions' job is simply to open up their world." In fact, to those who offer the false binary that schools should only have an arts teacher or an arts partnership, it is a well-known fact that schools

with arts staff are more than seven times more likely to seek out partnerships with cultural institutions.

The pandemic set Times Square back a bit, as it did with so many destinations around the world, but it didn't take long, under New42's thoughtful and intentional leadership, for the iconic landmark to return to pre-pandemic attendance numbers. Today, this cultural and geographic destination plays host to some fifty million souls of all ages every year, each of them feeling safe, entertained, and uniquely engaged by their visit. And each of them, too, improved by the way in which arts and a commitment to young people are so profoundly knit into the core of their experience.

# CHAPTER SEVEN

# Fundraising

I like to tell people that there are two types of philanthropy: the kind that begs and the kind that inspires. The latter has become a distant memory for many organizations, who, out of misguided strategy or dire necessity, adopt the go-to position of *Oh, woe is me*. I mean, sure, raising funds is not getting any easier, but it's been interesting to observe the crafting of a narrative that places the blame for our dwindling coffers entirely on systems and not on those of us engaging them. Many of us in arts organizations are very quick to talk about donor fatigue and to condemn this likely perpetrator for all our difficulties, enjoying how it releases us from culpability and plonks the responsibility for our generosity-attracting challenges squarely on someone else's shoulders. But if the donors are fatigued, it's worth pausing for some self-reflection about *why* they're fatigued—and the role we might be playing in fatiguing them.

Because here's the (surprising) truth: people are not, in fact, fatigued of giving. Indeed, a little research quickly reveals that philanthropy is actually up and that people are giving more than ever, hard times be damned. Total charitable giving in the United States grew 4 percent in 2021 over the year before with individuals, bequests, foundations, and corporations giving an estimated \$484.85 billion to U.S. charities in 2021. In 2022, that number increased to almost \$500 billion with causes like international affairs, religion, and health receiving at or above their past funding levels.

People aren't fatigued of giving, after all (especially when times are hard and the need is high). What they're actually fatigued of, it seems, is *us*.

That's the first lesson in fundraising for the arts. Any perception of philanthropic fatigue or opposition to giving is erroneous and our problems lie more with how our organizations are engaging with philanthropy and philanthropists.

The next lesson—it's us, but it's not *just* us—is less damning. The truth is you could swap out arts organizations for anyone in the non-profit field and discover that we're all feeling the same pinch right now. And so our challenge isn't unique. Everyone, it seems, whether a university or a hospital or a ballet company, is struggling to engage with donors these days, laboring to articulate a stronger value proposition (funny how all roads lead back to the all-important value proposition we talk about in Chapter One, isn't it?) and the power it has to connect with someone who might be generous in response. Making contact with that generosity is about aligning your values with the person behind it—and doing that *before* you ask them for any of it.

There is also a connection to be drawn between fundraising and another subject we've covered—the experience economy. It's not a stretch to imagine that people are more amenable to parting with their money if the beneficiary of their largesse is an experience with which they connect.

## The triad of giving

Right now, says Asha Curran, CEO of the global generosity movement GivingTuesday, "we're in a situation where giving went way up during the pandemic, but in 2022, there was a 10 percent drop in donor participation. It wasn't a drop in money but a 10 percent drop in donor participation, and that was just as alarming or even

more alarming for a bunch of different reasons." While a minor blip in the larger trend of the democratization of philanthropy, the thought of putting the fate of our non-profit organization in the hands of fewer donors who give more is alarming because, to run a healthy non-profit, an organization needs not only high-net-worth givers, but a broad and diverse base of supporters, giving and feeling involved. "The way we look at giving is giving is an act of civic participation; it's an act of kindness. All these good values are wrapped up in the act of giving. So the sector in the U.S. tends to wring its hands and look at these numbers and this declining donor participation, which had this blip over the pandemic but is a long-term trend now, and they wring their hands and say, 'Why aren't people more generous?'"

The answer, she says, might appear to be economic insecurity and income inequality, "but our data doesn't back any of that up." What GivingTuesday's data indicates is that people are in fact very generous, especially in hard times, with lower-income people proportionately giving more, and more often choosing to deploy their generosity in other ways beyond gifting non-profits with money. It's not because they don't like or don't trust non-profits, she clarifies. "It's that they're not being properly engaged or inspired by non-profits."

Which brings us to the Venn diagram of philanthropy and the lessons to be gleaned from its three identified circles of giving: money, time, and kindness. The overlap, says Curran, is enormous and worth paying attention to. Most people who give, it turns out, give in multiple ways. Studies of philanthropy generally only track monetary donations to registered charities. That's because it's easiest to document these gifts, which have to be reported to the government, while informal donations, like person-to-person giving and giving to unregistered organizations, more often involve non-monetary gifts, which are tricky to account for. "People are deploying their generosity in so many ways now," says Curran.

"We in the philanthropic sector have been so shortsighted in focusing simply on the money."

It's interesting to note of that Venn diagram, for example, that someone who gives of their kindness and time is more likely to give of their money. In fact, *only giving money* is the *least common* way people give, the smallest demographic within that triad. That, says Curran, means that, to get someone to commit financially, you need to align with their values and engage with them within the other two circles—those of time and kindness. And to align with their values, we must first be loud and intentional about articulating ours via our value proposition.

It's invigorating to consider these other acts of charity. Fifty years ago, the perception of philanthropy was that it was just for those folks who'd amassed such ridiculous wealth that it was assumed they'd have some to share. But giving now isn't constrained by such a narrow definition. You can give a dollar here, a dollar there; you can volunteer your time as a board member, advisor, or usher. You can volunteer your expertise with in-kind services and supports. So it's not just about money, but time and kindness. Of all the companies around the world currently leading GivingTuesday campaigns, some of the most joyful, optimistic, and broadly engaging ones are happening in countries that have pitifully few resources or are experiencing terrible crises of one sort or another. Noticing this reality, says Curran, has taught her much about "sheer hope."

It's why Curran, whose GivingTuesday movement raised more than $3 billion for charities worldwide on its tenth anniversary in 2022, feels bullish on the state of generosity and giving. Part of that optimism is connected to technology and the way it's facilitated giving like never before. Since people with less money tend to give more proportionately than people with more money, you have more people with fewer dollars wanting to do good—and with the technological mechanism to do so.

But Curran urges caution in attributing too much gratitude to technology's part in the process. "I think we have misjudged that role as being the driver rather than the vehicle." Today's digital tools are phenomenal at spreading the word, she acknowledges, but the reason most people give isn't because they can do it from their laptop and their couch, but because someone they trust in their network has talked about giving and has asked them to give.

Among GivingTuesday's most impressive success stories is the Michael J. Fox Foundation's "unselfies" campaign to raise funds for Parkinson's research. Here the foundation encourages followers to post "unselfish selfies" to showcase how they're contributing to Fox's campaign. In its first year, the Michael J. Fox Foundation was tagged in 107 unselfies; and while that may seem like a small number, those images generated 5,000 word-of-mouth endorsements and led to donations totaling nearly $400,000. The campaign was a hit, people have observed, for a couple of reasons. For one, the use of the #unselfie hashtag was already very high in November, and so the foundation was rewarded for participating in an existing trend to increase awareness for its own cause. For another, the campaign plays upon people's desire to be recognized for their contributions to good causes. This photo-posting call-out capitalizes on that human instinct. With this case study, fundraisers can learn the value of tapping into both an existing community that already participates in a nominated trend and people's inherent desire for recognition. As important, it's worth recognizing that going viral isn't always necessary to make an impact, as evidenced by the incredible ripple effect created by just 107 images.

Another GivingTuesday success story is the #BookBowl, enacted by the Enoch Pratt Free Library in Baltimore. Here organizers play into people's competitive streaks by inviting donations from fans of their home team Ravens. The library's friendly competition challenges a library from the city the Ravens are

playing with a proposition that a librarian from the losing city will conduct a playful performance in reply. This campaign—which raised a ton of cash—is a good one because it plays on people's taste for competition.

## Spread the word

"There's a tenet in every religious tradition that giving anonymously is the more noble way to give," Curran says. "But Maimonides didn't live in the time of social media. You do actually inspire more giving if you talk about giving. And I think one of the things GivingTuesday did was bring conversations about giving into the public square when they never existed there before."

Philanthropy is a very closely held value, she says, and conversations about it aren't as commonplace as they might be. Enter digital media and its ability to spread that conversation. Absent it, she says, people feel very polarized, divided from one another, almost like a civil conversation isn't allowed anymore. But technology only acts as a force multiplier for giving, she intones, not as the impetus. The online stuff is the connector, the spreader, the facilitator, where you find stuff, where you get inspired, and so on, but the action kicks in in the streets, within communities.

Around the world, COVID-19 was a great amplifier of injustices and inequalities, exposing social and economic needs and connecting people in unexpected ways around causes that invited and begged us to care for our neighbors. Arts operations that demurred in their asks in this period missed the point, Curran believes. Allowing yourself to become convinced that donors had limited resources and that they should be earmarking them for first responders and other more so-called *worthy* recipients in this time of calamity, she says, deprived arts organizations of essential, available funding. "Get out there and tell your story,"

she told artists during the pandemic. "You are not taking money from a food kitchen, we guarantee you. People are still giving to the food kitchens. But people need beauty and art and joy and music to have a full life."

She tells the story of a small jazz organization in Oakland, California, who had their concerts canceled at the height of the ordeal, but, rather than shrink back, they stepped forward and put on street shows for folks waiting outside in the snaking food-bank lineups. It's this kind of initiative, Curran says, that becomes a story—"and that's a story I'd give money to. I'd be like, *That organization is amazing. They've shown that they're innovative and creative and kind and that their mission is more important than the ticket sales. That organization gets our money.*"

Theirs is a story of aligning yourself with the need and the moment. Anything else for an arts organization, she says, and they do themselves a disservice, conceding in a time of global need that *they weren't important*. More than that, research indicates that people with money before the pandemic had lots more after, much of it sitting in donor-advised funds just waiting to be given away. Not asking for it is a mistake.

The shame, Curran believes, is in the scarcity mindset, in an unfounded idea that generosity is a finite pool and that we all need to rush at it as fast as we can and grab our pieces of it because at some point it's going to be empty. But we love our second children as much as our first because our reserves of love are infinite. Same with our reserves of generosity.

What's more, Curran says, generosity is a two-way transaction. "Giving actually has more of a payoff than receiving. It's like an explosion of positive hormones in the body. So I think there is this sense among non-profits that they're asking someone to do them a favor, rather than offering someone an opportunity. It's a blessing to be able to give to someone."

And for the cynics who believe that comforting reality can get lost in the ribbons of philanthropic red tape, Curran says she's never seen legislation or tax law listed among the top reasons people don't give. The human need to give trumps such workaday concerns. Absent this fundamental vehicle of care and connection, people can suffer massive unhappiness. Proof of this can be found in countries whose generations-long generosity traditions lift them above their high unemployment, low GDP, and general poverty. In the same way that lower-income individuals proportionately give more and more often, the same is true of countries. In 2022, the World Giving Index listed Indonesia as the country with the highest rates of donating and volunteering in the world (for a fifth year)—with more than eight in ten people donating money and more than six in ten volunteering time. This is compared to the U.S. and other western countries, she says, where "unfettered capitalism has sunk so deeply in our bones that we have a baseline acceptance of suffering."

## Diversifying revenue streams

A well-run arts organization should thrive courtesy of a *combination* of ticket sales and philanthropy, but the former can work against the latter in people's perceptions, even discouraging them from charity for the belief that the arts institution's earned revenue disqualifies their call for contributed revenue. But, as is the case with most non-profit arts organizations, the money people pay for tickets covers, on average, only 30 to 50 percent of the cost of running the business (with museums having the lowest percentage of expenses covered by earned revenues).

Artists and arts organizations need to piece together webs of support from a wide range of public, private, and earned revenue

sources in a balancing act that requires constant renewal and attention. In the early twentieth-century United States, individual donors were instrumental in founding symphonies, dance troupes, and theater companies, and arts organizations still heavily depend on their support. Direct government funding to the arts accounts for a small proportion of overall support in the U.S., and it can be unpredictable at both the state and national levels, whereas in many European countries, arts activities remain a government commitment (albeit less and less each day). European governments directly fund artists and organizations to advance a unified vision of a country's culture, but foundations and private philanthropy, as well as national lottery schemes, play an increasingly important role.

In Canada, we support the arts using a so-called "mixed" or "balanced" model, with non-profit arts organizations relying on a combination of public, private, and earned revenues. This model, which might prove aspirational to others around the world, falls between the primarily state-sponsored arts and culture of European countries and the free-market, privately supported model in the United States.

But regardless of their home base, most arts communities around the world have seen a disruption to the balance of how organizations are sustained, forcing an overdue reckoning of our business models. Much like organizations in every other sector, those in the arts are discovering the mounting expense and complication associated with presenting or producing artistic experiences. But unlike other sectors who may not be concerned with financial barriers to consumption or participation, ours is not quick to pass these burdens on to our audiences by way of significant increases to ticket prices. In fact, we all know that the cost of admission will probably never fully cover the cost of running our organization.

It's critical for non-profits to have healthy and effective fundraising strategies that empower them to not only maintain relationships with current donors but also build relationships with

new donors who can help drive their missions forward. Among the methods deemed effective for strengthening an organization's fund-raising efforts is conducting thorough prospect research. Prospect research, or donor prospecting, screening, or donor research, is a technique non-profit fundraisers, major gift officers, and development teams employ to identify high-impact donors within and beyond their current donor pool. Here non-profits gather massive amounts of data—information about donors' backgrounds, past giving histories, wealth indicators, philanthropic motivations, etc.—that they can leverage to strengthen their giving programs, solicit major gifts as part of capital campaign planning, or even kickstart new development initiatives. And while there is a huge disparity between the kind of data that is readily available from country to country (data is easily available for sale in the U.S., while very hard to come by in Canada), one thing is certain: arts organizations have a long way to go when it comes to building fundraising strategies that are based on rigorous prospect research.

Fortunately, everybody can be a philanthropist today, whether it's rounding up your bill at a cash register, contributing to a GoFundMe campaign, or signing on to be a monthly donor. Younger givers, armed with broad educational backgrounds, feel empowered to give to the causes that make them feel good and connected to a cause. The competitive nature of reaching them is considerable, and a fundraiser is just one piece of the puzzle. The quality of the product is vital for attracting funding but so is the leadership. If you don't have strong and inspiring leadership, you risk people never knowing about your cause. And it's not just the folks at the top that matter—it's the staff members and board members and employees of every stripe beneath them, a crew of would-be champions and ambassadors charged with maintaining a level of inspiration and communication consistent and remarkable enough to keep the funding flowing. At the end of the day, whether you subscribe to the kind that begs

or the kind that inspires, fundraising is a social experiment, one that depends on not only leveraging the right cause, but also on effectively communicating it.

I don't mean to imply that we are the only thing that's wrong with how philanthropy operates. A huge, problematic aspect of funding practices is donors' expectation that their short-term gift is merely an incentive for the operation to achieve self-sustainability on its back. They say, for example, *We're going to give you a gift for three years but then we expect you to have a plan for sustainability beyond that.*

*OK, but my plan is for you to keep giving.*

In her book *From Charity to Change*, Hilary M. Pearson shares, "The investor model for philanthropy doesn't capture the reality of how social change is made. Private investors place a bet that there will be a way to scale up and profit as a new product or service becomes widely adopted and successful, and they usually want an exit strategy." While there's always a need for social enterprises to become more efficient and make room for growth, there's no easy exit ramp for organizations who provide services to people at a subsidized rate.

Instead of expecting us to become less dependent on contributed revenues, funders should hold us accountable for diversifying our revenue streams. Indeed, that's what funders should want for their grantees, that they're robust and resilient and not overly dependent on any one base of support. And also that they're innovative. At Arts Commons, we constantly feel more like a tech start-up than we do a non-profit arts organization because we operate with an abundance of experimentation and a high tolerance of failure. We are constantly asking ourselves whether something works or if a program needs rethinking.

## Tell the story

I often look at others across the non-profit sector and wish I were a fundraiser in the health-care system or in a university, where they've seemingly kept up with this philosophy of impact-driven and cause-based philanthropy. But then I have to remind myself that health-care and academic fundraising is a world apart from ours. While hospitals can pull on literal heart strings, and universities have built-in alumni communities, it bears taking a closer look at how and where donors are choosing to support.

Universities clean up on GivingTuesday. At one point, the philanthropic organization had someone on staff who was there purely to cultivate colleges and universities, but they ended that position. "It was happening without us," Curran says, as she identified other organizations needing greater help telling their stories.

On the one hand, there's no question that hospitals and universities have incredible stories to tell in terms of their impact, and I'll admit that I've experienced some pangs of jealousy for the powerful, heart-tugging narratives at their fingertips. But on the other hand, there is another, very different story to these organizations that can actually work against them: does a university charging $100,000 a year for tuition with a billion-dollar endowment really need my donation as much as my local soup kitchen? The answer is very likely yes, but it highlights the importance of telling a story that can articulate values, impact, and need. More interesting still is that many people who give to universities and hospitals have had personal and meaningful experiences with these organizations, highlighting yet again the need for arts organizations to craft experiences that can compete.

So it's that balance of *What's the story of your impact?* and *What's the need?*

In the arts world, we've always been good at articulating our need—it seems we're always asking for money—but are we any

good at telling our stories? It's almost like ours is the reverse problem of the big institutions.

And as for what the arts world might learn from the health-care world in terms of attracting charitable donations, we might do well to remember the power of encouraging emotions associated with philanthropy.

In the best-case scenario, Curran says, people regard philanthropy as an exercise bound for democratization with distributed champions and ambassadors feeling like they can be a part of our organization's success. Digital platforms and crowdfunding apps are empowering people to lean into their generosity without having to go to some donor-advised fund or retain a financial advisor. "Gone are the days when the few and powerful wanted to see their names on a building. International research shows that more people are giving than ever before, but they are doing so in very different ways."

With this change, people are so committed to causes and their direct impact on others, she adds, that it's been proven that an organization should not place itself at the center of any philanthropic engagement. In fact, it's worth paying attention to the fact that asks with a single logo do worse than those with no logo. "There is actually a lack of trust when it comes to brands asking for money," she says. "And people aren't swayed the way they used to be by their parents' philanthropic loyalties. Today, they say, *I don't care who you are or what your brand is*. People are not loyal to brands anymore. They'll buy whatever shampoo creates the most engagement with them, whatever the brand. You need to engage me one on one and articulate your value and your impact."

GivingTuesday conducted a study that looked at hundreds of stories about giving and found that the use of a logo negatively swayed a donor's willingness to engage in the ask. They're more drawn to a coalition of organizations coming together, like a domestic violence campaign featuring a number of different

organizations. "The fact that they're linking arms, saying we're not competitors, we're all driving toward the same thing here—that speaks to people," Curran says. "That's just one of the many, many things non-profits could be doing better: putting their mission before their brand." Arts organizations would be wise to drop our egos and coalesce around a cause bigger than our own—a cause to which we connect via the articulation of our story.

It's in this realm that donors' true fatigue is uncovered. Donors are tired of us because our practices are not evolving at the same speed as their desire to give. They're tired of us because they care more about doing good than they care about our brand, which we are banging them over the head with. When you have directors of development or development teams who are used to asking in a certain way and, in spite of any shows of success, are still at it, well, they're living out the definition of insanity—repeatedly conducting the same failing exercise and expecting a different outcome. At what point do we say, *Hey, maybe we are the problem?* Because people are clearly giving— more than ever before. And if they're not giving to us, they're clearly just fatigued of the relationship they have with us. And that's our responsibility.

At Arts Commons, we never stopped articulating our value in a way that aligned with the needs of the moment. During the pandemic, we retained 93 percent of our workforce by pivoting to focus on such alternative preoccupations as outdoor pop-up concerts, digital offerings, and award-winning air-quality-handling systems. If we had gone dormant over those two silenced and confusing years and not engaged with a very active philanthropic community, we'd have had a pretty hard time coming out of the pandemic and trying to rebuild those relationships from scratch. Instead we were able to navigate this event and our civic responsibility inside it, and a newly imagined articulation of our value proposition revealed itself. Now we have three years of

philanthropic relationships that we can take on this revised ride with us, and our contributed revenues are at a record high.

For the arts organizations that didn't ask because they didn't have the bandwidth to do so or the wherewithal to know they should be doing so, who saw their job as making sure their orchestra performed in a concert hall in the traditional way, well, the pandemic gave them an out. They might have said: *I'm going to sit and wait for this to be over, wait for the world to get back to normal before I resume operations, and I'll pick up the baton again when it does.* But these people destroyed whatever momentum their organization had on its side in the meantime. And more devastating is they demonstrated that they don't view their work as larger than that closely defined vision. In truth, their job isn't to make sure the orchestra can perform in a concert hall but to make sure music is part of people's everyday life, regardless of the circumstances. Remember Calgary Public Library in Chapter One and its mission statement, "empowering community by connecting you to ideas and experiences, inspiration, and insight"? When we look back on the pandemic and see organizations that have thrived despite the chaos and devastation, we will recognize that they were the ones that were able to lean into a larger value proposition and leverage philanthropic dollars around it.

## The need for evolution

We've reduced the act of philanthropy to a single ask that's transactional, and the reason those asks are no longer winning is that we've forgotten that philanthropy is not, in fact, transactional. The activity of generosity has become far more nuanced, far more democratic, far more easy to engage in. In turn, we need to be building different kinds of relationships with different kinds of people. We need to embrace our value proposition, our impact

on society. We need to have a larger conversation about how the arts are necessary in the world.

In fact, during my tenure at Lincoln Center, I realized quickly that there were two approaches to fundraising: the one that asks first and tells stories later, and the one that starts by telling stories and doesn't even have to make the ask if the story does its job. At the time, the prevailing strategy was the first, more aggressive approach (one that made me so very uncomfortable). As I advance in my career, I am thrilled that the latter approach is shifting to the fore.

Yes, the legacy donors that have given millions will always be important to us, but how are we also cultivating relationships with younger patrons? People in these younger demographics and generations have a broader background of education and how they receive information than their parents, so gone are the days of just arts, education, and health care as beneficiaries for their largesse. It's essential for our organizations to remain relevant by how we communicate our impact and explain clearly why someone should support our causes. If anything, the fundraising landscape will not be getting any less competitive.

That delivers us back to the heart of the matter: how we are *inspiring* philanthropy as opposed to just *begging for* philanthropy. And if people want to do good in the world, and we can't align ourselves with their definition of good in the world, what are we even doing?

From a philanthropic perspective, it's critical to talk about our impact. Our value proposition cannot be self-serving; it needs to be outward facing. If it's a good enough value proposition, then people will want to help, whether with kindness, time, or money. So it's getting people to fall in love with what you're doing and what you stand for, and then it's saying *I want you to join me in this opportunity.* You're inviting them into a means to do good in a way that aligns with their ideas about doing good.

When I was working at Lincoln Center, the education department was one of the fastest-growing sources of contributed revenue in the organization's history. And the philanthropic dollars coming in there were not coming at the expense of any other part of the institution. Those were dollars coming in because, through our commitment to arts education, we were able to manifest a value proposition that was outward facing. It was about our impact on young people, families, and communities.

Let's talk about what's changed in the world of philanthropy. With the act of giving being democratized with new technologies and platforms like GivingTuesday, more people are being invited and empowered to give—and not just high-net-worth individuals, which means that, while there's a net gain in actual giving across the board, that money is being generated by a much larger number of philanthropists, and the number of asks to reach a goal will also increase accordingly. A $10 million gift that might have easily been achieved by a single family decades ago might today be exceeded but by engaging more families in smaller asks. With it being easier to give, more people are giving less to any one cause, and causes around the world have come to the forefront with better stories than ours.

That's what's changed on that side of the table. But, sadly, we in the arts have not changed with that. So many of our development teams continue to operate as if philanthropy is transactional, as if it is based on brand loyalty. (We assume that, because your grandparents gave to us, you will, too.) We have not built our relationships or evolved our stories. Libraries, faced with this dilemma, had their own decision to make. They could double down, be stubborn, or evolve. They chose to evolve. Arts organizations have the same choice, and right now we're behind. Philanthropy has evolved, but we've gotten stuck with how the practice worked thirty years ago. In redefining our value proposition, we have an opportunity to align with evolving trends in philanthropy.

Critically, as much as giving went up during the pandemic, donor participation—donors' authentic engagement in an organization's work and the dissemination of its mission amongst family and friends—declined by 10 percent in 2022. And monitoring a donor's engagement with us—their attendance, their active participation in our programs—is sometimes more important than monitoring their rate of giving. From the perspective of non-profits, that's alarming because, to run a healthy non-profit, an organization needs not only high-net-worth givers, but a broad and diverse base of supporters giving and feeling involved, recognizing their association as an act of civic participation and kindness. Declining donor participation, more than just a pandemic blip, is a long-term trend now. Not engaged or inspired by non-profits, people are choosing to deploy their generosity in other ways. We need to respond by looking inward at what we are not doing correctly and consider what actually works to inspire giving. If mutual aid, crowdfunding, and direct giving (people like to give to their neighbors) are experiencing a big spike, non-profit arts organizations might learn our lessons and replicate some of those best practices—but instead many of us are still using best practices that may have been applicable when our parents were giving.

Also popular in our parents' day? Asks that played the guilt card, perhaps TV commercials featuring a well-known singer parading sick animals in front of our eyes (with a very catchy song by said singer) in pursuit of our wallets. I once attended a theater company's black-tie fundraising gala in New York City, and when time came to support their education programs that proudly worked with at-risk youth, the organization's leaders chose to parade these students with baskets in their hands to collect chump change from wealthy Manhattanites. Such campaigns might work in the moment, but they can backfire, driving people away from having to endure the discomfort of bearing witness

to this misplaced method of fundraising. What's more, such an entry point into giving that is so lacking in joy, inspiration, and oxytocin could train the synapses in a person's brain to connect donations with self-reproach and shame. "You might see a big spike from that [sick animal] campaign, but you'll also see a whole lot of givers who aren't going to give again," says Curran. "So it was successful by one metric and not by another."

The bottom line is that arts organizations must figure out how to tell our stories in a way that will guarantee our place in people's brains and hearts where we're considered a necessity. Because we are, every bit as much as the soup kitchens and first responders. Every bit as much as the hospitals and universities. We provide so many benefits, so much pleasure, so much relief from the heaviness of daily life. If arts organizations can harness the storytelling skills that keep audiences coming back to us, then we can open donors' eyes to our indispensable nature.

# CHAPTER EIGHT

# Advocacy

C ommunity mobilization has been at the heart of so many
social movements in the past decade; and while arts organ-
izations are increasingly more open to responding to campaigns
like #MeToo and Black Lives Matter, it's surprising how little we
are willing to learn about what mobilizes community and how
undeserving we feel our own missions might be for similar action.

I hope this book awakens the arts sector to the need to tell a
different story, a story that innovatively catalyzes conversations
while also revisiting the inherent and historical social impact of
our work.

If I had to define what I mean by "community mobilization,"
I would say a process that brings together a wide array of stake-
holders—as many as possible—to raise people's awareness of
an issue and create a shared demand on how to address it. As
we've seen in recent years, a lot can be achieved when people
from different backgrounds come together with a shared goal
and actively participate in both identifying needs and being
part of the solution.

At the heart of this process, a process that must unapologet-
ically find commonalities between different communities and
stakeholder groups, is advocacy. Simply defined, advocacy is a
community-driven process that seeks to generate public support
of a particular cause or policy. It is far more prevalent in areas

such as affordable health care, criminal justice, immigration, and education—to name a few. And core to advocacy's success is a willingness to tell stories that place greater value on communication, collaboration, and compromise. The storytelling exercise that is advocacy is something we should be doing all the time. Advocacy is about telling the story and measuring the impact—whether we do that because we want to attract government funding or not. An organization that's good at advocacy is good at telling its story—to anyone. And for an organization that's not good at telling its story, securing government funding will only be one challenge. Advocacy is a muscle we need to develop for many reasons.

Advocacy is public support, whether that support is public dollars or public attention. For a sector that's been as elitist as ours has for so long, that's historically concentrated our service on the privileged few, we have a hard time aligning with the greater public good. Because of this, the exercise of advocating is a worthy one because it forces us to align to the public good and gain public support, whatever we may want from that public support—whether it be money, attention, or something else.

Fundraising, an exercise where the arts similarly go to bat with its story, can be distinguished from advocacy in a significant way: If I were pitching an individual, a family foundation, or a corporation on a fundraising ask, I would do research on what was important to each of them—that could be anything. Then I would build a sophisticated pitch that aligns with what I'd identified as being important to them individually.

But advocacy, when we're looking for public support, is about being able to zoom out and say, *Here's why we should be important to everybody*. Where fundraising is very dependent on who we're talking to, advocacy is being able to speak to the larger public good.

In a 2021 *Globe and Mail* article entitled "Eight Ways to Fix the Arts Industry, Postpandemic," journalist Marsha Lederman names "advocate for the arts" as one of the ways. I couldn't agree more.

Lederman quotes Ottawa musician Jim Bryson about his concerns for the arts' survival after such a traumatic upheaval as a worldwide pandemic. "When the scramble is over and governments are left with hefty bills, what will happen to arts funding?" he puzzles.

Advocacy is the only way out, he tells Lederman. And artists must be involved, as must each and every one of us who works in the arts world.

There's no question, when it comes to government spending, that every public dollar is scrutinized for the value it might bring to the taxpayer. Indeed given the seething multitude of demands on the public purse, whether the arts even qualify to put a hand in the bag emerges as just the concern Bryson has indicated.

But he and the rest of us must recognize that there is in fact much to recommend the arts' legitimacy in the civic landscape. The arts create jobs and produce tax revenue. They revitalize civic populations and attract tourists. They stimulate creative, critical thinking that will benefit students and the workforces they enter. They create a welcoming sense of space and a desirable quality of life for those in their midst. They preserve a city's culture and foster the physical, mental, and emotional well-being of its citizens.

Given all of this, a government's interest in and promotion of the arts seems sensible and well placed. But we're not always an easy sell, in part because we don't know how to tell our stories in ways that will resonate with others—yet again.

While there is a massive difference in how governments support the arts (all one has to do is compare the United States arts sector's seeming dependency on private dollars to the Canadians sector's seeming dependency on public dollars), the truth is that

we all need to find a new and healthier mix of revenues. In fact, no matter the country, the truth remains that non-profit arts organizations must find a balance of earned and contributed revenues to make the arts accessible. Many of our organizations are comfortable burdening our marketing teams with having to articulate a unique differentiating factor to our would-be patrons who are bombarded with endless amounts of competing options for their free time and disposable income. But when it comes to seeking out contributed revenues (whether private or public), many drop the ball in articulating their uniqueness with the same rigor and strategy as we do with our audiences. While marketing can tug at the decision-making strings of our patrons, advocacy can help tug at the decision-making strings of policymakers and funders.

Regardless of where any of us is located, the truth is that if we were to oversimplify the business of the arts, we might say we have two main stakeholder groups: private-sector stakeholders and public-sector stakeholders. As we've discussed in other chapters, our businesses must evolve by leaning into a more relevant future, in part, by strengthening our relationships with those private-sector stakeholders—the people who are going to vote with their wallets and feet.

But the other truth that is universal in the non-profit arts world is that the cost of buying a ticket will never (and probably should never) cover the full cost of running our business—otherwise, we risk our ticket prices, and our organizations, becoming a plaything for the 1 percent. In addition to constantly ensuring we're running an efficient business, we also need to find sophisticated, nuanced, and sustainable ways of subsidizing access to the transformative power of the arts.

## A case for public funding

As Naheed Nenshi reminded me in a recent conversation about advocacy, arts organizations' need for contributed revenues to complement earned revenues is still considerable, and we can tap into it by measuring and talking about our work's impact and value.

Nenshi, who served three terms as mayor of Calgary, between 2010 and 2021, and who was awarded the World Mayor prize in 2014 by the City Mayors Foundation (the first Canadian mayor to receive this honor), believes there are two roles for the government in the arts: to provide and direct public funding and to create and enable environments where people understand the importance of this effort by embedding arts and culture into a city's evolving narrative. He should know: he was also Canada's first tenured professor in the field of non-profit management and wrote his Harvard University master's thesis on Arts Commons.

Government and the arts need to be buds, in other words. Each needs to appreciate and acknowledge the value of the other. And arts organizations that fail to make a connection with the public and civic bodies whose constituency is the very audience they mean to cultivate miss a home truth about their operations' existence inside their municipalities.

"It's about how all of us might have the ability to create and experience art, and I think government can play an important role in reminding people about that," Nenshi says. "Through public art, through subsidizing things that increase access to art, and also by setting the tone. . . . As a politician you are a thought leader in the community, and helping people understand the importance of public investment in the arts is a big piece of that."

Critical to such contemplations is the question of what we are holding the arts community accountable to. In exchange for providing funds, how do we ensure funders aren't just supporting

our work but also helping us evolve and change our work? How can we be held accountable to running more efficient business models and becoming more sophisticated at measuring our impact? A funder can easily adopt a multipronged approach to giving: one that celebrates the work of an organization while also forcing it to become a better version of itself. We ask people to do endless program evaluations, which few evaluators read. We ask what the pay-per-performance model looks like and whether we're expanding our reach—but the answers aren't satisfying, and there's always more to be done. One main challenge with public funding within legacy organizations is that a vast majority of people who currently attend the arts would probably attend regardless of the public injection of funds. So the question shifts to one about the purpose of public funding. For Nenshi, this piece of the arts puzzle isn't complicated. "It's about city building," he says. "Even if you don't go to the ballet, you realize you want to live in a city that has a ballet."

Still, as emphatic as he is about this sentiment, he recognizes that it only goes so far, and that, at some point, you have to show that you are returning value—financial value, social value—within the community. Nenshi knows that it's how you measure something that's the trick. "We don't want to come in and bail out [the arts] all the time because that just leads to frustration and, at some point, the funder says, *We're not doing this anymore*," he says, adding that, in the non-profit sector, we often miss the incentives that cause "creative destruction," or people entering or exiting the market. It's an issue that's complicated in the arts because organizations don't disappear with the same rate with which they're created, and so you sometimes have to create artificial incentives for such things as exits, mergers, and acquisitions. And the folks in the best position to create these incentives are the funders. "In the private world, we'd never say Coke and Pepsi should merge. The competition is good," says Nenshi. "Figuring

out the balance is essential." And if you can't figure it out, then chances are you'd naturally go out of business. Non-profit organizations are really good at holding on tightly—and within that world, arts organizations are experts at never letting go.

The arts buoy a city for lots of reasons, he believes, and it's why he's convinced that, when politicians are looking to court companies to come set up in their towns, they need to bring the ballet dancers with them.

It's not just that the arts can attract people to our cities, he says. We're also a critical piece of the downtown strategy that government and arts leaders alike need to embrace: the arts keep people out at night. And that's a good thing, the nighttime economy. Delivering people downtown in the evening has two major benefits: it decreases crime and it gives other businesses, like restaurants situated near our venues, some much-needed traffic. Nenshi explains, "I hate to be that crass, and I wish it were more altruistic than that, but that's it. Everything you build in your city you build to optimize your capital, full stop. The arts—along with hotels—are seen, for better or worse, as a way to increase business in the downtown core where you've already built your stuff."

Attracting newcomers, and retaining those who are thinking about bailing, is always a goal for city builders who want to ensure that what they have to offer their citizens is desirable and liveable, Nenshi says—and the arts play a massive role in this gambit. Politicians necessarily operate from within their own ethos and beliefs and party lines, but the arts might be a space where people can meet in the middle. "Like with any lobbying, you've got to figure out what your entry points and common interests are."

A sense of entitlement is among the bigger misconceptions about the art world that people have to overcome, Nenshi believes: "You fund me now, you will always fund me—why should I have to defend myself? I am doing great work." More than that, he says, there's a skills gap and a call for society "to help train up

these folks, to learn some skills." And, he adds, "there needs to be a little more sophistication in figuring out how we do this stuff. Are there loss leaders? Does the Agatha Christie fund the difficult-to-sell stuff? Is that our role, to bring to the audiences the difficult-to-sell stuff?"

For those who would diminish the arts as justified in attracting political attention, particularly in the swirling melee of dangerous news about opioids and hate speech and climate emergencies that are also competing for public attention and dollars, Nenshi puts the subject in perspective. "I mean, look, it's not *that much money*. We doubled the funding to arts in Calgary, and that increase wasn't even $10 million. The police, for example, get half a billion a year. And the arts bring more people downtown and make it safer for people. Just as the city has to shovel the snow and mow the lawns, it needs to fund the arts. And that's not a [massive financial obligation]. If I were to zero out the arts budget, it would make no difference to anything else. Sorry to be that blunt."

## The sense of wonder

In *Building Up: Making Canada's Cities Magnets for Talent and Engines of Development*, Nenshi made a case for building neighborhoods and cities that people want to live in and introduced what he considers the three elements of liveable communities: density, diversity, and discovery.

Density is about having enough people living in a common space to create a critical mass. Diversity in every element—age, ability, ethnicity, income, etc.—is critical to making everyone feel welcome in your city and using this factor as a strength in your community. And a sense of discovery is about funding innovation all the time, whether that's through universities and research or through economic development, and "creating a sense of wonder

in the cities so that as you are wandering around inside them, living your everyday life, you're taken over by the element of possibility—*How can I live a better life?*"

But none of this matters, Nenshi says, if you can't afford to live, if your train breaks down on your way to work, if you can't get tickets to the game. A well-functioning city, he says, has to be frictionless. "You should be able to walk to the store, not need three or four cars in your household, be able to find the things you need in your neighborhood, not have to drive three hours every weekend if you're a parent whose kids play soccer. Or if you're a senior you should be able to live a different kind of empty nest life in a different part of the city. And so on. It all starts with having a well-functioning city, and that's enabled by density, diversity, and discovery."

And the arts community, he intones, should be aligning with each of these priorities. Seeing that through, he believes, requires arts organizations—particularly non-profits—to understand what their purpose is.

Here's a guy that understands city-building. When you think about all the transformations that cities are going through right now, hearing Nenshi say that, for arts organizations to be able to feel not like an afterthought but that they have a seat at the table in terms of redefining city-building, is huge.

And let's be clear: it's not one thing or the other—a city with high-quality arts *or* a city that's good at city-building. If we look at it through the lens of civic engagement, it's clear that we don't need to compromise to do good. In other words, if, in our role as a cultural center or arts organization, we can make that switch in our values, we can actually be a stronger arts organization that's in service to others. It's all about starting where we began this book: identifying and redefining our purpose and value to community. Our value proposition.

The first question Nenshi asks students in his "Non-Profit 101" class is: *If, last year at the drop-in center, I served 1,400 people*

*a night for the same amount of money as I served 1,500 people today, am I doing a worse or better job?* The answer, he says, is that *it all depends on what your mission is.* If your mission is to stop people from freezing on the streets in the winter, then you're doing a better job. If it's to reduce the number of unhoused citizens, you're doing worse, because there are clearly more unhoused people this year than last. "Understanding your goal is fundamental to whether you're achieving your purpose."

You've got to be efficient, Nenshi says, and to figure out how to stretch your dollar as far as you possibly can. "But a slavish devotion to efficiency can sometimes mean you're not achieving your vision because you're focusing too much on money."

And arts organizations keen to advocate for political support (of both the financial and temporal nature) need to employ some common sense. For one, we need to keep relationship-building top of mind, and Nenshi encourages leaders in this world to remember such basics as inviting local politicians to shows and then seating them next to influential and enthusiastic seatmates who will talk about the art they're witnessing and impress upon the politician how meaningful it is to the city. We also need to be acutely aware of the priorities that are being embraced by our politicians and elected officials during their tenures so that we can position the arts as a solution to their challenges. For example, as a province that is trying to diversify its economy to complement its strong energy sector, Alberta might find an investment in the arts attracting a wider array of newcomers whose definition of "quality of life" might include greater access to cultural offerings.

"Always be selling," Nenshi says. "Be strategic. This sort of thing makes a difference. Get your board members into this conversation. Give them an opportunity to get more involved in the advocacy piece."

And, he adds, make some noise at election time, particularly if you have candidates who haven't shown themselves to be that

keen on arts funding. After all, he reminds, inflation is a top-line issue, and governments are running out of money. Some of their cuts will invariably target the arts sector. "But if you've got relationships with civil servants, and you make sure that they're treated well, when they're making their recommendations to the politicians on their budgets, they can advocate for you."

## Inspire; don't beg

I like what Nenshi has to say about his "Non-Profit 101," because I feel like arts organizations are behind. We touched on this in our fundraising chapter, but it bears repeating here as well: we're not as good at articulating our value as, say, the health-care sector or if there's a humanitarian crisis in Ukraine. We normally don't see ourselves as non-profit causes of that magnitude, and so we kind of skulk around in the background, assuming people's generosity is finite and that it's been spent elsewhere. Even in the non-profit world, I feel like arts organizations haven't leveraged as much as we can. It's not just arts for arts' sake, it's *How do you make the city better? What are the narratives with which you can align yourself to tell a more fulsome story about our impact on the larger community?*

I think aligning our impact to this larger civic commitment is hard under the best of circumstances, but what I fear is that there are certain organizations that aren't even trying, certain organizations that are still out there saying the arts are important because the arts are important, which—while true—is just one self-serving piece of a much larger and complex puzzle. At a certain point, if we're going to advocate for increased attention and support, we need to look beyond our needs and articulate our value in terms of how we make people's lives better.

For example, a lot of arts organizations will go to the government and say, "We need more money."

"Well, what do you need more money for?"

The lazy answer is usually: "We need more money to continue doing what we've always done."

The more challenging answer is: "We need more money to have a greater impact on society."

But we need to be equipped to be able to say *how* we have a great impact on society, how we know that, how we measure that.

This changes the paradigm from the begging, *Give to us because otherwise we will cease to exist*, to the inspiring, *Join us in our growing passion to make the world a better place*.

Most arts organizations have some sort of public funding. Depending on where they are, public involvement in their institutions may look different—but *everyone* must develop their advocacy skills. Everyone needs to learn how to tell their story through the lens of how they make the world a better place.

And no matter the dollar amount they attract, public funds are about more than injected cash. In many ways, they are a gesture of confidence that you are doing right by the communities you're trying to serve. In some communities, the public piece may not be a large dollar amount, but it may allow the arts organizations to unlock other sources of funding. For one, it's a very powerful thing to be able to go back to government and say, *For every one dollar we get from you, we're able to generate two dollars from the private sector*.

Regardless of where you are, attracting public funds is a boost of confidence. After all, if you have government support, it means you're doing something right for your local community. For example, consider the National Endowment for the Arts (NEA) in the U.S. It's crazy to me, but the United States does not have a Ministry of Culture. There's no government agency at the federal level that funds arts and culture in the country. The overall budget for the NEA is embarrassingly low when you consider that it represents the totality of funding, at the federal level, for

the U.S. There's just not enough money in the U.S. for all the arts and culture there, which is why there is a perception that arts and culture in the United States is privatized.

So, no organization working in the U.S. is ever going to anticipate that the NEA, being the federal funding mechanism for the arts in the country, is going to fund the majority of their budget because they just don't have enough resources. But you'd better believe if you're a U.S.-based arts organization, and you get a grant from the NEA, that's a huge reason to celebrate, and it's a huge jumping-off point for leveraging other sources of funding.

"I think the role of public funders is going to change dramatically after the pandemic, and if it doesn't, shame on us," Calgary Arts Development chief executive Patti Pon told Marsha Lederman for her "Eight Ways to Fix the Arts Industry, Postpandemic" article. "We will be doing a disservice to the very sectors or communities that we were set up to serve."

## Why we matter

For us in the arts, defining our impact is something we're still new to, which may be why so many of my peers remain hesitant about measuring our strength through someone else's lens. But the same is not true for other types of non-profit business—particularly those in the education, health, and humanitarian sectors—many of which have grown and shifted to meet the evolving challenges they were designed to address. In the world of the arts, many are still offended when asked: *What's the impact of the arts on the economy? What's the impact of the arts on education? What's the impact of the arts on health care?* Arts leaders who are still stuck in a time where our commitment to artistry outweighed our commitment to communities say we have to stop defining

success through the impact the arts have in someone else's eyes. And I couldn't disagree more.

Indeed, that's the biggest criticism of advocacy—that it has us measuring the value of the arts according to their impact on someone else. But I don't align with this criticism because, in my heart of hearts, the arts always need to be in service; in my mind, the people that criticize advocacy are the people that don't place the arts in service to something greater.

When I was in the U.S., I spent several years as an advisor to Americans for the Arts, a non-profit whose primary focus is advancing the arts in the United States. One of its biggest gifts to the arts community was the development of an online Social Impact Explorer tool that identified the impact the arts have on a range of social systems, including such far-flung considerations as the military and housing. For example, of the impact the arts wields on "health and wellness," it says, "Health and well-being, both individually and for communities, is about being able to flourish and grow. In both arenas, the arts have played a strong role, leading to better care, cost savings, and an increased quality of life." And then continues with the provision of research and concrete data.

For "public welfare," it declares arts' value thus: "One of our number one concerns as Americans is our safety and the safety of our families and communities. The arts inspire community pride and mutual trust, provide alternative activities, and help make places healthier and safer."

Essentially a tool that allows arts organizations to articulate and measure their impact through the lens of social causes, this amazingly interactive tool has much to say about arts' values to the communities they share.

Honestly, and I think this may have something to do with why many in the arts are scared of advocacy, I think the extent of our impact might surprise many—and sadly, including many

currently working within our sector. One of the things this book exposes is that, historically, those of us in the arts aren't terrifically skilled at making a case for why we matter. That's in part because the arts can be ephemeral and in part because we've always been inward-facing. Lots of us are still inward-facing and in that way contributing to the problem.

"Over the past year, the arts have provided a ticket out of the pandemic doldrums via books, binge-watches, music to dance or cry to. The value of the arts has been on full display," Marsha Lederman writes in her how-to-fix-the-arts-after-the-pandemic column. "The economic benefits have also been in the spotlight."

And ironically, while most people have redefined their relationship with the arts during the pandemic, providing ample opportunities for non-profit arts organizations to leverage a new value proposition and new programming models, too many arts institutions are confused as to why pre-pandemic models for engagement are not working.

By not being open to the impact we can have on others, we've not paid enough attention to the personal balm and the economic boom of our sector. Reflecting on this, Lederman writes, "will be important when it comes to [the all-important task of] advocating for support. Organizations may need to take on a bigger role in activism."

# CHAPTER NINE

# People and Culture

Pretty much across the board, people struggle to define the amorphous, complicated, utterly necessary concept of organizational culture. They stumble around the idea, as confident that they understand it as they are incapable of articulating it. "It's the things that you see, feel, and experience in an organization, those physical and inherent experiences that people have when they're in contact with it," ventures Allison Allen, People, Diversity & Talent Officer and former vice president of global talent acquisition with Twitter. It's something, she says, "that lives and breathes, something *you can feel*. I know it sounds like a lofty answer, but that's what it is."

Lofty or no, defining an organization's culture through the experiences it provides its employees should be the first order of any organization's business, before it throws open its doors to the critical public—and no more so than an arts organization, for whom culture and experiences are in the blood. If we hang our shingle without knowing what we stand for, how are we taking care to match and build relationships with others—especially those whom we hope to drive in our direction? By failing to define and declare a culture, we risk our amorphous existence attracting customers and employees whose values simply don't align with our own—the ones we failed to define and declare. An arts organization can either live on this nebulous end of the spectrum, filled with good intentions but not any stated values,

and suffer chaos as a result, or it can spend some time being intentional about its culture.

One only has to go back a generation to remember when company culture was not a thing. No one had yet combined this particular pair of words and assigned it meaning as a central feature of a successful operation of any kind, least of all a free-wheeling arts operation. No one had yet imagined how critical it would be for corporate leaders everywhere—including those heading up arts organizations—to set and maintain a physical and psychic environment for their employees that kept everyone pointed in the same (meaningful) direction.

Indeed, to this day, precious few arts leaders fully appreciate the value of embracing this as essential or understand how many elements of their organization, including its bottom line, would benefit if they did. A healthy workplace culture is a cornerstone of every successful organization, but that's especially so for those engaged in the arts, where human connection is at the heart.

There's no question that the sheer profusion of distractions competing for a business leader's attention might account for this oversight. But I encourage you not to let it slip through the cracks. Company culture's kind of a big deal in our current understanding of what makes for a successful arts organization. That, of course, is because a company's culture is its people, and if the culture's strong, the people are; and if the people are strong, the organization is.

*People make the organization strong*

## Pinning down the ephemeral

The thing is, you have a culture if you're running a company, whether you know it or not, whether you can articulate it or not. Whether you like it or not. Think about it, talk about it, cultivate it. The determining factor is being intentional about it.

Becoming intentional about your culture means making it an area of focus, rather than simply something that happens to you passively. That means being mindful about conceiving your culture, writing down your vision for your culture, talking out loud about your culture, drawing attention when your people exemplify your culture. At Arts Commons, our values today are the following:

- Do the right thing: behave with integrity, applying professionalism, being honest, and erring on the side of grace.
- Be our best always: in service, in leadership, in professionalism, and in providing a quality experience.
- Be open in mind, heart, and arms: through empathy, openness, trust, and collaboration, seizing opportunities to impact our community in a positive way.

These values, while well-meaning, would be irrelevant if they were not intentionally integrated into our culture, where we can hold each other accountable to upholding them. They have embedded themselves into our recruitment strategies, our onboarding practices, our all-staff meeting agendas, and our performance reviews.

And having a thriving culture doesn't have to cost an organization a whack of money or transform them into a soft-shelled operation with yogurt tubes in the fridge and ball pits in the corporate rumpus room. It's not about those Silicon Valley giants like Google and Apple, where everyone's got a slide in their office and a Michelin-star chef working the cafeteria counter (although, how cool would that be?). It's about being authentic and compassionate and accountable and real. It's about ensuring that every soul in the building has a sense of purpose and belonging.

A sense of belonging is a massively important piece of life on this planet. As we explored in Chapter Three, the root of belonging

to an organization is its commitment to building parallels between worlds and celebrating those parts of our lives that connect us, that see us pulling in the same direction for the same objective. What business do we have committing to a sense of belonging for our patrons and audience members if we don't first exercise that muscle with our colleagues and peers?

The most robust arts organizations moving into the future will be the ones that are able to define and operationalize their values such that they become a magnet for what they believe. No different than what Apple and a bunch of other great, memorable, successful companies did in the early days. In the future, when it comes to building culture, a commitment to the company's product or output is going to be secondary only to the sense of belonging and purpose that come with being a part of a community whose values align with our own. It's becoming increasingly obvious, as remote working gives people endless options of where to work, that employees will put as much weight on a sense of purpose and belonging as they would on what product they're actually working on.

For companies without a defined culture, there are likely only transactional experiences on offer for those with whom they come into contact. People come in, clock in, clock out, go out. If I were to overgeneralize, these are the companies whose corporate headquarters are populated by folks who have opted to be there because their relationship to work is transactional: *I'll come in from nine to five, collect a paycheck, and head home*—never disparaging the occasional fortunate coexistence of a healthy culture, just perhaps not prioritizing it

For the most part, people go into the arts world because of a deep passion for the subject at its heart. While the topic of making a living wage as an arts worker is an important one, nobody (at least not that I know) goes into the arts to make money—regardless of how successful they may become. It's a

bold statement to make about an entire population of people, but those of us who found our way into this world have likely done it because of a deeply personal and moving experience we've had with the arts—an experience that makes it hard for us to embrace a purely transactional relationship with this world we love so much. And because we're incapable of prioritizing *transaction* over *passion*, we don't just come to work because we *have* to—we're here because we *want* to. (Or so goes the story, which can often be weaponized to underpay or overwork employees.) That's a distinction that speaks to an organization's culture and the power it has to motivate life choices.

Mind you, the pendulum can swing too far in this direction, indoctrinating an overly precious culture inside which no one can reasonably work, a culture so etched in stone that it becomes more important than the people, and its administrators run it like a dictatorship.

I use that word somewhat facetiously. But only somewhat. There are lots of arts organizations out there that are still negotiating founding artistic director syndrome, with cultures built around a single, pivotal individual. I would even say that everybody in the arts has, at some point in our careers, worked for a founder who *became the culture*.

An organization's philosophies and institutional values cannot live solely at the level of the CEO or anyone else who claims a bloated role in the business. They need to penetrate every fold and thread of an organization, from its C-suite to its most functional players. Those "l'état, c'est moi" CEOs are far from uncommon. But the organizational cultures that take shape in their jurisdictions are without democracy, burdened with power discrepancy, and completely unreceptive to schools of thought that stray from their own. Here, culture is a one-way street, not a joy-riding freeway we might speed along with the top down, ever open to the breezes of change. Oh, no. It's something quite different from that.

A culture must live within an entire institution and be open to ownership by everybody in a very personal way. Indeed the magic happens when a culture is presented to us such that, first, we identify and feel comfortable with it, and, next, we feel in a position to contribute to it, elevate it, make it stronger.

Because as much as an organization's culture is the hit outsiders get from spending time in its midst, more critical is the hit insiders get from allowing it to permeate their pores during their immersive exposure to it. Thus permeated, every member of a team becomes an ambassador for it, filled with their employer's character and compelled to represent it to others. Ideally, it's a positive permeation, but that's why the ambassadorial role is an important one. If you get culture right, you do yourself a tremendous favor, sending into the world a phalanx of organizational emissaries who are enthusiastic about what you've got going on. "I'm three companies away from Bloomberg, and I still talk about Bloomberg," Allen says, referencing her former employer whose culture's mark resonates still. "I think it's shocking when employees don't recognize their role in creating a desirable environment in which themselves and their peers spend time.

"Watching what happened at Twitter made me sick to my stomach. We don't know what's going on with people every day, what's going on in their lives, so for this little bit of time they're working, wouldn't it be good if we made life OK for them? No one has to be confused about the fact that you're there to make money, but you don't have to be toxic."

There's something about noticing that people's experiences go further than their paychecks and benefits to you. You need to treat employees as well going out as when you brought them in because if you exhibit human kindness to the experience when people leave, they might be upset, but there won't be venom when they talk about you. There won't be disdain or disgust.

## The sandbox

If the idea of thinking differently about your organization and its value proposition is starting to land with you, the next step is to acknowledge that these things are going to need to manifest throughout the organization, and that, if a change in course is to succeed, the entire ship has to turn, not just the bridge. Everyone in an organization needs to be on board with the new ethos—an enthusiasm for which needs to be stimulated early and often through broadly disseminated organizational mission statements that describe a cultural objective in appealing terms. This way, the CEO is relieved of the weight of *being the culture* and understands that culture is a shared responsibility with shared accountability—along with shared excitement for engaging in the collective, collaborative endeavor of developing a culture. And while it might seem daunting to nurture a sense of shared excitement in the workplace, isn't this what we do with audiences all year round? We provide cultural experiences that align with their values in such a way that gets them excited and engaged with what's happening onstage, and with each other. If we can curate and instill excitement in arts consumers, why can't we also be held accountable for curating and instilling excitement in arts-workers?

When reflecting on the arts sector, Allen and I talk about how employers place a serious focus on outward-facing standards to attract audiences, but when people get inside, they realize their organization, which does so much for others, does precious little for itself. It is not an unusual situation for an organization operating in our sector. Our focus in the arts, after all, is on providing experiences of joy, bringing people together, taking care of people—not so much on caring about ourselves. How curious. There's an apt phrase for this phenomenon that comes out of social work: *You cannot give what you do not have.* And you can only have it when you cultivate it.

It's a reasonable observation. I mean, you've got the for-profit sector, whose definition of success revolves around taking care of shareholders. You then have B Corps, for-profit companies that, in addition to focusing on profits, self-select to meet high standards of social and environmental performance, transparency, and legal accountability. Finally, you've got us in the non-profit sector, who are so focused on giving back and tending to others that we barely know how to take care of our own. But what business do we have giving people joy if we don't have it ourselves? And what business do we have caring for people when we don't care for ourselves? The irony of it is irresistible. Nothing short of a paradigm shift is required.

And, again, as with most paradigm shifts, we need to be resolute and absolute. We need our *new ways* to saturate every layer of our organization, and we need that saturation to begin at the interview table. We need to do nothing less than democratize culture, to spread its mood across the whole of an artistic operation, to let it infuse every layer. "An organization can't be successful if everyone's driving a different culture," says Allen. This tends to happen easily and frequently when you have an organization that is being unintentional about its workplace culture and instead overrelies on the well-meaning nature of its employees. How many of us have worked at companies where we really enjoy working with our colleagues but don't really love going into work every day? When left with a void of intention, an organization's culture is held hostage by the many different personalities that inhabit it.

"The beauty of culture is that it defines the sandbox in which you can play. The sandbox has these borders around it. Think of those as rules, policies, guidelines, leadership. You learn the rules and how decisions are made, what you have control over, what you don't have control over. But the sand in the middle is where you can play, do the work, have the experience. That's what culture is."

When people join a particular workforce, cultural alignment needs to be part of the process from day one. An organization's commitment to culture, which is the expression of its values, must manifest itself in its selection of who its leadership wants to work with, who it wants to train, who it wants to spend break-room confabs with. Because, ultimately, it's not so much what we do as an organization but *how* we do it that will allow the people behind the *doing* to get along. People don't need to be friends at work, but there needs to be a general understanding that we're there for the same reason and that *this* is how we're going to be working together. "My interviewing experience should not be a contrast to my hiring experience," Allen says. "When you think about the interview phase, everything about the organization should come through that experience, so you're not shocked."

## Whole selves

Cultures manifest because of our relationships with one another. I have been known to say to people, *I don't care how smart you are, if you are not able to communicate with others, none of your brain power matters*. It's why an individual's ability to connect with other colleagues should literally be part of the job description—in any company but especially in one devoted to the arts, where creating safe and brave spaces for the sharing of ideas is pretty much the overarching objective. You obviously need to check certain boxes and demonstrate expertise in certain proficiencies, but how well do you communicate with other people? Let's say you have a fabulous accountant who is challenging to be around. Not good. For some reason, we've gotten into this mindset where we think we can only hold people accountable to the skills of their job. But the expectation that they demonstrate all the interpersonal skills

should be as rigorous as the one around their call to demonstrate professional prowess.

When we hire people at Arts Commons, the paper stuff, their CV and cover letter, are a reflection of their expertise and those hard skills. But when we run an interview process, 90 percent of it is to gauge their people skills. We're not doing it in a sneaky way. We're being very intentional about it. Because if you're an amazing programmer that doesn't know how to work with others, well, then you're not going to be good at your job. Because your commitment to the culture must be just as important, if not more so, as your talent and skill. The same goes for anything else—stage management, fundraising, marketing, so on.

But it's more than just about how we hire. It's also about how we provide support and professional development to colleagues and employees once they're a part of the team. Given how much time we spend at work, we should want to bring our full selves—including our fragile mental health and bursting kit bags of human frailties—with us into our workplaces every day, so it makes sense to acknowledge and support the entirety of who we are. As a sector, we do it because professional conversations are increasingly homed in on wanting employees to bring *all of themselves* into their jobs, especially in the arts, where passion is the prevailing currency. But the irony kicks in when we then turn around and reveal that our true focus is on the hard skills and that we're actually more comfortable sidestepping uncomfortable mentions of the prickly bits of being human.

The disconnect is screaming here. How can organizations insist their people bring their whole selves into a culture that doesn't know how to talk about the whole self and only knows how to talk about number-crunching and scheduling and KPIs and attention to detail? If we're going to welcome whole selves into the workforce, we need to talk about hard skills *and* soft skills—and be able to support both.

Gen-Z workers, Allen believes, are demanding more and more care from employers. *If I need to work hard, you need to take care of me*—that's what they say. They're the ones doing the work and putting their wellness on the line, after all—and that includes every level of the organization.

The other thing I find interesting about setting, protecting, and nurturing a culture is that, oftentimes, and I've been guilty of this, people think a culture just needs to be comfortable, come as you are, nobody imposing their values on anyone else. Earlier in my career, I would've thought that a healthy culture was this—an autonomous, easygoing philosophy, one where you can come and be whoever you want to be and be embraced for it. But I eventually realized the reality is quite the opposite: an organization's culture cannot be unintentional, undefined.

There's a bonus to being extremely intentional about the culture you want to create, and that's that this intention also serves you well at the other end of the onboarding process, where you might find yourself having to *offboard* someone. That's surprising to some people, who tell me, *You have this culture that is both transparent and generous.* They point out that they seem counter to each other, a welcoming culture and some of the unpleasant but inevitable business that needs to happen inside it. I mean, *How do you create this welcoming space but also be rigorous about asking people to leave as necessary?*

One of my first jobs out of college was running an after-school drama program for teens from low-income communities that wanted to have a creative outlet in a peaceful and productive setting at the end of the school day. I remember in the first year I found myself having to make the difficult decision to ask a participant to leave the program. I was torn: on the one hand, it was kids like him that really needed this safe environment; but on the other hand, his behavior was really threatening the integrity of the group and making it unsafe for everyone else. While the

situation is different than hiring and firing employees, this taught me that I can be compassionate with somebody and want what's best for them but still prioritize the health of the collective culture.

People confuse kindness for weakness. I used to, as well. Today I know that a healthy and welcoming culture can and must be rigorously protected with an unwavering sense of kindness.

## Listening tour

Culture must be defined, articulated, and deeply connected to our organization's values. That's the other irony. All our non-profit arts organizations talk about mission statements, but most of these mission statements exclude the very people declaring them. As organizations, we tend to spend a lot of time focusing on our mission, vision, and values as they relate to external stakeholders, but very rarely do we use them as a lens to evaluate our own community and our impact on ourselves.

And with that comes the idea of mission statements evolving over time, a practice of which I'm a great fan. If we in arts organizations are going to evolve, and do so in accordance with the communities we serve, then we can't be so rigid in defining our own culture that we overlook that this is a living, breathing thing that, just like our organization, can and should evolve over time based on the community of people who are within it.

Look at the impact COVID-19 had on our comfort talking about mental health. Ten years ago, that was a subject organizations rarely talked about internally—if at all. Today, in the pandemic's wake, the most evolved cultures engage in conversations about mental health with open eyes and a full heart. A flexible culture constantly folds such social developments into its evolving reality, upon which its emissaries regularly reflect. Such plasticity can be tough, no question. I find that people, when faced with the

possibility that something has to be forever subject to change, opt not to do it at all. But it's a meaningful commitment to make nonetheless.

When I was interviewing for my role at Arts Commons, I discovered its special culture very quickly. After I had gone through months of conversations about skills and leadership style, the bulk of the interview was determining whether I aligned with Arts Commons' values and culture. I had to take leadership tests and personality tests, had to declare how I might respond to this or that situation. When I got the job, it literally felt like this honeymoon that I'm still on years later.

Since starting here, two things have happened that I find very interesting. The first, which is a fabulous thing, was it took me a very long time to find ground zero for this very beautiful culture into which I had just walked, to figure out that it was our Chief Operating Officer, Colleen Dickson, who was its beating heart. It was a fabulous thing, the challenge I experienced in solving this origin mystery, because it was a sign that the culture she'd championed was thoroughly infused throughout the organization, top to toe. She was not *the whole culture*, but she was an early proponent of its dissemination throughout Arts Commons.

But the other thing I discovered during my first-ninety-days listening tour was that the beautiful culture Arts Commons had set up for itself internally, for which I ultimately discovered Colleen was responsible, was not aligned with how others perceived us. I knew this because I was having conversations with people who worked at Arts Commons, who said, *I love working here, this is an amazing place to work*, and so on. And then I'd talk to members of the community, civic and business leaders, and others outside the organization, and they'd have a very different experience to talk to me about.

Most organizations, bubbling along with well-intentioned staffers devoted to presenting an attractive face to would-be

customers, might have the opposite problem. We knew we had an amazing culture, that people loved working with us. But we also knew that many of those on the other side of our doors had only a very transactional relationship with us. The exercise for us internally was to ask, *How do we change who we are to the outside world so it becomes an extension of who we are to each other?*

A year or so into my being here, I sat down with all our staff and we went through several exercises of updating our mission, vision, and value statements. And the way that I started the workshop was by explaining that many organizations define their mission statement as something aspirational. *Before we reach for that level of long-term planning*, I told them, *I want to define a mission statement that reflects who we already are to each other, that allows that energy to pour into the world.* In response—and I'll never forget this—one of my colleagues who rarely speaks up in a crowd, said to the group, teary-eyed, *Whatever mission statement we land on will be lucky to have us.* With this, she was elevating our culture and saying, *It's already magical, it's just a matter of figuring out a way to communicate that to others.*

As part of our puzzling this out, somebody commented on how access to Arts Commons, just like access to the arts, should be a basic human right. Had it not been for this comment, we wouldn't have gone down a rabbit hole of research to determine that, in fact, equitable access to arts and culture *is* a basic human right, as described in Article 27 of the UN Declaration of Human Rights (Everyone has the right to freely participate in the cultural life of the community, to share scientific advances and its benefits, and to get credit for their own work). Arts Commons had never known to lean into that idea, we had never owned it.

We own it now.

Now, if you go to our website today (note that it could change tomorrow as we continue to evolve) in search of our mission statement—"To be an inspirational force where artists, community,

and organizations celebrate cultural identities, experience the full breadth of human emotions, and ignite positive change"—you'll see that it's prefaced by a belief statement, "That equitable access to the arts is a human right." That's important because the belief statement is a stepping stone, as is our responsibility statement, "To redefine a bold and adventurous Calgary by championing and investing in creativity." It's important for people to see where our mission statement comes from, to know that it's the product of our attention to other culture fundamentals. And if the culture's going to be informed by our values, then we need to tell the world—inside and out—how we get from one to the other.

## People-centered approach to business

I think today's arts executives are trying too hard to live within systems created decades ago. We need to define our new purpose, because only then will we be able to build a new sandbox that is people-oriented and align our culture with that redefined purpose.

All organizations have a clear culture, says Allen, whether they know it or not. "You feel it and know what is important to them through the interview all the way to retirement. People fall in love with companies because of experiences they've had with them. With their culture." At its heart, culture is the force behind organizational development. Every year, organizations aim to get better at their products or services, she believes, but don't always focus as intently on getting better at developing their culture.

And once you've gone through the challenging and rewarding task of defining your culture, she says, next is putting the right systems in place to support that culture: leadership, ways of thinking, technology, benefits, access. "It's a process. That's why they say it takes about two to three years to turn a culture over." And finally, once you've articulated a culture and found ways to

nurture it, pay close attention to how people are interacting with it and making it their own.

Ignore that at your peril and know that's where many organizations fail—in not bringing people with them. It's an arrogance of companies wanting people to work with them without investing in them, without explaining where they're going and how they'll play a role in getting there. "That's where it falls down," Allen says, homing in on the critical oversight that still gets play in executive suites. "We fought for years to get a seat at the table, got one, then made it less about the people. But our sole business is people."

People are at the center of everything arts organizations do—in both the doing *of* and the doing *for*. The concept of "company culture," as misunderstood and muddy as it is, similarly has humanity at its heart. If an organization elevates its appreciation for the people who sustain it and the people it serves—by polishing its culture, this idea of articulated values and nominated priorities—it can only get better.

# CHAPTER TEN

# Leadership

E verybody, everywhere, has got a thing to say about leadership. Good thing, too. It's essential for every sector to identify excellence within its community, particularly when it's going through a transformative and challenging period. A sector in dire condition—like, say, the arts—may not deserve to be saved in its current form, so a new kind of leader is called for to shepherd the revised template. Paradigm shifts are fertile ground for conversations about leadership, and the subject is urgently elevated if the point of an effort is not merely to advance or reiterate an existing definition of leadership, but to reflect on and unlearn what has not been serving us well. And, post-pandemic, there's quite a bit that hasn't been helping our sector prosper.

Specific leadership traits have been identified among the population of individuals who stand at the helm of organizations. Robert Simons, a Baker Foundation professor and emeritus Charles M. Williams professor of business administration at Harvard Business School, has spent some time compiling them and he cites optimism and hope as primary among them. "Without exception," he writes of the leaders he's profiled in his pursuit of this subject—a list that includes Margaret Thatcher and Jackie Robinson—"all these people are opportunity seekers. They wake up every morning and see the glass as half-full, not half-empty."

When popular culture tells the story of leaders, we are generally led to visualize *Succession*-esque corner-officed chief executive officers, dark-suited heads of state, or turtlenecked entrepreneurs with busy thumbs and a public thirst for revolution. We don't usually think of, or look for, the quieter people who define success as being in service to others. And that's too bad. Leadership and service are essential for the necessarily regular re-evaluation of personal or institutional relevance. The arts have strayed from a commitment to service, so we who live inside them, understandably, have a skewed definition of what leadership should look and feel like. This, again, is too bad, because few sectors have our influential storytelling abilities—especially meaningful at a time when the world could use a reminder of what people are capable of when they come together and exude kindness and generosity.

While far from quiet, let's consider the influential storytelling of actress Reese Witherspoon, who was instrumental in the Time's Up movement and who created her own company, Hello Sunshine, as a way of promoting greater representation in Hollywood for people of color, the LGBTQ+ community, and women. Or actress America Ferrera, who's used her voice to speak out about politics through the creation of her non-profit, Harness. Or U2 frontman and activist Bono, and how he's used the annual World Economic Forum as a regular platform to fight extreme poverty and promote the ONE Campaign, which has helped secure more than $30 billion in funding. With their visions and influence, they have the potential to shift the Overton window, a concept Joseph P. Overton, an executive in a Michigan think tank, introduced in the 1990s to describe the range of policies considered acceptable at any given time. It is also known as the window of discourse. Still, to be clear, celebrity status is not a requisite for exercising influence or embodying these values—nor is the value of service a guarantee of financial success, as some schools of thought might lead us to believe.

As we think about leaders and where we might find them, it's also worth noting that the roles of arts organizations and arts administrators are still relatively modern concepts in the history of creating and consuming culture—as is the evolving "business" of the arts. In fact, while many artists and works of art are supported by the work of arts organizations, in many countries around the world, arts activities are brought to life by a different, often more decentralized leadership force: artists. In addition to leading the creation of their work, they are also having to become business leaders and producers responsible for liaising with stakeholders and funders directly, private or public. In countries like the United States, Canada, the U.K., and Australia, we see an evolution of arts organizations (or non-profit organizations in general) in which artists are dependent on institutions that are not extensions of governments, and which are instead led by business leaders within a public-private framework. One might argue that the need to compete in an increasingly saturated market, with an increasing dependency on private-sector philanthropy, has increased the need for an evolved model of arts organization, which in turn, calls for a new kind of arts organization leader—someone who can build bridges between artists, audiences, and the resources required to develop a sector that outlives any one individual.

But while the role for this intermediary broker is necessary (and, according to artists in some countries who have had to become cultural gestators, enviable), it has created a new power dynamic, and one that should have facilitated the flow of culture from creation to consumption. Instead, we have embraced the role of gatekeepers and become part of the problem. Still, there needs to be a disclaimer: while I believe leadership in North America's arts organizations is ripe for overhaul, I'm not prepared to write off the lot of current leaders. Indeed, there is an abundance of innovative arts leaders out there intent on dismantling the bad

stuff and ushering in the good—and there is much we need to learn from them.

## Scaling deep

Ayesha Williams is an arts professional who is the executive director of The Laundromat Project (The LP). This Brooklyn, NY-based arts organization is dedicated to advancing the relationships between artists and neighbors as change agents by investing in multiracial, multigenerational, and multidisciplinary arts programs committed to societal change.

The Laundromat Project originated in 1999, in the eponymous laundromat, the natural gathering place where neighbors clash and share news while doing a wash. Since The LP's incorporation in 2005, it has hosted presentations, gallery showings, yoga sessions, and film screenings, along with an abundance of rich arts conversations, all of them against the mechanical, slushy backdrop of industrial washing machines and dryers. After almost twenty years of literal reference, the physical site has today become more of a metaphor.

An organization that frequently places the creation of art in service to a larger, community-driven cause, The LP realizes that, while mighty, they cannot change the world on their own. "I often find it striking when organizations will do a lot of things, but it's very surface," says Williams. "But you can do this one thing really well if you just stay in that one lane, and allow the other folks to flourish in their lanes."

Trying to be and do everything is a problem, she believes, because it can wreak havoc on the distribution of resources within what should be a well-balanced ecosystem of non-profits and partners. Arts leaders might sooner view their growth vertically than laterally, Williams explains, and focus on deepening their

area of expertise and becoming a more meaningful contributor of change and overall partner to others. For its part, The LP, which supports the development of artists of color predominantly and communities of color exclusively, has grown exponentially since its inception, when its artist-development program extended $500 to artists so they might participate in a three-month residency; now it offers them $25,000 for a year-long residency that engages the community. "We didn't scale up," Williams says. "We scaled deeper."

Her distinction is significant for the way it rejects the default position that organizations take when they're growing or have grown—namely, that you need to do more things for more people. At The LP, Williams took that money and invested it into deeper grants with the same artists. Hers is an admirable commitment to clarity.

The clarity piece is important because it is only when you are clear about your value proposition and mission that you can go deeper and become better at them. Being committed to clarity allows you to know where your expertise begins and ends— essential to being able to say *no* to opportunities (a struggle for so many arts organizations who feel like we need to chase the money regardless of where it may lead us), and, more importantly, to being able to say *yes*. There's great humility in that, and in the regular conversations and reflective discussions The LP has with their affiliated artists about their current offerings, considering whether they're aligned with what the community needs.

When they moved in 2020 to their new location in Bedford–Stuyvesant, a neighborhood in northern Brooklyn, The LP conducted a listening tour that consisted of sitting down with one hundred members of the community to chat, get to know them, and better understand how the arts organization might support or facilitate the work they were doing. "One of the values that I hold very deeply is that we're a listening and learning operation,"

says Williams, identifying a critical piece of leadership and values-driven success. "We listen to what you need and learn how we can incorporate that into the function of what we do. It's always reflective and always responsive."

Williams considers herself in deep alignment with the organization, and, while she is excited about what the future holds, she also reflects constantly on legacy, organizational sustainability, and what the future of The LP might look like when someone else takes over the reins. She says she appreciates that the evolution of The LP is not informed by the agenda of its leaders, but rather by what local artists have built with members of the community. "We're just a container," she says.

The Laundromat Project, just like Calgary Public Library in Chapter One, is very much a people-driven organization, she says. "We just happen to be stewarding it and holding the container and making sure it's resourced and moving along. It's not ours; it's everyone's who has chosen to be part of it."

There's that humility again. And it's necessary, regardless of the size of the organization exercising it, because it invites everyone to consider ways to be fresh and truly responsive through the lens of their mission. Humility for a larger organization might be expressed with its redirection of resources to another organization that could really use them, for example. "That's humble, to me," Williams says. "That's saying, that's not something that we currently do—perhaps someone else could use this." One might argue that this ability to define ourselves around our strengths and partner with others around our weaknesses would create a far more efficient and collaborative arts sector.

In a performing arts center like Arts Commons, where our venues and spaces are activated by independent resident companies, community groups, and third-party renters, our success depends on our ability to work well with others to provide our city with an amazing array of cultural experiences. Even as one

of the largest arts centers in the country, the concepts of humility and partnership are essential.

## Moving society

There can be somewhat of a chicken-and-egg metaphor applied to the evolution of leadership: are organizations changing because their leaders are evolving, or are leaders changing because organizational needs are evolving? Regardless of how you might answer that riddle, it is indisputable that organizations and leaders trying to redefine institutional relevance are being held accountable for how they bring value to others. The best arts organizations today aren't just in the business of creating or presenting art, but of moving society—a bigger aspiration by far and one that places the arts in service of a greater purpose. Attention to civic tasks alongside the artistic ones is a characteristic of a strong leader, as is a value-centered worldview.

Purpose is a biggie in conversations about leadership. In his book *Deep Purpose: The Heart and Soul of High-Performance Companies*, Ranjay Gulati explores how some leaders embrace "deep purpose" as a generative force that can be a catalyst to both impressive economic results and positive social impact and demonstrates how purpose-driven business leaders find success by focusing on delivering not only for their shareholders and customers but also for their employees, communities, and the environment.

Gulati quotes prominent new-age author Deepak Chopra: "The purpose of any organization or business is to improve the quality of life, period. Focus on the quality of life for your employees because if your employees are happy, then your customers are going to be happy. If your customers are happy, then your investors are going to be happy. So start with your employees first, and then everything else will fall into place."

Too many leaders today ask: "What are we good at?" rather than "What are we good *for*?" That little shift embraces that all-important sense of humility. Too many organizations determine humility is an indicator of weakness.

Once again we return to my trick question: "What's more important, the intent of the artist or the perception of the audience?" When I posed this question to Williams, she introduced a third player to the consideration: the institution. Strong leaders understand that cultural experiences are only successful when we pay attention to the relationship between the artist and the audience, to the dialogue that our institutions must convene without ego. There's great purpose and intentionality in being the convenor, so long as the humility that allows for that space in which others can build and create together is present.

She reminded me that the job of our organizations is to protect and nurture the dialogue between the artist and the audience as opposed to feeling like we need to take sides: the arts leader as *facilitator*.

Such facilitation, Williams believes, calls for not just humility, but flexibility—in a leader's understanding of how to operate the organization, how to collaborate with staff, how to engage with community. "I think there's sometimes an air that we've created this big thing, so we know what we're doing, and there's inflexibility around thinking of alternative ways of doing things. I think a humbling of those points of view is critical in how we all grow and move." Indeed, the reason The Laundromat Project exists at all is that there was a call for it. If mainstream arts organizations had been doing their job, inquiring why certain people were not being engaged in the cultural activities of the city, there never would have been a need for The LP and the seemingly unsophisticated innovation it injected into the status quo. Here, innovation came from a place of service, and it was not just about *what* they did, but *why* they did it, *how* they did it.

Honestly, when you look at what The LP does and you see their work in action, you come away from it thinking, *This is so basic and simple. You're turning a laundromat—a place in which people naturally gather—into a place of cultural exchange.* That's not rocket science. But it's innovative because the sector had strayed so far from meeting people where they were at.

At a recent meeting at The LP, an artist generously offered to put together art supply kits for the community. The immediate response to the gesture, Williams points out, was asking whether the community *actually wanted* these kits. It's that requirement to stop and consider the community engaged with your initiatives that needs to rise to the top, she believes. Otherwise, without the role of an organization who can help grapple with the tension between the intent of the artist and the perception of the audience, she says, "artists might go into the community with this idea, and it becomes like God on a pedestal."

To be fair, the God-on-a-pedestal trope is not an unfamiliar one in arts administration, where people are too often taught to have the answer before they even know what the question is. Indeed, I think it's fair to say that a lot of arts leaders feel it's necessary to walk into jobs assuming they know what's best, that they can hit the ground knowing how to fix or change something. At no point are they invited to say, "Maybe I don't have the answer to this question just yet."

That's a problem, because, to be honest, if we are going to be values-driven and people-centric, we need to have greater respect for the questions and for how we build community around them, rather than feeling that any one person must have the answer. Listening becomes imperative in this process—whether it's leveraging our work in education to get to know what's important to young people or families in our community, or engaging in social media listening to have our fingers on the pulse of what matters to our audiences, or understanding the civic priorities

and aspirations of our politicians through our advocacy work, listening will allow us to manifest our work differently. I tell my senior leadership team that they need to be better at their jobs than I am. I'm not being facetious or passive-aggressive. I say to my chief operating officer, *You need to be better at running administrative systems than I am*; I say to my chief development officer, *You need to be better at fundraising than I am*. I do this not because I want to absolve myself of responsibility, but because I want to empower these other individuals and make plain my trust in them and my intention not to micromanage them. Just as Williams invites us to think about what *scaling deep* might look like in our work, so too must we ponder the benefits of letting people demonstrate the depths of their expertise. The way I see it, that's not being a bad leader, that's not simply pushing the responsibility onto anyone else. I'm not out to lunch while they're doing their jobs. I'm just seeing to it that I don't make decisions in a vacuum.

## Intent vs. impact

And as for the folks who set up shop in the vacuums, well, I know these people, I've worked with these people. We all have. They can be incredibly stubborn, and sometimes their stubbornness can lead to toxicity in the workplace.

One might assume—incorrectly—that the alternative to a conviction that you have all the answers is anarchy and a lack of structure. It's not—it's being curious. But the presumed endpoints of cockiness and chaos persist—and are equally unappealing. I wonder what it might look like to find a balanced middle ground, where there is great intentionality in being the convenor, where there is attention to how you facilitate the conversation, where your role as the leader is to be held accountable to creating that

space—or that container, as Williams was talking about—but not to feel entitled to the outcome of the conversation.

When I see the cocky, presumptive leaders, I think, *You're fighting over the wrong thing. This is not about you being the smartest person in the room, and you are not any less of a leader because you don't have all the answers. In fact, you are a more effective leader when you can bring people around a question and facilitate the collaborative process of arriving at an answer.* Look at all these business schools. Twenty years ago, the goal seemed to be to graduate people who would become the smartest people in the room. Today, these programs have evolved to be values-driven, people-centric, relationships-driven, community-driven, inquiry-based.

No doubt, creativity and curiosity are critical skills for leaders. It's why more and more universities are bringing the arts into MBA programs to promote a new paradigm for future business leaders, like the World Economic Forum, which collaborated with Columbia School of the Arts on a week-long creative course to benefit the forum's Global Leadership Fellows program. It's why designers of MBA programs have long dipped into the arts as teaching tools—for example, using performance classes to improve executives' communication skills—and some schools have made efforts to bring arts and business students together. In London's Imperial College Business School, for one, the Entrepreneurial Journey program matches MBA students with design students from the Royal College of Art to form start-up teams with skills in finance and product development. As we touched on in the chapter on education, we're not always looking for exposure to the arts to lead to the next generation of artists, but rather well-rounded individuals who can *think like artists*.

And so, the business community seems to have successfully pulled off this critical psychic shift. No longer consumed with candidates' alma maters or scores on standardized tests, business leaders now seek out contenders that culturally align with

the values of their organizations. Now more than ever, they're interested in: *Can you have a conversation, can you hold space with people, can you listen?*

Arts leaders need to similarly master the dismantling of out-dated priorities because, business or arts, one thing is clear: good leaders must be relationship driven, engaged with those people they seek to serve, and making room for conversations. "For me, it's all about that dialogue, opening that space for transparency," says Williams. "It's intent versus impact and the constant under-standing that the impact is the most important thing. If we're an organization that's in true service to our community, we're going to get things wrong, maybe often. But if [arts organization leaders] are not humble and reflective, then we're no longer following along in partnership with our community. Our humility lets us reflect on what we're doing: is it relevant? *Is it necessary?*"

These are the self-reflective questions of a genuine leader—and the time is right for all of us in the arts space to start asking them.

# CHAPTER ELEVEN

# Design

Just as we need to think about the internal DNA of our organizations differently, we also need to anticipate how doing so might manifest physically.

When I got to Arts Commons, I inherited a beautifully massive expansion and renovation project that had already been under exploration for more than a decade. The Arts Commons Transformation (ACT) project exceeds a half-billion dollars and is a once-in-a-generation opportunity to imagine the physical manifestation of an arts center that is undergoing an ideological reinvention.

Now, don't misunderstand me: you don't need hundreds of millions of dollars to enact a different way of thinking inside your arts organization. The ethos of an organization can be transformed regardless of its physical footprint, and, let's be honest, the future of arts institutions is a deeply philosophical contemplation, not an exercise in bricks and mortar. But when we build or renovate or change a physical space, the physical reality we imagine must align with our values. We have a responsibility to take that opportunity seriously.

Reimagining an arts organization is an evolving process—on every front. All organizations should have an unfiltered idea about who they are, and an even clearer vision of who they want to become. But we don't always know how to get from where we

are to where we want to go. In my case, I knew what questions to ask to disrupt the status quo of how arts spaces are designed and used, but I needed to surround myself with the right people to come up with a new kind of answer—and a new kind of vision.

The single largest cultural infrastructure project in Canadian history, ACT benefits from some of the brightest minds from around the world in theater design, accessibility, acoustics, and so many other trades. Between them, they are poking and prodding at dated assumptions and challenging us to think about our future in new ways—not just physically, but on a deeply philosophical level as well. The questions, thoughts, and provocations they bring up are worthy of exploration by everybody—regardless of organizational budget size or the scope of a capital campaign. This cast of experts is led and inspired by a design team that includes architects Marianne McKenna, a founding partner of KPMB Architects in Toronto; Jesse Hindle, a founding principal of Calgary's Hindle Architects; and Wanda Dalla Costa, a principal at Tawaw Architecture Collective and the first Indigenous woman to become an architect in Canada. Dalla Costa's thoughtful take on how we might build a physical manifestation of Arts Commons' commitment to reconciliation is very much informed by the broader strategy we have been creating with Elders Reg and Rose Crowshoe.

But when I first got to Calgary in 2020, the project was already ten years into the game—partly because of rigorous due diligence and partly because of inconsistent funding commitments—and, to some stakeholders, a tired endeavor. The board of directors, weary of its much-delayed realization, basically invited me to make new sense of what the future of our city's arts community might look like. At the time, it was clear to me that what everyone meant by "transformation" was our *physical* transformation alone. My response, as flippant as it was honest, was that anyone with the right amount of money could build a building. I said, *We need*

*to transform who we are and what we mean to Calgary, and then whatever we design needs to be the physical representation of who we've become.* The mission became to articulate the future of Arts Commons and Calgary in an architectural gesture that would inspire others around the world to think of, and experience, arts and culture differently, an architectural gesture that would be a holistic expression of an enlightened ideology, its physical and philosophical elements in perfect harmony.

As I've shared throughout these pages, I sadly believe that the arts have become a luxury good that's overconsumed by too few people. I would submit that their physical presence has long borne that up. After all, iconic cultural destinations might be beautiful—but they're also reflective of how arts organizations work, or worked, in the era in which our worst selves reigned, when the arts domicile was perceived as a luxurious palace meant for the privileged few.

These palaces have historically been popular enough to consistently attract crowds. But if we're going to be intentional in how we think about our future, we need to lift our attention from *Who's coming?* and ask another question: *Who's not coming—and why?*

## A call for intentionality

There's no greater visualization for me of the cyclical nature of audiences gathering than watching three generations of a family go to a production of *The Nutcracker* at Christmas. It's a beautiful tradition, no doubt, but it poses a question: how do we replicate that experience for others who might define and celebrate cultural identity differently? And, if given the incredible privilege, how do we work with architects to ensure that we are designing places and spaces that are meant for a wider variety of cultural activities? The answer, it should be noted, isn't always *design something that's*

*flexible*—because, as theater designers will tell you, the danger in designing something that is intended for everyone has the potential of not meaning anything to anyone; hence, the call to being intentional.

I'll give you a tiny example of something we're changing—philosophically and physically—here in Calgary. Ticket holders—here, and generally—have long gotten their tickets to events scanned when they walk into the building, a convention that imparts a clear message: unless you've purchased a ticket for this particular show, you're not welcome here.

At Arts Commons, we're contemplating something different—namely, not scanning tickets when someone crosses the threshold into our complex, but, rather, when they enter the inner hall of the theater to find their seat. That way, the once impenetrable fortress becomes a welcoming place—and quite possibly a culturally rich one, if we introduce cultural experiences within the building. It's no different from what's happening at airports, where the security threshold has been pushed and everyone's wondering how it would enhance their travel experience if their loved ones could hang out with them right up to the gate. At the core of this exercise is the design challenge of trying to figure out how we can provide cultural experiences for people whether or not they've purchased a ticket.

In the arts world, a lot of organizations are asking their lobbies to do double duty—containing and funneling bodies toward an exclusive cultural activity, but *also* engaging them, and others, in the process. Think lobby restaurants and free happy hour performances and so on. "Stop calling it the lobby," Dalla Costa challenges our design team often, reminding us that, from an Indigenous perspective, the term suggests it's an extension of the exclusivity of the artform, as opposed to an extension of the city into the building. She's invited us to call it "the lodge," a place where, in several Indigenous cultures, people come together to build relatives.

Focused on not only Indigenous aesthetics but Indigenous engagement, the Arts Commons Transformation project engages with Indigenous stakeholders in collaborative conversations about a design that invites in people of all walks of life and references Indigenous priorities without being overt about it. In other words, the building won't be a giant literal tipi, but it should hopefully be a beacon for what it means to be a community destination that is both open to everybody and mindful of the lands we are on and of certain communities that we know have been historically excluded. Such engagement means the project doesn't move as fast as it might have ten years ago, given the Indigenous emphasis on oral ways of doing business and the social aspect of acquiring knowledge. But the protracted negotiations are worth it for the gracious and evolved results they produce.

"Indigenous considerations have forced us to slow down and listen," Jesse Hindle acknowledges. "I think it's easy to fall back into processes or ways of working that are very familiar, and I think Wanda has forced us to stop and think about what we're doing and why."

## Precious adaptability

Another thing we're constantly talking about at Arts Commons is the concept of universal accessibility, which invites designers of spaces and experiences to think about how all individuals (even those whose mobility, communicative ability, or understanding is reduced) to access and enjoy a place freely and independently. For us, that means not having one route or experience for able-bodied people and another route or experience for people with disabilities. Instead of having a ramp to the left and a staircase to the right, why not have a beautiful ramp for everybody? We're designing for all of us, after all, and architecture has evolved to consider inclusion and

accessibility. These are conversations that arts organizations rarely had to have before, and few are offered the opportunity through expansion or renovation projects. Fifty years ago, the world was having very different conversations about being welcoming to all—or not having them, as it turns out. Today, we need to be less precious about the way things have always been and become more precious about being adaptable. One of the things we struggle with right now, especially as it relates to the modernization of existing structures, is that they're so inflexible, so static, and so damn precious about a past of which we should not be terribly proud from a civic standpoint. What we're working to achieve with the Arts Commons Transformation is a level of flexibility such that the architecture is less of an object and more part of the place. Adaptability hasn't been part of the conversation for a lot of arts-based organizations for a long time. Adaptability is also an environmental strategy. It reduces waste, allows for evolution. A building is a living organism if it's operated properly. I think that's one of the bigger aspects of this revised consideration. When people become too precious about the wrong things, those opportunities get lost.

A founding partner of KPMB Architects, Marianne McKenna has been honored as an officer of the Order of Canada for her contributions to creating "architecture that enriches the public experience." She was named one of Canada's Top 100 Most Powerful Women by the *Financial Post* and in 2019 one of the top thirty "outstanding women in architecture and design" by *Azure*. No stranger to arts and culture herself, she has led such achievements as the Royal Conservatory TELUS Centre for Performing Arts in Toronto, Orchestra Hall for the Minnesota Orchestra, and Banff Centre for Arts & Creativity.

"As you age," she says, "you get to what's the most relevant." Relevance for her these days can be uncovered in storytelling. She heralds from a tradition of functionalism and believes that "when you tell a story, it's self-referential."

I'm thrilled and humbled that the transformation of Arts Commons sits among her latest stories: together, we are reimagining an arts campus in the downtown core of Canada's third largest city, and we're telling this story through the lens of Indigenous legacy, climate change, and an underlying crisis of compassion in a precariously shared world. What makes this such an interesting story is that it is being told at a time when architecture is going through every bit the philosophical evolution the arts world is. It's a story about arts and culture and architecture—and a project that's deconstructing them, making them more accessible.

"It's about where we are, who we are, how we connect with each other, what rituals connect us, and how we share in Canadian culture with respect and appreciation," McKenna says. "Transformation cannot just be physical, but must be philosophical. We're not just putting up another roadhouse—we're really trying to connect with the people that live in Calgary and get their involvement. You can talk about the relationship between an organization's psychic presence and physical presence, what wisdom the organization can take from its history. You're asking for change. You have to consider: how ready is the organization to be transformed? How ready is the city to be transformed?"

Too often, McKenna says, designers get dragged down by short-term thinking and build venues that are too big to fill consistently or fail to invite the local population to participate in a vision for the institution. "In the arts, we should be looking for synergies," she says. "We should be looking for change and shifting out attitudes dramatically. We have to leave our colonial past, and leave behind the systems of domination that perpetuate misogyny and racism. We must make time to think about how we can do things differently. As Albert Einstein said, 'we cannot solve our problems with the thinking we used to create them.'"

## Paths of change

For his part, Jesse Hindle, a member of the Alberta Association of Architects and the Royal Architectural Institute of Canada, says he's seen many organizations grapple, philosophically and programmatically, with how to evolve, how to become more accessible—and that this has trickled its way into conversations about design. "So many of the civic- or arts-based institutions I've experienced are such stoic places," he says. "The architecture and design of these buildings, their programs, they don't seem to be for everybody. In my experience, the arts have always been something for the *haves*, and only those that can afford it can experience it." Arts Commons' original architecture was "very firm," he says. "It wasn't porous."

But the design team at Arts Commons, he believes, has upended that reality with a new design that extends a deep gesture of welcome to its patrons, "and that's what sets it apart. At the end of the day, it's trying to spark someone's curiosity. Now it's more about drawing someone in, putting an arm around them, and taking them with you, as opposed to saying *You're inside something that isn't about you.* I think people are understanding that the more diverse our communities get, the more intentionally welcoming the environment needs to be."

He agrees that architecture and the arts are on parallel paths of change, and references the tradition of people-centric design that's making its way into residential and office proposals. In people-centered design, designers focus on specific people's needs, taking the time to learn from particular populations, and create solutions when they live among their target groups, tap their insights, and find real issues to which they can respond with design solutions. Empathy and innovation lie at the core of human-centered architecture. As Dr. Prabhjot Singh, director of systems design

at the Earth Institute, puts it, "We spend a lot of time designing the bridge, but not enough time thinking about the people who are crossing it."

According to the Interaction Design Foundation, this approach to design has four principles: people centered, solve the right problem, everything is a system, small and simple interventions.

"People-centric design is about enriching the everyday experience. It's about the feeling you have in a place, how it's set up for those everyday collisions that are such a huge part of how we live our lives. It's about those everyday moments, not just the ones you have to seek out or work to experience. That's what we want to bring to our community." When I reread this quote, I realize it could just as easily be attributed to an arts leader who is equally committed to creating welcoming experiences that bring people together in new, innovative, and unexpected ways. We're not that dissimilar in our ambitions, those of us in the arts and architecture worlds.

This approach represents a dramatic departure from the traditional approach to designing—the Western-centric one, which tends to place undue praise on internationally acclaimed "starchitects" who may not fully understand the people they are designing for, since they rarely spend longer than several weeks with them in their location, and so their efforts fail to understand what people really need and what their environment provides for them to do. A move away from this approach can only be a good one and I would certainly say that, if the work of our design team is any indication, architecture is taking a turn for the better. With people-centric design, architecture, now more than ever, isn't about building icons. You look at international arts destinations around the world—the Met Museum, Royal Albert Hall, and so on—and they're icons. They were built as

icons, and they've been trying to make sense of that legacy ever since, instead of being bestowed that honor by the people they were meant to serve. At Arts Commons, we didn't select a team interested in making something for the sake of making it an icon. Our architects are eager to get a deeper understanding of our organization, the city, and its people—and how all these can be wrapped in architecture in a way that makes people feel safe, welcome, and inspired.

"My feeling is that many aspects of design are as much about consumption as experience," Jesse Hindle says. "When I visit new places, I rarely go where most people want to go. I'd rather walk the streets, sit at the cafés, visit the galleries. I think the culture of a place rises up from the everyday experiences and the arts come with that. Icons interrupt that process and put a level of importance on things that often feel foreign. It's not just about the consumer aspect of these so-called icons. It's about instilling or embedding these institutions with significance, building places of long meaning."

The bottom line is this: we're not designing buildings because we want people to come to see the building; we want people to come because of the energy, the community, the welcome. Architecture today is about drawing people together, creating conversations and experiences. "I would hope that the buildings we design in some way play a role in that everyday experience," Hindle says. "That makes for a better city."

As a result of Hindle being more focused on people and community, his work as a designer and architect now sees him being more open with the voices in the room and allowing more people into the conversation. "That's how we operate as an architecture studio. We have a big group of people with a broad range of experiences and demographics. We're a melting pot of experiences. It makes for a more well-rounded conversation."

## Meaningful contributions

To me, the idea of becoming a people-centric business seems crazy to say out loud. We're an arts organization—of course we should be people-centric. But we've spent the last several decades limiting our focus to a particular segment of the population. So here is our turnaround, I suppose.

It's a major paradigm shift, no question, says Hindle, who spent summers with a father who believed deeply in Indigenous traditions and ways of life, looking for arrowheads and listening to stories about elders his father had met. "But I never really appreciated it until we got into this process and started to think about how your work can influence the experience of people who have not been invited into this space previously.

"It's about making places for where you are. It's about architecture that listens—not just to the users but to the environment, to the landscape—and that situates places in a way that makes sense. It's not about dropping the icons. It's about meaningful contributions to communities by people who understand them because they are a part of them. The work we're doing now and the decisions we're making are not just for today. We're doing work that we see as meaningful for future generations. Place-based design is about how you project forward. The things we leave behind are going to be inspiring and enriching for the people who come after us. When my kids go to these places, when my grandchildren do, I want them to be inspired."

Wanda Dalla Costa is also interested in the people who come after us. In fact, many Indigenous communities embrace the philosophy that decisions made today should result in a sustainable world seven generations into the future. She writes a lot about cultural sustainability theory and architecture, and identifies some of the power dynamics at work in her discipline: "I just have to accept what I can push now and accept what I can't," she

says. She's grateful and excited about Arts Commons' adoption of the lodge concept and designs that incorporate Indigenous porcupine quillwork—a beautiful and sacred form of artistry in which dyed porcupine quills are often wrapped, woven, or sewn together to decorate such items as buckskin clothing, medicine bundles, drums, tipi covers, and moccasins.

"We can't look at design in a vacuum. An architectural project is not an aesthetic exercise," Dalla Costa clarifies. "It's a huge undertaking and we should be thinking about it, as architects, in measured and calculated ways, in terms of environmental psychology, which is about measuring how our environment affects us."

To that end, she says, architecture has to be a decentered act. It's an idea that flies in the face of the one that celebrates the single superstar or visionary. More than that, she says, there's a lot of opportunity for intergenerational inclusion at Arts Commons, though she acknowledges the tension between wanting to mean more things to more people and being intentional.

That an arts organization's philosophy and physicality are connected seems obvious. Indeed, physicality needs to be an extension of philosophy. McKenna talks about architecture in terms of the opportunity it affords us "to step across a threshold that's both metaphysical and physical." But there are too many organizations that start with physicality and don't pay any attention to meta-physicality or philosophy.

Up until I got here, the Arts Commons Transformation project might have been a victim of this. The imagined transformation was really about a building. It took the pandemic for everyone to realize the transformation had to be deeply philosophical, eminently internal. I think the worst thing that could happen is we make a building that represents an architect's vision of the future of the arts—a vision that's been imposed on a city or on an arts community but that doesn't reflect the change we've gone through. We might have a shiny new edifice at the end of it, but

when you pulled back the curtain, you'd see an organization that was still operating as it had been forty years before. "We get excited about small wins," Dalla Costa says. "One of the biggest gaps in an architect's portfolio is seeing the impact of their designs. We're taught what is the flavor of the day, but these environments should be thought of as sacred."

# AFTERWORD

As I've stated throughout these pages, and as you've probably realized by now, this book is not about the impacts of COVID-19 on the non-profit arts world, but rather (and more importantly) it is a reflection on our sector's past inability to navigate crises and lead meaningful change. Indeed, in the year it took to write this book between 2022 and 2023, a year in which pandemic-related restrictions all but disappeared, the inability of our organizations to adapt to a new reality wreaked a new kind of havoc on institutions around the world—one that, while triggered by recent global events, can no longer be blamed on COVID-19, and that will have a long-lasting effect on those of us who work and depend on this sector.

Still, I remain hopeful that lessons have been learned and that the arts sector can move forward and face future calamities with a comprehensive handle on what's important in sustaining a successful operation—namely, the value of creating cultural experiences that celebrate our shared humanity. The *shared* piece of that humanity is critical, for it insists upon a connection with all those involved in the creation, dissemination, and consumption of the arts. The artistic process cannot be separate from the experience of engaging audiences, and arts organizations must be in lockstep with the artists they support and the audiences they serve, or they will suffer both during the term of a crisis and in its aftermath.

Case in point is the fervent resumption of social and experiential activities I witnessed over the course of writing this book—at least for some elements of society. Air travel came back with a vengeance with airlines charging an arm and a leg for tickets we were all too happy to pay—more people boarded international flights in 2022 than in 2015. I noticed childhood friends of mine from Argentina travel to Qatar in November 2022 to join 3.4 million other attendees for the FIFA World Cup (which ranked as the third-highest attended FIFA World Cup in history). The 2023 Calgary Stampede, touted as the "Greatest Outdoor Show on Earth," recorded its second-highest attendance in one hundred years, welcoming an average daily attendance of 125,050 eager and money-spending patrons. And, as luck would also have it, I'm writing these words immediately after seeing my brother perform onstage with the Jonas Brothers on their "Five Albums. One Night" tour—where I was surrounded by more than 20,000 rabid fans at the sold-out Rogers Place arena in Edmonton.

After two years of pent-up demand for social experiences, you would think that non-profit arts organizations would be thriving, leading the kind of evolution and revolution that result from two years of deep social and communal reflecting on the state of the world—a state that can only be made sense of through the arts. People's desperate desire to finally leave their homes and come together around a shared cultural experience surely would be the wave of attention the non-profit arts sector had been waiting for. And yet . . . it wasn't.

Not only did we not see the kind of love and attention our peers in the experience economy were facing, our sector also fell victim to a wave of unexpected pain and devastation that felt like a cruel joke after such pandemic-related challenges.

Over the course of writing this book, in 2023, the Kitchener-Waterloo Symphony, the third-largest orchestra in Ontario, known for cultivating world-class talent and delighting audiences of all

ages on an international stage, declared bankruptcy less than a week after abruptly canceling its upcoming season. The same month, Toronto's well-established Reel Asian International Film Festival, known around the world for showcasing contemporary Asian cinema, made a rare public plea for funding as it faced an "unprecedented challenge," and in doing so, according to the *Globe and Mail*, asked potential donors to please redirect additional money to other local arts organizations "as we are far from the only ones faced with this situation."

But it wasn't just the orchestral world and the film festivals that were suffering. Beyond the limits of Ontario, which is often accused of being isolated from the rest of Canada, 2023 also saw a number of performing arts organizations in Manitoba and across the Canadian Prairies tell the Canadian Broadcasting Corporation that they were nearing a fiscal cliff crisis.

It's almost like there were two alternative post-pandemic realities.

And while it might seem convenient to blame the fragility of the Canadian arts community on our unique business model and our perceived overdependency on public funds, friends south of the border are suffering a very similar fate.

In the summer of 2023, with COVID-related restrictions a thing of the past, the *New York Times* interviewed seventy-two top-tier regional theaters outside New York City and learned that, in aggregate, they feared that a reduction of at least 20 percent in their number of productions would be needed to make ends meet—and while that may not seem like a devastating number, they warned that their upcoming season would feature shows with significantly shorter runs, smaller casts, and simpler sets.

Closer to the infallible arts and culture market that is New York City, newspapers have been covering stories of significant layoffs at the off-Broadway giant that is the Public Theater, one of my all-time favorite arts organizations and home to the Under the

Radar Festival—which has been indefinitely postponed as part of the organization's programming. As a former Brooklyn resident, I was heartbroken to hear that BAM (Brooklyn Academy of Music) went through similar reductions in staff and even chopped its Next Wave Festival, which has played an important role in catapulting generations of artists to prominence.

More than that, in June 2023, LA-based Center Theatre Group, one of the biggest theater companies in the U.S., announced it was indefinitely pausing shows at the Mark Taper Forum— one of the most important homes for new plays in the country. That same month, the thirty-five-year-old Tony Award–winning Lookingglass Theatre Company in Chicago announced it would also take a pause from producing shows until spring 2024 and would lay off over half its staff.

All one has to do is look for news articles from 2022 and 2023 on the Oregon Shakespeare Festival, Williamstown Theatre Festival, and Dallas Theater Center to realize that geography does not discriminate in our sector's fragility. Perhaps most devastating for the legacy of American theater is the 2023 cancellation of the Humana Festival of New American Plays, one of the most prolific and internationally renowned festivals celebrating contemporary American playwrights.

And lest we think that the performing arts are uniquely vulnerable, in April 2023, the board of the Center for Contemporary Arts in Santa Fe, New Mexico, voted to close after more than four decades. Meanwhile, across the pond, the National Gallery in London received the unfortunate distinction of having lost more visitors than any other museum surveyed in the *Art Newspaper*'s exclusive Visitor Figures 2022 survey, with nearly 3.3 million fewer visitors in 2022 than in 2019, the last year before COVID-19 hit.

The hunger with which people have resumed in-person experiences post-pandemic is cause for great optimism, but only if our organizations can tap into this zeitgeist. In fact, another

revelation during 2023 was the coining of the term *funflation*, which describes an unprecedented phenomenon of increased spending on entertainment and experiences, despite escalating living costs. Under normal circumstances, when inflation runs high, consumers cut back on spending money on such things as travel, concerts, and non-durable goods like experiences. But unlike the slow bounce back from the 2009 recession, many are now engaging in what some call "revenge spending," a zeal to indulge in experiences now that pandemic lockdowns are in the past.

How does any of this make sense? If the pandemic was truly and solely the single cause of our misfortunes, then why weren't our organizations bouncing back at the same rate as others in similar sectors? And how is it possible that, their particular areas of artistic focus notwithstanding, non-profit cultural organizations across the world, irrespective of their age and legacy, were not able to leverage decades and systems of support into a new way of doing business?

Perhaps because we failed to invest in innovating—and I don't mean innovation as it is often adopted by corporate tech giants. I mean it in the truest and most basic sense of the word. Perhaps we failed to invest in thinking about ourselves differently.

In hindsight, it's becoming increasingly clear that an organization's ability to navigate crises—whether they're international viruses, economic recessions, or calamities we can't currently fathom—is highly predictive of its success and survival. More than that, it's clear that those arts organizations who surfaced from the latest catastrophe relatively unscathed were those that already understood the value of being in communion with their audiences and of producing art in which they had an expressed interest.

You've probably heard the saying *A budget is an expression of priorities*. During the pandemic, facing a crisis of unknown magnitudes, many arts organizations did a common, and common

sense, thing: knowing they would need strong cash reserves to navigate what could be a lengthy return to normal, they retained as much earned and contributed revenue as possible, while reducing expenses considerably (a relatively easy task when you're not producing or presenting cultural experiences). Some, out of an abundance of misplaced caution, went as far as firing, furloughing, or laying off large numbers of staff members. The need and desire to amass record cash reserves might seem smart and incredibly well intentioned, but this exercise in budgeting in times of crisis also tells a different story—a story of prioritization. By reducing all activity, along with their workforce, organizations froze in time and became incapable of using the downtime to figure out a new path into the future, became incapable of innovating at a time when the world was calling for it.

Fast forward to the end of COVID-19 restrictions and to the subsiding of a crisis we spent years praying would end, and find—ironically—a preponderance of frozen arts organizations, blinking into the light, many with record amounts of cash in their coffers, utterly bereft of a sense of purpose in a new world. In our collective excitement, many began to ramp up business according to their muscle memories of pre-pandemic standards, and in doing so, quickly burned through enough money that they were suddenly faced with having to reduce their seasons, cancel their plans, or fold up their shops. The scary sight of watching organizations scrambling with such unprecedented cash reserves is the clearest indication that so many within our community had the resources but perhaps not the ability, desire, or brain trust needed to organically step into a new relevance.

During the pandemic, Arts Commons benefited just as much as everyone else from government subsidies, sympathetic sponsors and donors, and the generosity of ticket buyers who converted their tickets into donations. But we did not amass record amounts of cash—a fact that caused people to look at us like we were crazy (and,

to be honest, some days, I felt like we were!). In fact, we were one of few arts organizations that barely broke even during pandemic fiscal years. The reason we had a very different financial story to tell was because we leveraged unprecedented amounts of generosity into rethinking who we were and who we wanted to become.

This process of reinvention and rediscovering a new sense of relevance and purpose was an "all-hands-on-deck" exercise that saw us retaining 93 percent of our workforce—a workforce kept busy coming up with a new model for the future. With our 560,000-square-foot facility shut down, a lot of our people couldn't execute on their normal job descriptions. Where other organizations might've said, "You know what—your job doesn't exist anymore, so we're going to part ways," at Arts Commons, we said, "We're going to keep you on and we're going to give you three questions to guide you through the pandemic."

First, we asked them, whether they were in departments as varied as production, programming, finance, or HR: *Is there any way in which you could do your job differently right now?*

*If the answer's yes*, we told them, *then go off and do it*. If the answer was no, we'd pose our second question: *Is there any way you can support a different department within the organization in doing things differently?* "If the answer's yes," we said, "then go off and do it." If the answer was no, we'd ask them question number three: *Is there anything you can do within the community on behalf of Arts Commons that will help others do things differently?* That could be helping out a different organization (including our resident companies), volunteering at a food bank, anything that got them engaged in a larger and different community.

If and when any of our colleagues got to question three, *the answer was always yes*. And that was how we retained a lot of our workforce—not just to help us rethink how we did things, but more importantly, to help us build new relationships with others. Relationships that would feed a new sense of purpose.

Given the kind of eager participation we had in navigating crisis, it's no surprise that we came up with all the new initiatives we did during that time—particularly hyperlocal programs that saw us building intentional partnerships, like our arts incubator program, an increased commitment to arts education, and a pop-up concert series around Calgary. We invested record amounts in digital infrastructure and launched the development of an Indigenous Reconciliation strategy with the Crowshoes. Everything that I've talked about in the book—every conversation unpacked in these chapters—is about different ways of doing things that we stumbled upon because we knew we had to invest in just that: doing things differently.

I use the phrase "stumbled upon" very intentionally. During this time, we became comfortable with taking measured risks—particularly those that we knew would have a positive social impact on the communities of Calgary.

Like others, we built a rainy-day fund. Unlike others, though, we took a massive risk by saying *now is the rainy day we've been waiting for* and started investing in the exploration of innovations—innovations that placed Calgary and Calgarians at the center of our processes, explorations that defined innovation through the lens of *who* got to participate in our programs, *how* they participated, and *where* they participated. At the core of our innovations? Participation.

And, again, while it might sound like I'm talking just about navigating COVID-19, the ability to navigate crises this way is what we need to focus on as the big takeaway. The past year has taught us a lot about ourselves, but most importantly that we must lean in to rethinking our relevance in times of catastrophe: how we do things and who we do them for and with. If we don't do this, it's when the catastrophe subsides that many of our organizations start to struggle.

Perhaps this reflection explains why, with the pandemic having loosened its gnarly grasp at last, so many organizations' problems are just getting started. And perhaps the work we did at Arts Commons can inspire others who fear the process of navigating change and uncertainty. In 2021, I may not have been ecstatic that we were among a mere handful of organizations not storing cash reserves and barely breaking even, but you'd better believe that today I'm beyond excited that we ended our 2023 fiscal year with a modest surplus, while so many others are recording massive deficits. To me, that's a demonstration of how we were able to succeed by leaning into redefining our relevance every step of the way.

More importantly, we have rebuilt our relationship with a city in flux. So much so that we are now stewards of the largest cultural infrastructure in Canadian history. In looking back at the pandemic, I'm proud to say that Arts Commons didn't simply get by with meeting our organization's basic needs while navigating the struggles of massive interruptions to our business—we actively redefined our mission and its fulfillment to align with social and civic needs.

In this book, which seeks to puts the arts world in conversations with leaders from other sectors, while also putting the evolving city of Calgary in conversation with other cities facing similar challenges, my hope is to provide the confidence that this process of transformation isn't based on luck—it isn't fluff. It's based on values. And these values have a direct and concrete impact on different areas of our business, which is why, chapter by chapter, we delve into the impact of *relevance* on every aspect of an arts organization's business.

For decades, the arts and culture sector has struggled with how to pivot when times are changing. For generations, it appears as if we've built a reputation of saying, *Nah, we're just going to keep on this path.*

The conversations in this book highlight the need to constantly reassess our relevance and to measure success by how responsive we are and how in service to our community we are. Organizations facing such moments of need as the pandemic represented have two choices. We can either lean in and ask, *How do I redefine my relevance and measure my success of being in service to others in times of need?* Or we can freeze, wait for things to be over, and wake up feeling completely irrelevant in a world that's outgrown us.

Not only is the second choice the wrong thing to do, it deprives arts organizations of an incredible opportunity to help reshape this new world. As a civically minded organization, our mandate is never going to be clearer than when the world is falling apart. If we choose to lay low in these times, we're doing a disservice to our ability to change ourselves and preventing our work from evolving with the world around us.

Five years from now (or tomorrow—let's be real), there might be another economic crisis, another worldwide health pandemic, a new manifestation of the climate emergency—who knows? The task then, as it was this time, will be to lean into that moment to not only make a difference to the world, but to give ourselves permission to build a new kind of business model. If we can imagine a new business model that thrives on our ability to deliver truly positive social impact, then we will have learned our lesson at last.

If the past several years have taught us anything, it's that we are living in increasingly unpredictable times, which is terrifying when, as organizations, we pride ourselves on predicting—we attempt to predict attendance numbers, ticket sales, donations, and so on. Instead of being so scared of losing this self-imposed need to control everything in a vacuum, why can't we imagine a purpose and a business model that are in greater dialogue with the world around us—and that can change with the world around us? Let's imagine it, and let's anticipate it. Perhaps if we can

anticipate it, we will finally see ourselves as skilled in addressing the challenges outlined in this book—challenges that plagued our sector long before COVID-19 turned us upside down.

Only then might we feel the bold hope and optimism that comes with trusting a process of evolution and reinvention that prioritizes conversation, inquiry, curiosity, service, and relevance.

# ACKNOWLEDGMENTS

None of this would have been possible without the constant support, love, patience, and generosity of my partner and best friend, Aliza.

Writing this book was so much more fun and rewarding than I ever could have imagined, thanks to the support of Jennifer Smith and everyone at ECW Press.

One of the greatest gifts this book gave me was the opportunity to have unforgettably rewarding conversations with a number of individuals whom I admire very much about subjects that excite and inspire me. I want to acknowledge and thank each of them for the time and thoughts they shared with me. Their passion breathed life into this book. They are:

- Allison Allen, People, Diversity & Talent Officer
- Dr. Reg and Dr. Rose Crowshoe, Blackfoot Elders, Traditional Knowledge Keepers, and Members of the Order of Canada
- Deborah Cullinan, vice president for the arts at Stanford University
- Asha Curran, chief executive officer at GivingTuesday
- Wanda Dalla Costa, principal at Tawaw Architecture Collective

- Tanya De Poli, founder and chief operating officer at Founders
- Russell Granet, president and chief executive officer at New42
- Todd Hansen, executive producer at Web Summit
- Jesse Hindle, principal at Hindle Architects
- Marianne McKenna, founding partner at KPMB Architects
- Sarah Meilleur, chief executive officer at Calgary Public Library
- Naheed Nenshi, former mayor of Calgary
- Ayesha Williams, executive director at The Laundromat Project

To everyone at Arts Commons who enables me to be the CEO of an organization that I am honored to be a part of, thank you for letting me serve and for welcoming me into this community we share together. To the Arts Commons board of directors, chaired by the wonderful David Smith; and to my amazing colleagues, without whom I would not have had the time and space to pour my energy into this book: Kelsey Deveraturda, Colleen Dickson, Kaija Dirkson, Greg Epton, Tasha Komery, Alynn Spence, Sarah Garton Stanley, and Katie Zuber. Additional thanks to Kate Thompson and my friends at Calgary Municipal Land Corporation.

Thank you to Laura Pratt, from whom I learned so much about storytelling, and to Anam Ahmed, whose thoughtful editing has given shape to these conversations.

Endless gratitude to my new home of Calgary for teaching me daily the meaning of hospitality, possibility, generosity, adventure, and community.

Nobody has been more important and foundational to the development of who I am today than my family and friends. To

my parents, Holly and Andrew, and brother, Mikey, thank you for always guiding, supporting, and inspiring me.

Finally, to all those who have ever taken a chance on me and played a role in my getting here (you know who you are), thank you.

## Entertainment. Writing. Culture. ──────────

ECW is a proudly independent, Canadian-owned book publisher. We know great writing can improve people's lives, and we're passionate about sharing original, exciting, and insightful writing across genres.

────────────────────────── **Thanks for reading along!**

We want our books not just to sustain our imaginations, but to help construct a healthier, more just world, and so we've become a certified B Corporation, meaning we meet a high standard of social and environmental responsibility — and we're going to keep aiming higher. We believe books can drive change, but the way we make them can too.

**Certified**

**Corporation**

Being a B Corp means that the act of publishing this book should be a force for good – for the planet, for our communities, and for the people that worked to make this book. For example, everyone who worked on this book was paid at least a living wage. You can learn more at the Ontario Living Wage Network.

This book is also available as a Global Certified Accessible™ (GCA) ebook. ECW Press's ebooks are screen reader friendly and are built to meet the needs of those who are unable to read standard print due to blindness, low vision, dyslexia, or a physical disability.

This book is printed on Sustana EnviroBook™, a recycled paper, and other controlled sources that are certified by the Forest Stewardship Council®.

**FSC**
www.fsc.org
**MIX**
Paper | Supporting
responsible forestry
FSC® C103567

ECW's office is situated on land that was the traditional territory of many nations including the Wendat, the Anishnaabeg, Haudenosaunee, Chippewa, Métis, and current treaty holders the Mississaugas of the Credit. In the 1880s, the land was developed as part of a growing community around St. Matthew's Anglican and other churches. Starting in the 1950s, our neighbourhood was transformed by immigrants fleeing the Vietnam War and Chinese Canadians dispossessed by the building of Nathan Phillips Square and the subsequent rise in real estate value in other Chinatowns. We are grateful to those who cared for the land before us and are proud to be working amidst this mix of cultures.

**ecwpress.com**